Black Bart Black Museum Little Black Sambo
Conrad's *Heart of Darkness* *Black Beauty* Law
Dark City Black Dragon Society
Lonely Black Sky Blackout Blackshirts
Black Hand of Serbia
Black Forest Cake Black Market The Black Chamber
"The Whisperer in the Darkness"
Black Lightning Black Sox Scandal
Black Tuesday
Black Lion Tamarin Discovered Black Volga Legend
Black Smoker Discovery
Black Sabbath Reinhardt's Black Paintings
Dark Side of the Moon
Hoyle's Black Cloud "Baby's in Black" *Dark Shadows*
"Paint It, Black" The Dark Side "Black Magic Woman"
Black Admiral Restoration Darknets
Black Black Dark Energy Blacklist
Dark Tourism Black Hole Antiterrorism
Dark Matter Black Triangles
Black Swan Theory Black Dahlia
Blackest Black Color Black Mold
Black Velvet Paintings
The Black Sun Men in Black Conspiracy
Universe Fades to Black

THE BOOK OF BLACK

BLACK HOLES, BLACK DEATH,
BLACK FOREST CAKE
AND OTHER DARK SIDES OF LIFE

CLIFFORD A. PICKOVER

CALLA EDITIONS
Mineola, New York

SPONSORING EDITOR: ROCHELLE KRONZEK
PROJECT MANAGER: JANET B. KOPITO
DESIGN MANAGER: MARIE ZACZKIEWICZ

Copyright

Copyright © 2013 by Clifford A. Pickover
All rights reserved.

Bibliographical Note

The Book of Black: Black Holes, Black Death, Black Forest Cake and Other Dark Sides of Life is a new work, first published as a Calla Edition, an imprint of Dover Publications, Inc., in 2013.

International Standard Book Number

ISBN-13: 978-1-60660-049-8
ISBN-10: 1-60660-049-4

Calla Editions
An Imprint of Dover Publications, Inc.
www.callaeditions.com

Printed in China by C & C Offset Printing

*Why has God been symbolized everywhere as light?
Not because God is light, but because man is afraid of darkness.*
—Osho, *The Book of Secrets*

Black cat or white cat: If it can catch mice, it's a good cat.
—Chinese Proverb

Black is beautiful.
—John Sweat Rock (1825–1866), American abolitionist

I've been 40 years discovering that the queen of all colors was black.
—Pierre-Auguste Renoir (1841–1919), French painter

*Any customer can have a car painted any color that he wants—
so long as it is black.*
—Henry Ford (1863–1947), automobile maker

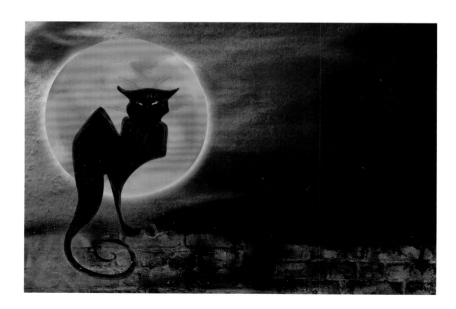

Contents

Introduction *vi*

c. 3 Billion BC	Black Diamonds	*2*
c. 1.8 Billion BC	Black Hills	*4*
c. 300 Million BC	Black Slug	*6*
c. 250 Million BC	Black Widow Spider	*8*
c. 200 Million BC	Black Fly	*10*
c. 150 Million BC	Black Swallowtail	*12*
c. 150 Million BC	Black Mamba	*14*
c. 125 Million BC	Black Iris	*16*
c. 50 Million BC	Black Seadevil	*18*
c. 10 Million BC	Black Ghost Knifefish	*20*
c. 6 Million BC	Black Sea	*22*
c. 1.2 Million BC	Black Tusk	*24*
c. 80,000 BC	Black Magic	*26*
1213 BC	Black Pepper	*28*
c. 1100 BC–750 BC	Greek Dark Ages	*30*
841 BC	Black Obelisk of Shalmaneser III	*32*
c. 700 BC	Black Pudding	*34*
c. 80	Outer Darkness	*36*
c. 100	Black Mass	*38*
476–1000	Dark Ages	*40*
602	Black Stone	*42*
c. 1000	Black Madonna	*44*
c. 1200	Black Cat Fear	*46*
1330	Black Prince	*48*
1339	Black Crown	*50*
1348	Black Death	*52*
1549	Blackbird Pie	*54*
1601	Blackmail	*56*
1606	Black Nazarene	*58*
c. 1680	Blackbeard	*60*
1690	The Black Guard	*62*
1723	Black Act	*64*
1740	Black Pullet	*66*
c. 1750	Blackjack	*68*
1756	Black Hole of Calcutta	*70*
1761	Black Drop Effect	*72*
1779	Black Eye Galaxy Discovery	*74*
1783	Black Holes	*76*
1816	Byron's "Darkness"	*78*
1819	Goya's Black Paintings	*80*
1828	Black War	*82*
1829	"Coal Black Rose"	*84*
c. 1830	Blackface	*86*
1842	Black Angus	*88*
1850	Black Ice	*90*
1855	Browning's Dark Tower	*92*
1858	"Black is Beautiful"	*94*
1862	Death by Blackdamp	*96*
1865	Black Hawk War	*98*
1865	Black Codes	*100*
1875	Black Bart	*102*
1875	Black Museum	*104*
1877	*Black Beauty*	*106*
1899	Little Black Sambo	*108*
1900	Blackbody Radiation Law	*110*
1901	Black Dragon Society	*112*
1902	Conrad's *Heart of Darkness*	*114*
1903	Black Light	*116*
1907	Shooting of the Last Black Mamo	*118*
1911	Black Hand of Serbia	*120*
1915	Black Forest Cake	*122*
1919	Blackshirts	*124*
1919	The Black Chamber	*126*
1919	Black Sox Scandal	*128*

1920	Black Market	*130*	1977	Black Smoker Discovery *172*
1929	Black Tuesday	*132*	1977	The Dark Side *174*
1931	"The Whisperer in the Darkness" *134*		1983	Black Black *176*
1933	Dark Matter	*136*	c. 1987	Black Hole Antiterrorism *178*
1933	Black Velvet Paintings	*138*	1996	Dark Tourism *180*
1937	Black Mold	*140*	c. 1997	Black Triangles *182*
c. 1940	The Black Sun	*142*	1998	Dark Energy *184*
1947	Black Dahlia	*144*	1998	*Dark City* *186*
1947	Blacklist	*146*	2002	Darknets *188*
1953	Men in Black Conspiracy	*148*	2003	Blackout *190*
1953	Reinhardt's Black Paintings	*150*	2006	Black Admiral Restoration *192*
1956	Black Lightning	*152*	2007	Black Swan Theory *194*
1957	Hoyle's Black Cloud	*154*	2008	Blackest Black Color *196*
1959	Dark Side of the Moon	*156*	100 Billion AD	Lonely Black Sky *198*
1964	"Baby's in Black"	*158*	100 Trillion AD	Universe Fades to Black *200*
1966	*Dark Shadows*	*160*		
1966	"Paint It, Black"	*162*	Notes, Acknowledgments, and Further Reading *202*	
1968	"Black Magic Woman"	*164*	Index *213*	
1969	Black Sabbath	*166*	Photo Credits *214*	
c. 1970	Black Volga Legend	*168*		
1971	Black Lion Tamarin Discovered *170*			

We live on a placid island of ignorance in the midst of black seas of infinity, and it was not meant that we should voyage far.
—H. P. Lovecraft, "The Call of Cthulhu"

You will become aware of the beauties of the darkness, which only darkness can have—the depth, the silence, the velvety touch of it, the stillness, the music of the dark night . . . Darkness . . . has its own luminosity.
—Osho, *Intimacy: Trusting Oneself and the Other*

Our Universe is made of darkness.
—Geoff McNamara and Ken Freeman, *In Search of Dark Matter*

Introduction

Shedding Light into the Darkness

God gave us the darkness so we could see the stars.
—Johnny Cash (a.k.a. "The Man in Black"), "Farmers' Almanac"

To ancient humans, the dark represented the unknown, the spirit world—sometimes menacing, nightmarish visions that reflected man's fear of the uncontrollable and the need to give shape and structure to his apprehensions. Sigmund Freud (1856–1939), in his *A General Introduction to Psychoanalysis*, recounts an early encounter with the dark:

> I once heard a child who was afraid of the darkness call out: "Auntie, talk to me, I'm frightened." "But what good will that do? You can't see me"; to which the child replied: "If someone talks, it gets lighter."

Welcome to *The Book of Black*, in which we shed light into the darkness. Here, a book topic can turn from sexy to cosmic with just the turn of a page. In what other book can you find a discussion on the hit rock-and-roll song "Black Magic Woman" alongside an entry on mysterious Dark Energy, which may one day tear apart galaxies and end the universe in a terrible cosmic rip? Few books attempt to explain the Blackbody Radiation Law, which started the science of quantum mechanics, only a page after an entry on Little Black Sambo, an adventurous and clever Indian boy who outwits hungry tigers in a beloved, but controversial, 1899 children's book. (Although the term "Sambo" may be considered pejorative today, I intend no disrespect and use the phrase only within the context of the famous book.)

Each book entry is short, at most only a few paragraphs in length. This format allows readers to jump in to ponder a subject without having to sort through a lot of verbiage. Want to know about some of the deadliest creatures on our planet? Turn to the entries on "Black Widow Spider," "Black Death," or "Black Mamba"—and you'll have a quick adventure and gruesome scare.

When was the first time humans glimpsed the far side of the moon? Turn to the entry on "Dark Side of the Moon" for a brief introduction. Do black cats really mean bad luck? Who first conceived of black holes, centuries before we could show that they exist? What are black diamonds, black lights, and darknets—and who started the conspiracy of

the secretive Men in Black? Who was the Black Dahlia, the Black Prince, or the Black Nazarene? We'll tackle these and other thought-provoking questions in the pages to come.

I provide suggestions for further reading in the "Notes, Acknowledgments, and Further Reading" section. Readers interested in pursuing any subject can use the references as a useful starting point. Sometimes, authors or famous researchers are quoted in the entries in this book, but purely for brevity I don't immediately list the source of the quote or the author's credentials; references in the back of the book should help to make the author's identity clearer.

For an excellent introduction to the "semantic history" of the use of the words *black* and *white*, see Farhad Dalal's *Race, Colour and the Processes of Racialization: New Perspectives from Group Analysis, Psychoanalysis and Sociology*. Dalal writes that "it is striking how few positive associations there are to the word black," but he lists a few favorable items such as black belt (in martial arts), Black Stone (the Islamic sacred stone), Black Power (the ethnopolitical movement), black earth (fertile soil), and "in the black," referring to profit. Dalal notes that black has mostly negative associations today, with concepts such as dirtiness, death, evil, immorality, and unpleasant emotions. The first association of black with sorrow or gloom, according to Dalal, came in the mid-1600s, and the first linkage with death in the written English language occurs around 1400, when black was the color of mourning. Dalal's book is also concerned with the history of how racism is affected by the notions of black and white.

"Retrospective blackening" is a phrase Dalal uses to describe a relatively modern attachment of the word *black* to an event that took place years in the past. For example, the phrase "Black Death," which is associated with the great plagues of the 1300s, may not have actually had the "black" association until the nineteenth century. Dalal writes that "the naming of the plague a black one" has nothing to do with the plague itself. "The blackness has been read back into it from 500 years in the future. This feat is now possible because by the nineteenth century, the word black has taken up sufficient associations with death, terror, illness . . ."

Book Organization and Purpose

There's something about black. You feel hidden away in it.
—Georgia O'Keeffe (1887–1986), American artist

The concept of "black" is relevant today in both the arts and sciences. In fact, in 2008, scientists at Rice University reported on the darkest material known at the time, a carpet of carbon nanotubes about $1/100^{th}$ of an inch long that reflected only 0.045 percent of all

light shined upon the substance. This black is more than one hundred times darker than the paint on a black car! This "ultimate black" may one day be used to more efficiently capture energy from the sun or to design extremely sensitive optical instruments.

My goal in writing *The Book of Black* is to provide a wide audience with a brief guide to curious, fun, and important ideas related to "black," with entries short enough to digest in a few minutes. We'll roam far and wide through fashion, philosophy, politics, popular culture, science, sociology, sports, economics, beliefs, religions, and superstitions in which the color black may have both negative and positive symbolism. For example, in some societies, a black cat crossing one's path is considered bad luck; however, in various places, including parts of England, seeing a black cat is considered good luck. Black is often the color of secrecy or the unknown. For instance, the term "black box" refers to a device whose internal workings are a mystery, and classified military programs are often referred to as "black projects."

The entries in this book are ones that interest me personally. In fact, when I was younger, I became fascinated by anything dark—topics ranging from black velvet paintings to Asian "Black Black" chewing gum and H. P. Lovecraft's haunting tale "The Whisperer in the Darkness." These kinds of quirky, dark, and influential gems are included in this book. Alas, not all of the great scientific, historical, and cultural concepts related to "black" or dark" are covered in this book in order to prevent the book from growing too large. Thus, in celebrating the wonders of darkness in this short volume, I have been forced to omit many important dark marvels. Nevertheless, I believe that I have included numerous entries with historical and cultural significance or that have had a strong or curious influence on science and society.

The Indian spiritual teacher Osho (1931–1990) wrote in *The Book of Secrets*, "Why has God been symbolized everywhere as light? Not because God is light, but because man is afraid of darkness." Some of this fear is manifested in art and music. Many popular songs have the word "black" in their titles. One of my personal favorites, "Black Magic Woman," is included in this book partly because it relates to black magic and spells. Astonishingly, even today people are sometimes imprisoned for casting spells in certain countries. Other notable songs with "black" in their titles include: "Baby's in Black" (1965, The Beatles), "Black is Black" (1966, Los Bravos), "Paint It, Black" (1966, The Rolling Stones), "Black Sabbath" (1970, Black Sabbath), "Back in Black" (1980, AC/DC), "Fade to Black" (1984, Metallica), "Black" (1991, Pearl Jam), "Back to Black" (2006, Amy Winehouse), "Black is Back" (2007, Public Enemy), and "All Black" (2007, Good Charlotte). The lyrics of some of these songs reflect a gloomy mindset: English singer-songwriter Nick Drake recorded "Black Eyed Dog" in 1974, the same year that he killed himself. The title of the song was inspired by Winston Churchill's description of depression as a black dog. "Paint It, Black"

appears to be told from the point of a view of someone suffering from depression.

Our brains may be wired to predispose us to believe in black magic and unseen forces, and to have a need to exert control over the universe and have our deepest fantasies fulfilled. If this is so, the reasons for our fascination, and the rituals we use, are buried deep in the essence of our nature. Magic is at the edge of the known and the unknown, poised on the fractal boundaries of psychology and many other scientific disciplines. Because of this, the kinds of topics associated with black magic are important subjects for contemplation.

While I try to study as many areas of science and culture as I can, it is difficult to become fluent in all aspects, and *The Book of Black* clearly reflects my own personal interests, strengths, and weaknesses. I am responsible for the choice of entries included in this book and, of course, for any errors and infelicities. This is not a comprehensive or scholarly dissertation, but rather it is intended as recreational reading for students of science and culture, and for interested lay people. I welcome feedback and suggestions from readers, as I consider this an ongoing project and a labor of love.

The Book of Black is organized chronologically, according to the year associated with an entry. Dating of entries can be a judgment call when more than one individual made a contribution. Often, I have used the earliest date where appropriate, but sometimes I have surveyed colleagues and other scientists and decided to use the date when a concept gained particular prominence. For example, many dates could have been assigned to the entry "Black Holes," given that certain kinds of black holes may have formed during the Big Bang, about 13.7 billion years ago; however, the term "black hole" wasn't coined until 1967 by theoretical physicist John Wheeler. As I mention in *The Physics Book: From the Big Bang to Quantum Resurrection*, in the final analysis, I used the date when human creativity and ingenuity first allowed scientists to rigorously formulate the idea of black holes. Thus, the entry is dated as 1783, when geologist John Mitchell discussed the concept of an object so massive that light could not escape. Similarly, I assign the date of 1933 to "Dark Matter," because on this date, Swiss astrophysicist Fritz Zwicky provided the first evidence that implied the existence of this mysterious form of matter. The year 1998 is assigned to "Dark Energy" because this was not only the year that the phrase was coined but also the time when observations of certain supernovae suggested that the expansion of the universe is accelerating.

Dating of non-science entries is also frequently a matter of judgment. As just one example, the entry "Black Pepper" is dated to 1213 BC, because we have definitive and fascinating evidence of human use of this spice on this date—in particular, we know that black peppercorns were jammed into the nose of Egyptian pharaoh Ramesses II in 1213 BC immediately after he died. However, pepper was used well before 1213 BC in India,

and, in fact, pepper has been used since prehistoric times.

Finally, dating of animal entries can only be approximate, based on limited fossil evidence and hypotheses of paleontologists and evolutionary theorists. Sometimes we may be aware of the date of the oldest known fossil but suspect that the creature actually evolved millions of years earlier. Thus, these dates can be viewed as highly approximate and meant only to give a rough idea of the animal's origination. Whenever possible, I have given at least a partial justification for the dates used.

I hope that mental stimulation and a joyous mystic transport arise from reading this book and its wonderful panoply of topics that induce a kind of neural nirvana. In a similar vein, writer A. J. Jacobs in *The Know-It-All* expresses the pleasure and shocking mind-expansion that he received from the *Encyclopaedia Britannica*, as he completed his quest to read all entries in alphabetical order:

> The changes are so abrupt and relentless, you can't help but get mental whiplash. You go from depressing to uplifting, from tiny to cosmic, from ancient to modern. There's no segue . . . Just a little white space, and boom, you've switched from theology to worm behavior. But I don't mind. Bring on the whiplash—the odder the juxtapositions, the better. That's the way reality is—a bizarre, jumbled-up Cobb salad.

The Book of Black provides a relentless smorgasbord, a hyperpizza with hundreds of different toppings. On our journey, we'll encounter some of the quirkiest and most profound topics under the sun. Did I say "sun"? To get in the mood, I suggest you read this book at twilight, as darkness descends. Osho writes in *Intimacy*, "Clarity gives shallowness to things; vagueness gives depth and mystery. Light can never be so mysterious as darkness. Light is prose; darkness is poetry."

Consider the true picture. Think of myriads of tiny bubbles, very sparsely scattered, rising through a vast black sea. We rule some of the bubbles. Of the waters we know nothing...
—Larry Niven and Jerry Pournelle, *The Mote in God's Eye*

The Book of Black

Black Diamonds

c. 3 Billion BC

When the Beatles sang of "Lucy in the Sky with Diamonds" in their hit 1967 musical album, they never realized that real diamonds may have descended from the heavens in the form of black diamonds, known as carbonados.

How might these mysterious and ancient stones have formed? One theory is that meteorite impacts can cause the extreme pressures needed to trigger the creation of black diamonds in a process known as *shock metamorphism*. In 2006, researchers Stephen Haggerty, Jozsef Garai, and colleagues reported on studies of carbonado porosity, the presence of various minerals and elements in carbonados, the melt-like surface patina, and other factors that suggested to them that these diamonds formed in carbon-rich exploding stars called supernovae. These stars may produce a high-temperature environment that is analogous to the environment used in chemical vapor deposition methods for producing synthetic diamonds in the laboratory.

Around three billion years old, black diamonds may have originally crashed down from space in the form of large asteroids at a time when South America and Africa were joined. Today, many of these diamonds are found in the Central African Republic and Brazil.

Carbonados are as hard as traditional diamonds, but they are opaque and porous, and are made of numerous diamond crystals that are stuck together. Carbonados are sometimes used for cutting other diamonds. Brazilians first discovered the rare black diamonds around 1840 and named them "carbonados" for their carbonized or burned appearance. In the 1860s, carbonados became useful for tipping drills used to penetrate rocks. One of the largest carbonados ever found has a mass corresponding to about one and a half pounds (3,167 carats, or 60 carats more massive than the largest clear diamond).

Incidentally, the title of the Beatles' psychedelic song about diamonds in the sky was inspired by a fanciful drawing of the young son of songwriter John Lennon, and not because the first letter of each of the title's nouns spelled "LSD," as was rumored at the time!

SEE ALSO The Black Stone (602), Black Holes (1783), Black Eye Galaxy Discovery (1779)

Some scientists hypothesize that exploding stars called supernovae *produced the high-temperature environment and carbon required to create carbonados. Shown here is the Cassiopeia A supernova remnant, with colors indicating different wavelengths of electromagnetic radiation.*

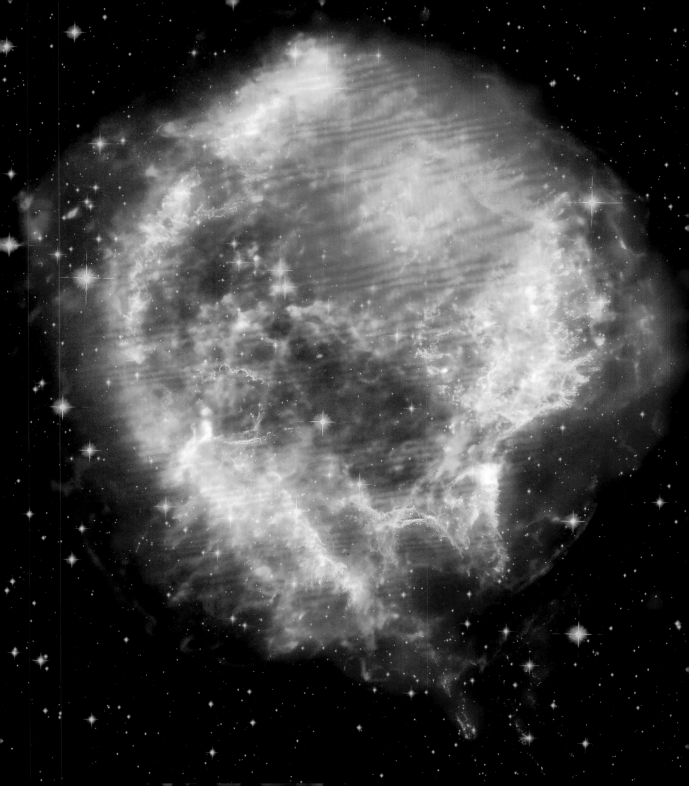

The Black Hills

Crazy Horse (1842–1877)

In 1902, author John Sanford poetically wrote of the Black Hills: "This interesting and peculiar bunch of hills rises abruptly out of the surrounding plains, tossed up by one of Dame Nature's frisky freaks [that forced upward] much of the wealth and many of the secrets of the nether world, creating the third richest gold producing district on this golden continent, a puzzle to geologists and scientists, and a never-ending source of wonder and admiration to all . . ."

The Black Hills mountain range is located in eastern Wyoming and western South Dakota. These hills rise about 3,000 feet (914 m) above the surrounding Great Plains with the highest peak (Harney Peak) reaching an altitude of 7,242 feet (2,207 m). The name "Black Hills" is a translation of the Lakota phrase *Pahá Sápa*, and, from a distance, these pine-covered hills form a dark silhouette against the plains surrounding them.

A gold rush to the Black Hills started in 1874 when gold was discovered, at which point the U.S. government reassigned the local Native Americans to other reservations. Today, famous Black Hills tourist locations include Mount Rushmore—with its huge sculpted heads of four former U.S. presidents—and the Crazy Horse Memorial, a sculpture still being carved out of Thunderhead Mountain, which represents the Oglala Lakota warrior riding a horse. The horse's head will be big enough to fit a five-bedroom home. The tall, mysterious-looking Black Hills rock formation named Devils Tower was a key location in the 1977 film *Close Encounters of the Third Kind*.

The core material of the Black Hills is approximately 1.8 billion years old. Native Americans have lived in the Black Hills since around 7000 BC. In the 1700s, the Lakota drove out other tribes and settled the region. In 1980, the U.S. Supreme Court ruled that the Black Hills were illegally taken from the Lakota and that the Lakota would be paid approximately $106 million in reparations. The Lakota rejected the settlement and instead demanded the actual return of the Black Hills.

SEE ALSO Black Sea (c. 6 million BC), Black Tusk (1.2 million years BC)

This intriguing granite spire, called the Eye of the Needle, is located in the Black Hills of South Dakota and is about 35 feet (19.6 m) tall.

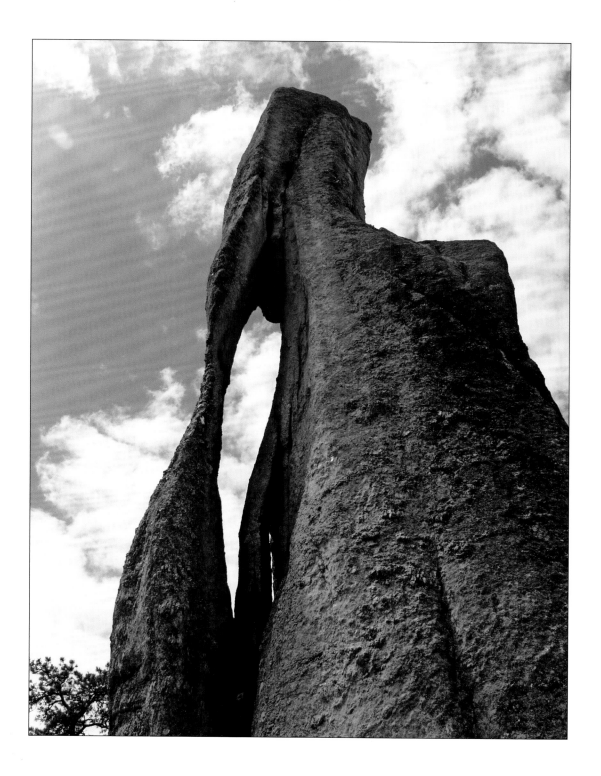

Black Slug

Sir Arthur Everett Shipley (1861–1927), **Sir Sidney Frederic Harmer** (1862–1950)

British zoologists Arthur Everett Shipley and Sidney Harmer write, "*Arion ater*, the great black slug, although normally frugivorous [fruit-eating], is unquestionably carnivorous as well, feeding on all sorts of animal matter, whether decaying, freshly killed, or even in a living state . . . It is frequently noticed feeding on earthworms; kept in captivity it will eat raw beef; it does not disdain the carcasses of its own dead brethren."

The black slug, native to northern Europe, is sometimes referred to as the European black slug or the "northern menace." Approximately 5 inches (13 cm) long when fully extended, the black slug lives on the land and belongs to the class Gastropoda, which includes marine and land snails. Some examples of the oldest-known, land-dwelling gastropods have been discovered to exist during the Carboniferous period in Europe about 300 million years ago.

The thick, bad-tasting mucus surrounding the slug helps to protect the creature from predators as well as helping the slug to remain moist. The slug is hermaphroditic, meaning that each individual has both male and female sex organs. When a potential predator makes contact with the black slug, the slug contracts into a dome-shape and rocks from side to side, possibly to confuse the predator. Thomas Curtis gruesomely notes that "a black slug powdered over with snuff, salt, or sugar, falls into convulsions, casts forth all its foam, and dies."

These slugs are extremely voracious eaters. According to Shipley and Harmer, a British man once discovered a black slug "devouring" a dead mouse. "Being of an inquisitive turn," when the man returned in the evening, he found that "the mouse was reduced almost to a skeleton, and the slug was still there." The 1988 American horror movie *Slugs* featured large black killer slugs with prominent teeth—apparently mutations from a toxic waste dump. These man-eaters traveled through the sewers and wreaked murderous havoc.

SEE ALSO Black Seadevil (50 million BC)

The black slug is native to northern Europe and approximately 5 inches (13 cm) long when fully extended. A thick, bad-tasting mucus surrounds the slug, which helps protect the creature from predators.

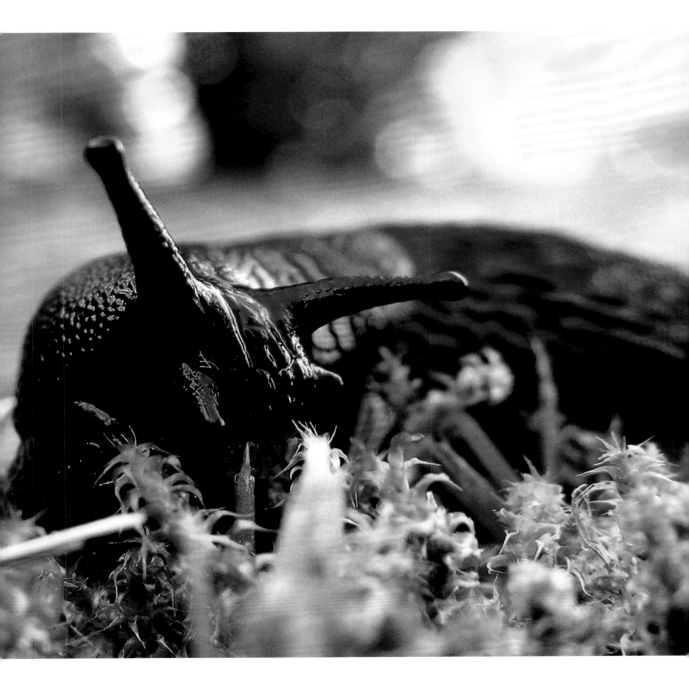

Black Widow Spider

Spiders with spinnerets (silk-spinning organs) at the end of their abdomens came into existence more than 250 million years ago. When an insect is trapped in the black widow spider's web, the spider wraps the prey and then injects its victim with venom from its chelicerae, or fangs, to paralyze the prey. Males are less venomous than females.

The name Black Widow Spider often refers to three North American species known for their dark bodies and red hourglass patterns on the females' abdomens. The male spiders are sometimes less than half the size of the female and have hourglass markings in a variety of colors. The brightly colored markings may be evolutionarily advantageous because they warn predators to avoid the spider. For example, if a bird eats a black widow, the bird usually does not die but becomes sick, and may begin to associate the sickness with the spider's coloration.

Contrary to legend, the female only rarely eats the male after mating. "Husband cannibalism" was indeed observed in studies from the 1920s when females and males were kept together in small containers. However, in more natural settings, the male is usually able to safely leave the female's web after mating.

The venom of a black widow spider is fifteen times more potent than that of the rattlesnake. However, because the spider only injects a small amount of venom, the bite is usually not fatal for a healthy adult human. Symptoms may include painful muscle cramps, nausea, a rise in blood pressure, appendicitis-like pain in the abdomen, excess salivation, heartbeat irregularities, and vomiting.

The dragline silk that serves as the structural foundation of their webs is extremely strong. Researchers have identified the genes for two key proteins in one of seven different kinds of silk produced by the black widow spider, and scientists hope that elucidation of the genetic and biochemical secrets of the webs could lead to new synthetic materials for military uses, such as super-strong body armor.

SEE ALSO Black Fly (c. 200 million years BC), Black Mamba (c. 150 million BC)

The female black widow spider has venom that is much more potent than rattlesnake venom.

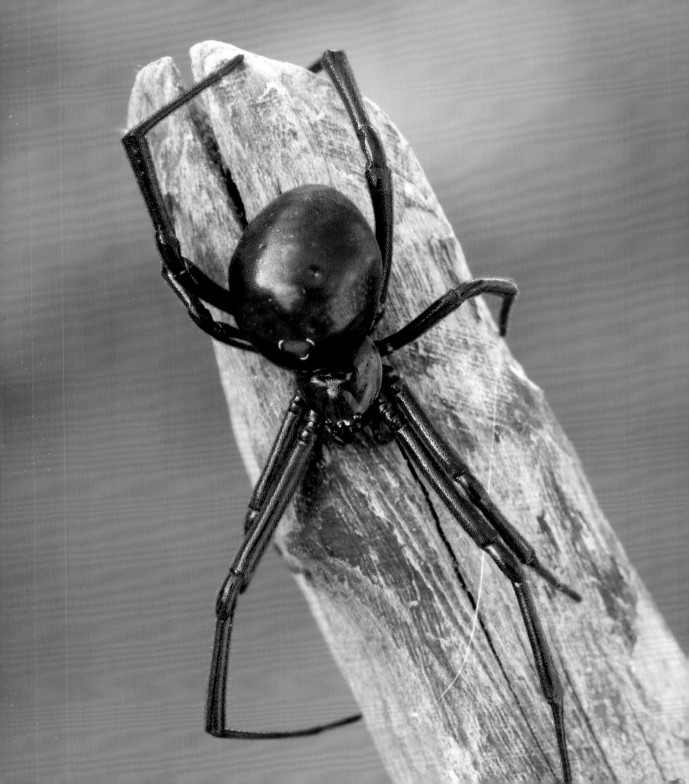

Black Fly

Leland Ossian Howard (1857–1950)

American entomologist Leland Howard writes of the dreaded black flies, "They rival the mosquito in their blood-thirsty tendencies, and not only do they attack human beings, but poultry and domestic animals are frequently killed by them. There is one case on record in which a man was killed by innumerable bites." Indeed, swarms of these flies may be deadly because livestock animals can breathe the flies into their airways and asphyxiate. The *Encyclopedia Americana* refers to these insects as "this tormentor of travelers and fishermen . . . The labrum is free, sharp as a dagger . . . the proboscis is well developed and draws blood profusely."

Over a thousand species of the black fly exist in the family Simuliidae within the order Diptera. The first true dipterans, with their single pair of wings, arose in the Middle Triassic period, about 230 million years ago. Most black fly females suck the blood of other animals, but the males mostly feed on nectar. Particularly in Africa and South and Central America, the black fly is known to spread river blindness. This disease is caused by a parasitic worm that can live for years in the human body and is transmitted in the saliva of the fly. The black fly lays its eggs in running water where the larvae often attach themselves to rocks using abdominal hooks.

After encountering swarms of black flies, domestic animals and people have sometimes died in a few hours through blood loss, allergic reactions, and occluded bronchial tubes. Dark clothing attracts the flies more than light clothing, and the flies are also attracted to animals by the carbon dioxide in the animals' exhaled breaths. To give an idea of the seriousness of black fly swarms, in 1923, black flies killed sixteen thousand farm animals in Romania. Although today insecticides can be used to help protect livestock, black flies can cause great suffering among wild animals.

SEE ALSO Black Widow Spider (c. 250 million BC), Black Swallowtail (c. 150 million BC), Black Mold (1937).

Scanning electron micrograph of an adult black fly (Simulium yahense) *with a nematode worm* (Onchocerca volvulusii) *emerging from the insect's antenna. The parasite is responsible for the disease known as river blindness in Africa.*

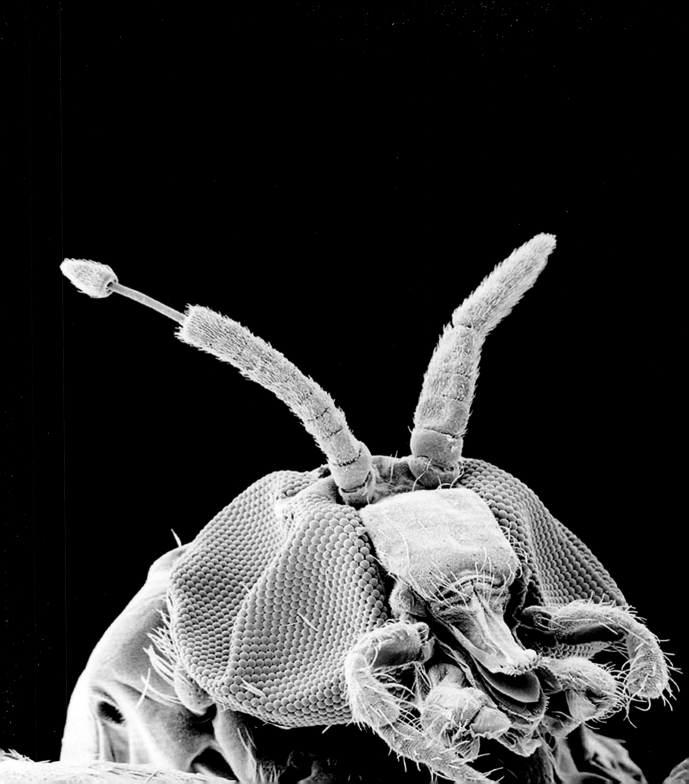

Black Swallowtail

Anna Botsford Comstock (1854–1930)

"When we were children, we spent hours poking these interesting creatures with straws to see them push forth their brilliant orange horns . . ." writes naturalist and educator Anna Comstock. "We did not realize that from these horns was exhaled the nauseating odor . . ." Here, Comstock describes the scent organ of the Black Swallowtail caterpillar. When provoked, the caterpillar turns a pocket within its body inside-out to spread the noxious odor so as to avoid becoming prey for birds.

The beautiful Black Swallowtail (*Papilio polyxenes*) butterfly roams freely through much of North America. The female is larger than the male and tends to have more blue markings on her wings.

Although the caterpillar can be quite colorful in later stages, it is black and white in its early stage and resembles unappetizing bird droppings to "hide" from predators. Interestingly, the chrysalis can vary from green to brown. When created on a smooth surface, the chrysalis is usually green, while rough surfaces lead to brown chrysalises. The brown chrysalis visually blends well with sticks to provide good camouflage.

Recent research suggests that the bright, colorful patches on the wings of many swallowtails work in a way that is reminiscent of high-emission light-emitting diodes (LEDs), which are efficient versions of diodes sometimes used in electronic equipment displays. For example, certain swallowtail butterflies have evolved a technique for signaling one another in which the wing scales act as photonic crystals that contain fluorescent pigments. Reflective undersurfaces, and hollow air cylinders in the wing scales, ensure that the light is directed outward and is not lost.

The earliest-known butterfly fossil is of *Archaeolepis mane*, which roamed with the dinosaurs in the Jurassic period, about 190 million years ago. Swallowtails belong to the suborder Ditrysia, which evolved in the mid-Cretaceous period, roughly 145 to 65 million years ago. Ditrysians have two openings used for reproduction—one is used for laying eggs, another for sex. A third opening is used for excretion.

SEE ALSO Black Fly (c. 200 million years BC)

The beautiful black swallowtail flies freely through much of North America. The earliest-known butterflies roamed with the dinosaurs in the Jurassic period, about 190 million years ago.

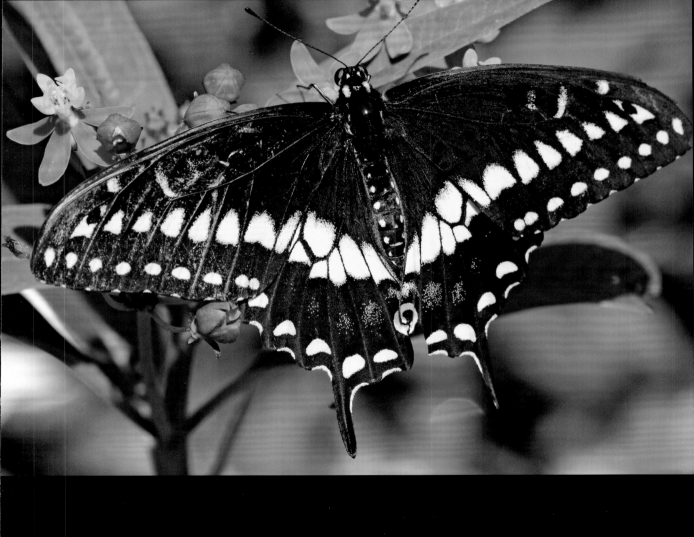

Black Mamba

Peter Hathaway Capstick (1940–1996)

The famed American hunter and author Peter Capstick writes, "The black mamba . . . has probably been the subject of more legend than any other African snake. The very sight of a black mamba . . . is enough to send a shiver through anybody but a congenital idiot. . . . [Its] glimmering black eyes look into your soul like a fluoroscope. . . . Inside the black mouth (which is really the basis for the name "black" mamba) . . . is as much lethalness as a hand grenade."

The black mamba is the largest venomous snake in Africa, reaching maximum lengths of 14 feet (4 m). Among the most aggressive and deadly snakes, a single bite may inject sufficient venom to kill thirty adults. Its bite can kill an adult human within twenty minutes due to paralysis of the muscles used for breathing. Before antivenin existed, the bite of a black mamba was always fatal. Even with antivenin, the mamba is often deadly. One famous case in 1996 involved a snake farmer who was bitten through his trousers. Within a minute, he injected himself with mamba antivenin. Even so, doctors had to perform a tracheotomy on him and connect him to a mechanical respirator, which allowed him to gradually recover.

The black mamba is also one of the fastest snakes in the world, capable of moving at nearly 13 miles (21 km) per hour. Interestingly, scientists hope to someday make therapeutic use of a portion of the black mamba's venom, which seems to contain painkiller molecules called mambalgins that are as powerful as morphine.

According to current scientific thinking, snakes most likely evolved from burrowing lizard ancestors during the Cretaceous period, about 150 million years ago. In fact, some snakes today, such as pythons and boas, have vestigial hind limbs in the form of "anal spurs" that are used to grasp a partner during mating. Another evolutionary theory suggests that snakes may have evolved from mosasaurs—ancient, serpentine marine reptiles that breathed air and were powerful swimmers.

SEE ALSO Black Widow Spider (c. 250 million years BC)

The black mamba, the largest venomous snake in Africa, displays a defensive posture in this photo. Note the characteristic black coloration on the inside of its mouth.

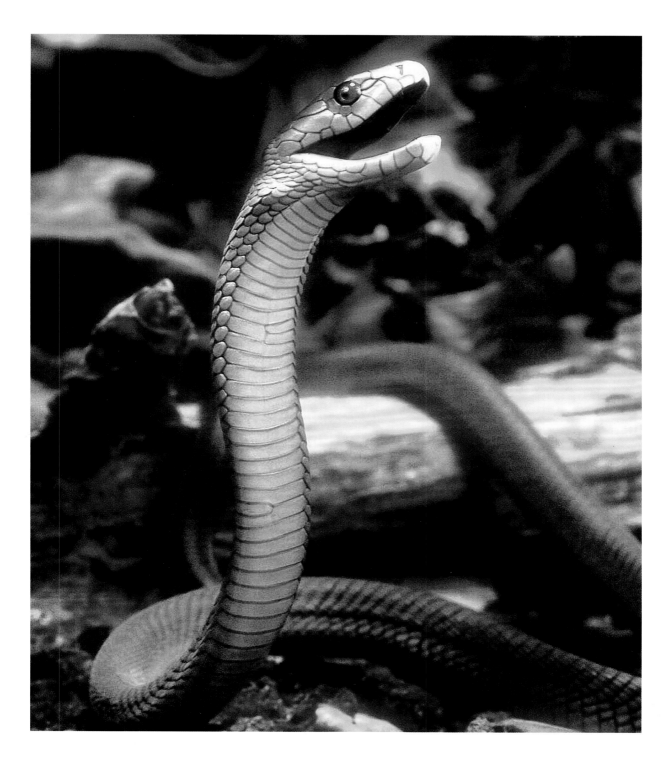

Black Iris

Carol Klein (b. 1955)

"Life would be poorer," writes British gardening expert Carol Klein, "without the velvety darkness of black *Iris chrysographes* . . . which makes the difference between the mediocre and the unforgettable. *I. chrysographes* is a slender, elegant Asiatic iris whose flower colour varies through red, crimson and maroon to almost black. It is the black form that holds the greatest magnetism . . ."

The alluring black iris is native to southern China and Myanmar. Aside from the *Iris chrysographes*, another famous black iris is *Iris nigricans*, the national flower of Jordan. "The iris is one of the oldest cultivated plants," writes physician Michael J. O'Dowd. "Its name came from the Greek, *Iris*, the Rainbow goddess, messenger to the gods, because it appeared in many different colors." Soranus of Ephesus, a Greek physician who lived around 100 AD, "advised iris in oil as an abortifacient; with honey or on its own for vaginal discharge; in oil as suppositories, for inflammation of the womb. . . ."

The earliest fossil of a flowering plant is dated to about 125 million years ago. However, flowers may have existed as far back as 250 million years ago, according to researchers who have detected a chemical called oleanane in ancient oily rock deposits. Oleanane is produced by many common flowering plants as a defense against microbes, insects, and fungi.

According to the PBS TV show *First Flower*, "Flowering plants delight our senses; we love them in our gardens. Yet it is little appreciated that they are the basis of our food . . . and are essential for human life." It is often forgotten that less showy plants like wheat, corn, and rice are also flowering plants, as are apple and oak trees, and require flowers for their reproduction and existence. As a bizarre aside, note that the world's largest flower, called Rafflesia, can have a diameter up to 3 feet (1 m) and can weigh up to 15 pounds (6.8 kg)! It also smells like rotting flesh in order to attract insects such as carrion beetles that pollinate the plant.

SEE ALSO Black Pepper (1213 BC)

Many alluring varieties of black irises are known to exist around the world. The flower's name comes from the Greek, Iris, *the Rainbow goddess, because the flower appears in many different colors.*

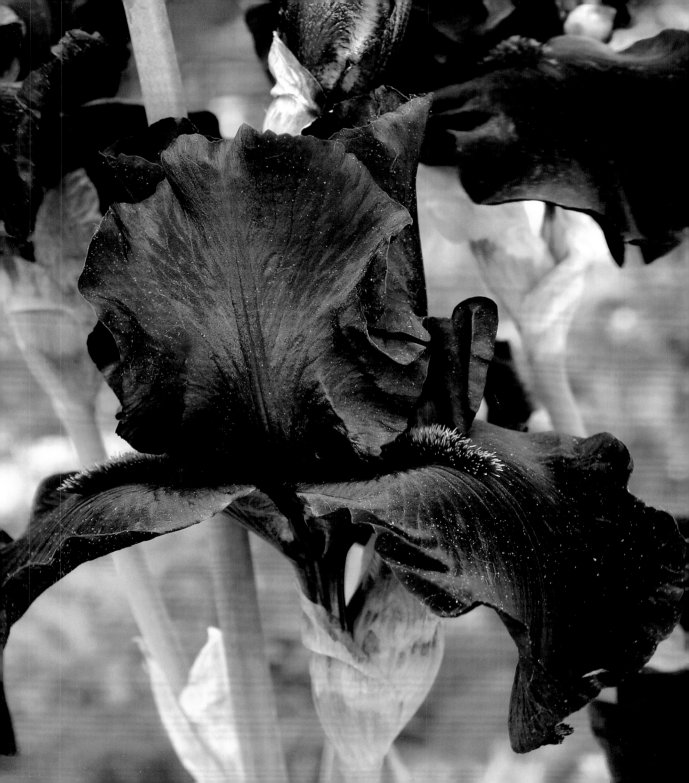

Black Seadevil

Timothy Fridtjof Flannery (b. 1956)

"Consider the black seadevil," writes Australian zoologist Tim Flannery of this deep-sea creature. The female is "a somber, grapefruit-sized globe of a fish—seemingly all fangs and gape—with a 'fishing rod' affixed between its eyes whose luminescent bait jerks above the trap-like mouth." In stark contrast, the male seadevil is less than 3 cm (about an inch) in length. When the male encounters the female, "he bites her and never lets go. Over time, his veins and arteries grow together with hers, until he becomes a fetus-like dependent . . . When she has had her way with him, the male seadevil simply vanishes, having been completely absorbed . . . Not even Dante imagined such a fate."

Black seadevils are classified in the order Lophiiformes, which contains representatives of the "anglerfish," the fossil record of which extends back to the Eocene epoch, about fifty million years ago. The female black seadevil (*Melanocetus johnsonii*) lives at depths of 330–9,000 feet (100–2,700 meters), and her protruding, fleshy, luminous bait is used for attracting smaller fish for her to eat. The seadevil's glowing parts are activated by a process known as bioluminescence, involving light-producing chemical reactions in symbiotic bacteria. The female's stomach is easily capable of stretching to allow her to eat prey larger than herself.

When the attached male loses his gut, he essentially transforms into a blob of testicles on the skin of the female. Under her hormonal commands, the remnants of the male release sperm upon request. Science writers Mark Shrope and John Pickrell note that we "might think there is little left to discover on Earth in the twenty-first century, yet the deep sea remains almost entirely unknown . . . It is extremely cold, utterly dark, often low in oxygen and smothered by a pressure one thousand times greater than at the surface—so immense it alters biochemistry." We now know that such deep waters are home to an amazing variety of creatures that include mysterious blood-red squids and octopuses with glowing suckers.

SEE ALSO Black Slug (c. 300 million BC), Black Ghost Knifefish (c. 10 million years BC)

Humpback anglerfish (Melanocetus johnsonii), *also called the common black devil. [From* Die Tiefsee-Fische, *by German zoologist August Brauer (1863–1917).]*

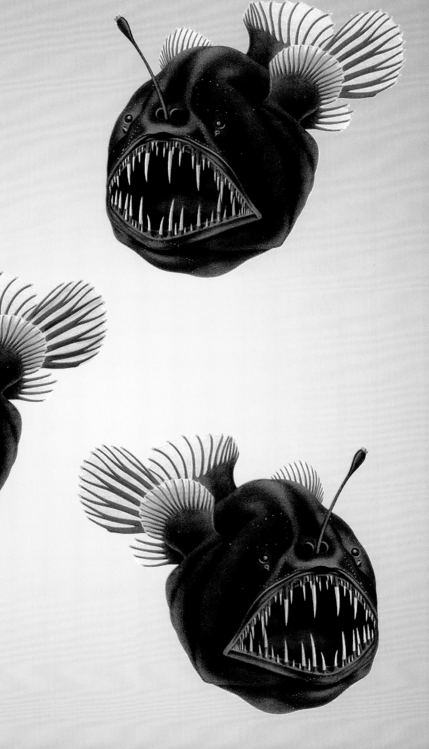

Black Ghost Knifefish

Several fish exhibit electrical senses. Like the echolocation of bats, which registers the reverberations of high-frequency sound waves, electric impulses can be used to "sound" nearby objects. True electric organs have evolved independently in several different groups of fishes, and examples of fishes with electrical sense include the skate, knifefish, elephant fish, electric eel, electric catfish, electric ray, and the stargazer—an elongated fish that buries itself at the bottom of oceans.

The black ghost knifefish, *Apteronotus albifrons*, a tropical freshwater fish from South America, usually hunts for food at night using an electric organ and receptors distributed over the length of its body to help it locate food such as insect larvae. Some of the indigenous populations of South America once believed that the ghosts of the dead inhabited these fish.

The knifefish's electric organ discharges a high-frequency (approximately 1 kHz) signal. Because potential prey differs in electrical impedance from the surrounding water, they give rise to small fluctuations in the electric field around the fish, fields that are sensed by the knifefish's extremely sensitive electroreceptor organs.

The black ghost knifefish belongs to the Gymnotiformes order of fish, with fossils from Bolivia dating back as far as the Miocene epoch, about ten million years ago. Related fish of the genus *Eigenmannia* have elaborate social behaviors based on electricity. For example, when two of these fish meet, they have the ability to adjust their frequencies up or down to avoid "jamming" of signals and can turn off the electrical field to be electrically undetectable as they hide or listen. The *Sternopygus* electric fish uses electricity for love—if a female fish swims past an adult male of her own species, she "turns him on," and the male's steady-state single-frequency discharge changes into a chaotic electric love song.

SEE ALSO Black Seadevil (c. 50 million BC)

The black ghost knifefish, a tropical fish from South America, usually hunts for food at night using an electric organ and receptors distributed over its body to help it locate food.

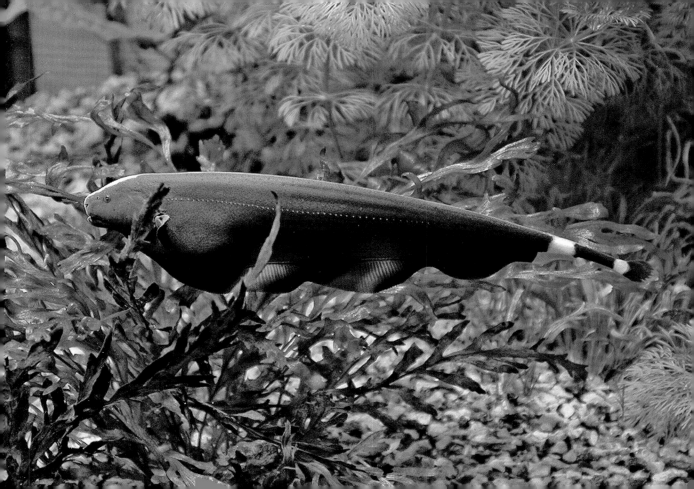

Black Sea

Charles King (b. 1967)

Large movements in the crust of the Earth led to the formation of the Alps, Carpathian Mountains, Balkan Mountains, and Caucasus Mountains in Europe and Eurasia about six million years ago. These shifts in land caused a huge, ancient body of water, the Tethys Sea, to become divided into several smaller brackish bodies of water, one of which was to become the Black Sea located between southeastern Europe and modern-day Turkey. Around five thousand years ago, a connection between the Black Sea was established to the Mediterranean Sea through the Bosphorus and the Dardanelles, two straits of water. Today, a majority of the creatures living in the Black Sea seem to have come from the Mediterranean.

The name "Black Sea" is at least as old as the thirteenth century, although the reason for the name is unclear. It is true that visibility in the Black Sea is much lower than in the Mediterranean, due in part to the great depth of the sea and also to a higher concentration of certain algae. The hydrogen sulfide layer that begins about 656 feet (200 meters) below the surface makes it impossible for fish and other nonbacterial life forms to exist below this depth. American academician Charles King speculates on another possibility for the name, noting that "the earliest Greek name, *Pontos Axeinos* (the dark or somber sea) . . . may have reflected sailors' apprehensions about sailing its stormy waters . . ."

According to some researchers, around 5600 BC, water flooded into the Black Sea from the Mediterranean, and the memories of terrified survivors led to the biblical account of Noah's Flood. However, recent evidence suggests that the level of the Black Sea was higher than originally estimated, which greatly reduces the potential for flooding.

The Black Sea and its immediate surroundings were the sites of important naval and land battles in World Wars I and II. Professor King reminds us that "over the long course of history, the Black Sea has more often been a bridge than a barrier, linking religious communities, linguistic groups, empires, and, later, nations and states into a region as real as any other in Europe or Eurasia."

SEE ALSO Black Hills (c. 1.8 billion years BC), Black Tusk (1.2 million years BC)

Cliffs overlooking the Black Sea in Crimea, a peninsula of Ukraine located on the northern coast of the Black Sea.

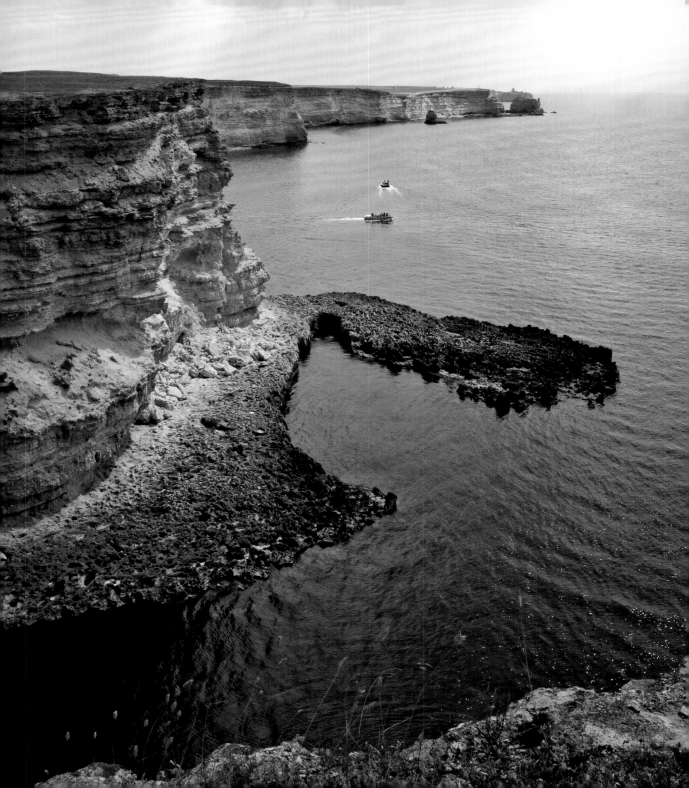

Black Tusk

"No other rock formation in the Coast Mountains [of Canada] is as noticeable as the Black Tusk," writes author Janna Fleming. This awesome prominence is made of volcanic rock standing 7,608 feet tall, a remnant of a large lava flow. To the Squamish indigenous nation, the Black Tusk was known as "the landing place of the Thunderbird," a huge bird that lived on the top, "flapping its wings to cause thunder and shooting lightning bolts from its eyes." The Squamish observed a strict taboo against climbing the structure and believed that the rock was burned black by the lightning of this enormous mythological creature.

The Black Tusk in British Columbia, Canada is what remains of a cinder-rich volcano that formed about 1.2 million years ago. The actual lava flow forming the summit is about 170,000 years old. Because of the ubiquity of the thunderbird myth, some researchers have speculated that the creature is a recollection of the now-extinct bird called Merriam's Teratorn (*Teratornis merriami*)—a large North American bird with a wingspan of up to 12 feet (3.8 meters).

According to researcher and lecturer Carol Rose, the thunderbird persists for "most Native American people in North America . . . Some revere the Thunderbird as a deity, others simply as a semi-supernatural being of the skies. The Thunderbird may be portrayed as a gigantic type of eagle with either red plumage or a feathered cape (Crow traditions), sometimes with a human face (Sioux tradition), or a human face on its belly (Haida tradition)."

As a fascinating aside, the Squamish people have a flood myth vaguely reminiscent of the story of Noah. The Squamish ancestors prepared for a great flood by building a giant canoe, larger than any had ever seen before. All of the Squamish people drowned except for the few in the boat. After many days, the boat finally came to rest in the mountains, and the Squamish race was saved.

SEE ALSO Black Hills (c. 1.8 billion years BC), Black Sea (c. 6 million BC), Black Smoker Discovery (1977)

The Black Tusk in British Columbia, Canada, is the remains of a cinder-rich volcano that formed about 1.2 million years ago. To the Squamish people, the Black Tusk was known as "the landing place of the Thunderbird."

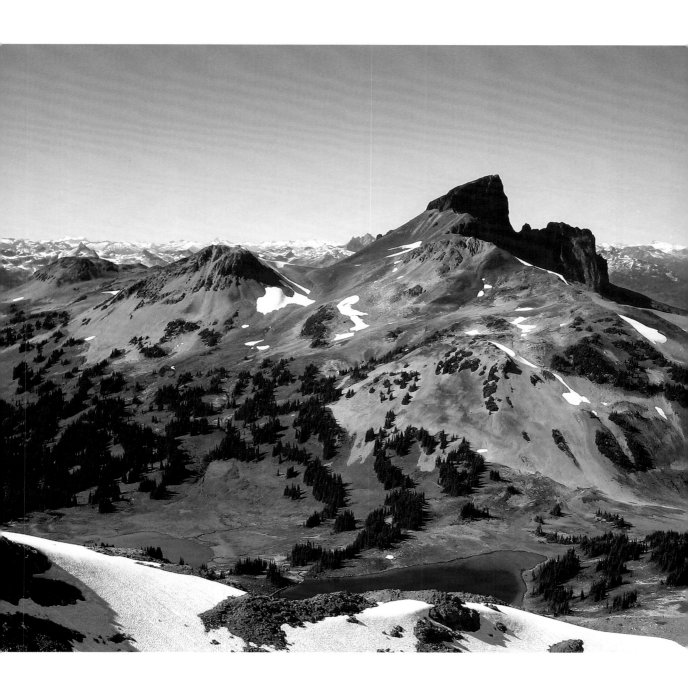

Black Magic

Richard Cavendish (b. 1930)

"The driving force behind black magic is a hunger for power," writes British historian Richard Cavendish. Black magic is "rooted in the darkest levels of the mind . . . but it is much more than a product of the love of evil . . . It is a titanic attempt to exalt the stature of man, to put man in the place which religious thought reserves for God."

The phrase "black magic" often involves an attempt at supernatural control of the natural world and covers topics ranging from witchcraft and the mastery of evil spirits to ceremonial magic, Satanism, necromancy, and rituals used in the Black Mass (discussed in another entry in this book). The practice of some form of black magic probably emerges at the dawn of humanity. For example, the Drachenloch cave in the Swiss Alps features bear skulls, all pointing to the mouth of the cave, as well as skulls sitting in niches of the walls. This example of Neanderthal ritual dates to around 80,000 BC.

Cavendish reminds us that even if we consider the ideas and rituals of black magic to be unscientific, it is still a worthy area of study, as black magic involves a type of thinking that was common throughout the history of Europe. Our brains may be wired with a desire for black magic, unseen forces, and a need to exert control over the universe and have our deepest fantasies fulfilled. If this is so, the reasons for our fascination, and the rituals we use, are buried deep in the essence of our nature. Magic is at the edge of the known and the unknown, poised on the fractal boundaries of psychology, history, philosophy, biology, and many other scientific disciplines. Humans need to make sense of the world and will surely continue to use both logic and magical thinking for that task. What patterns and connections will we see as the twenty-first century progresses? What will be our magic in the future?

SEE ALSO Black Mass (c. 100), Black Cat Fear (c. 1200), Black Pullet (1740), *Dark Shadows* (1966), "Black Magic Woman" (1968)

Witches (*woodcut, 1508*), *by German Renaissance artist Hans Baldung Grien (1484–1545).*

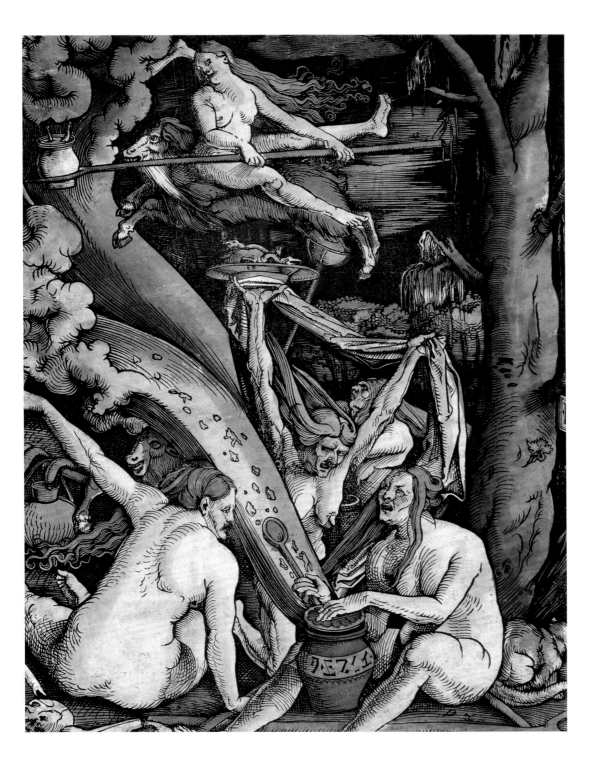

Black Pepper

Ramesses II (reign 1279–1213 BC)

According to R. S. Paroda, an official of India's Ministry of Agriculture, black pepper has been christened the "King of Spices" and "black gold"—and is "the most important and most widely used spice in the world, occupying a position that is supreme and unique. In the past, black pepper ranked with gold and was used as barter money. It was so precious that only kings and others in the highest class were allowed to possess it."

Black pepper (*Piper nigrum*) is a flowering vine native to South India whose fruit is dried and used as a spice. The pungency of black pepper is caused by piperine, a chemical compound discovered in 1819 and also used in medicine and as an insecticide. To produce black pepper, the green "berries" of the pepper plant are dried for several days.

The date 1213 BC is significant in the history of black pepper because we have definitive proof that black peppercorns were jammed into the nose of Egyptian pharaoh Ramesses II immediately after he died during this year. The peppercorns may have helped the mummified nose retain its shape and also served as a preservative.

Pepper has been used in India since prehistoric time, and virtually all of the black pepper found in Europe during the Middle Ages came from India. Throughout history, pepper was sometimes viewed as sufficiently valuable as to serve as a form of money. We owe the discovery of America by Europeans to the value of pepper and other spices, and to the desire to find a new route to India.

Spice expert and researcher P. N. Ravidran writes, "It is difficult for us now to appreciate the extent or influence that pepper and other spices had on nations and people during the chequered history of human civilization. Wars were fought, kingdoms were built and demolished, cities grew, flourished and declined—the density of humankind was influenced so much—all for the sake of spices."

SEE ALSO Black Iris (c. 125 million BC), Black Pudding (c. 700 BC), Black Forest Cake (1915).

Through history, pepper was sometimes so valuable that it served as a form of money. Wars were fought, and kingdoms rose and fell, based on the desire for spices.

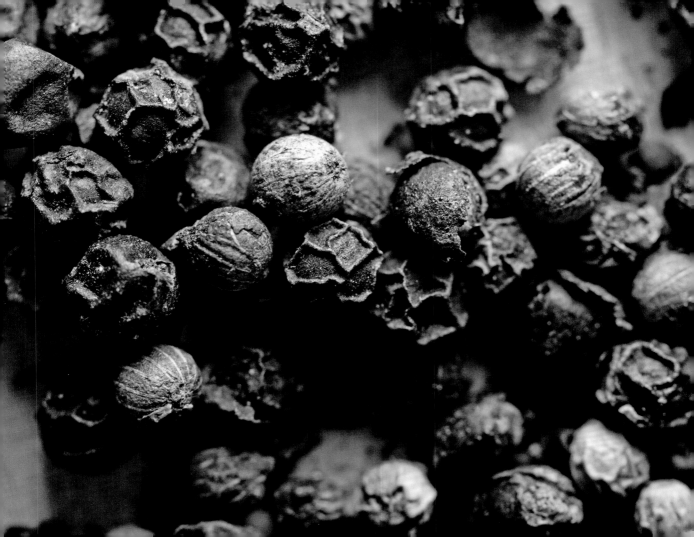

Greek Dark Ages

According to historian and religious scholar Louis Ruprecht, the Greek Dark Ages followed the collapse of three civilizations: the Minoan civilization in Crete, the palace-centered and highly literate Mycenaean civilization on the mainland of Greece, and the Cycladic civilization in the Aegean islands. "This does not mean, as the name seems to suggest, that the Greek peoples in the Dark Ages were too stupid to come out of the rain. Instead, it means simply that we 'are in the dark' about them, given the comparative absence of archaeological and literary remains from this period . . ."

A study of archaeological evidence reveals a general destruction of civilization in the eastern Mediterranean during this period, and the great palaces and cities of the Mycenaeans were abandoned. Depictions of animals or people featured on the ornate pottery of the Mycenaeans were replaced with simple geometric designs. Moreover, there was an apparent cessation of written Greek language during this time.

Author Roger Henry writes, "We are expected to believe that the people either disappeared completely or adopted a lifestyle that left nothing behind . . ." In the thirteenth century BC, an invasion of the Peloponnese (southern Greek peninsula) appears to have occurred, and then, strangely, the conquerors left. Greece then entered a Dark Age, which ended around the same time that the first Greek Olympic Games took place.

Some theories suggest that the Mycenaean civilization disappeared as a result of an ecological calamity involving human destruction of forests. When the Greek Dark Ages came to an end, and the Mycenaean script was replaced by a new alphabet system adopted from the Phoenicians, Greek civilization finally reflowered and spread far across the Mediterranean. Ruprecht writes, "The lesson of the Greek Dark Ages is a poignant one: it suggests that nearly all we value as 'civilization' is more fragile and more tenuous than perhaps we like to believe. Civilizations . . . can age, wither, and perhaps they can even die."

SEE ALSO Dark Ages (476–1000)

The Greek Dark Ages followed the collapse of the Mycenaean civilization. This famous funeral mask, discovered by archaeologist Heinrich Schliemann in a Mycenaean tomb, has long been the center of delicious debates regarding its authenticity, and the mystery persists to this day.

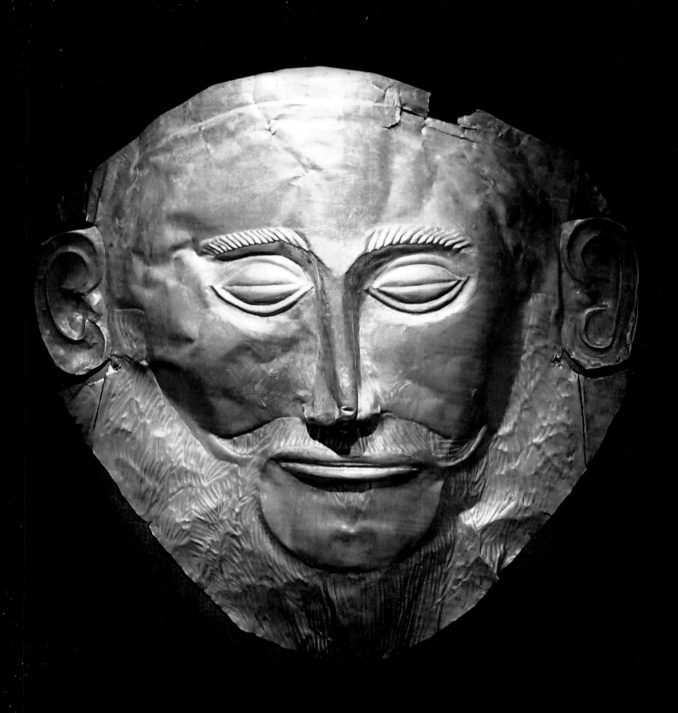

Black Obelisk of Shalmaneser III

Shalmaneser III (reigned 858–824 BC), **Sir Austen Henry Layard** (1817–1894)

The Bible gives its readers a glimpse of other ways of thinking and of other worlds. It is a mysterious collection of information because we don't know the ratio of myth to history. We are not always sure of the intended messages, but it is clear that the Bible has reflected some of humankind's deepest feelings.

The seven-foot-tall Black Obelisk of Shalmaneser III, erected by the Assyrian King Shalmaneser III in about 825 BC to celebrate his military prowess, provides a fascinating piece of evidence that validates an ancient biblical kingship. On the obelisk, we see the image of Israel's King Jehu (who reigned roughly from 841–814 BC) bowing in tribute after Israel is defeated by Assyria. The depiction of Jehu is one of the earliest surviving images we have of an Israelite, and the Black Obelisk is the most complete Assyrian obelisk ever found. In 1846, archaeologist Austen Henry Layard discovered the Black Obelisk in Nimrud, an ancient Assyrian city on the Tigris River. This black limestone obelisk is covered with relief sculptures and cuneiform information.

Religious scholars John Barton and Julia Bowden write of the depicted encounter with King Jehu: "Although this particular incident is not mentioned in the Old Testament record of Jehu's reign in 2 Kings 9–10, the inscription is particularly interesting because it refers to Jehu as 'son of the house of Omri.' This [passage] indicates that Omri, King of Israel (885–874 BCE), had been such a prominent king that the Assyrians referred to Israel as 'the house of Omri'—an interesting point given that the biblical record of Omri's reign warrants only six verses!" The obelisk does not only focus on Israel, but features five different subdued kings. The Assyrian cuneiform caption above the scene featuring Jehu may be translated as "The tribute of Jehu, son of Omri: I received from him silver, gold, a golden bowl, a golden vase with pointed bottom, golden tumblers, golden buckets, tin, a staff for a king, and spears."

SEE ALSO The Black Stone (602), Black Madonna (c. 1000)

A portion of the Black Obelisk, showing Jehu, King of Israel, giving tribute to King Shalmaneser III.

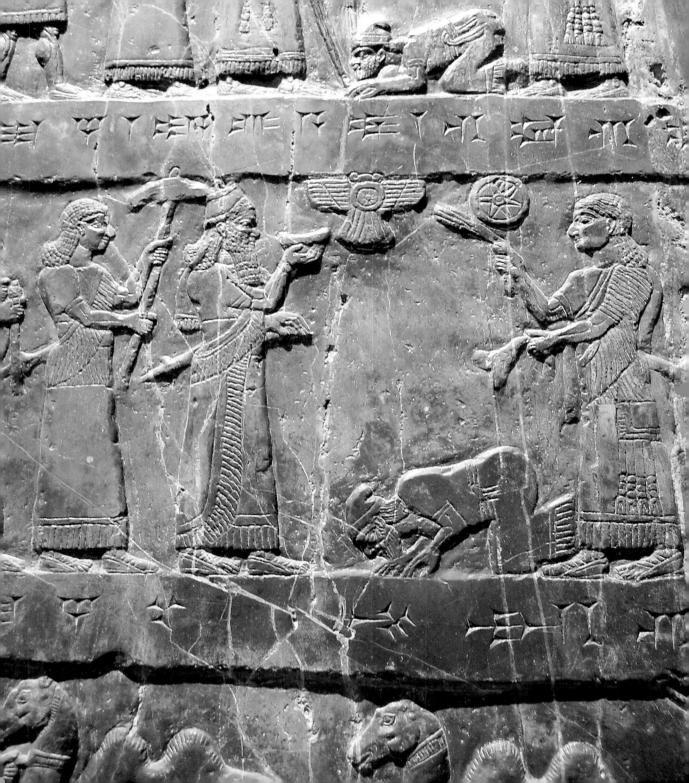

Black Pudding

Plutarch (c. 46 AD–120 AD)

Black pudding is popular in Europe and is often a part of a traditional breakfast in England, Scotland, and Ireland. The pudding is actually a kind of sausage made by cooking blood (usually from a pig or cattle) with a filler such as flour, fat, oatmeal, or meat until it is thick enough to congeal.

The first reference to food made with blood comes from Homer's *Odyssey*, the ancient Greek epic poem that is often dated to around 700 BC. He writes of a man near a great fire who "has filled a sausage with fat and blood and turns it this way and that and is very eager to get it quickly roasted."

The ancient Spartans were rather fond of *melas zomos*, or black soup, made from boiled pigs' blood, vinegar, and pork. The vinegar may have helped to prevent the blood from clotting during the cooking process. Plutarch, in his *Ancient Customs of the Spartans*, noted: "A thing that met with especial approval among them was their so-called black broth . . . Dionysius, the tyrant of Sicily, for the sake of this bought a slave who had been a Spartan cook, and ordered him to prepare the broth for him, sparing no expense. But when the king tasted it, he spat it out in disgust, whereupon the cook said, 'O King, it is necessary to have exercised in the Spartan manner, and to have bathed in the Eurotas, in order to relish this broth.'"

Culinary expert John Taylor writes of his fondness for black pudding: "On Barbados, whence came many of the early English settlers and African slaves, blood pudding and souse are still traditional Christmas dishes. . . . I go to my butcher's on slaughter day with a bucket to catch the fresh blood. He gives it to me to bait sharks, but what I really do is make blood pudding. . . . Vinegar stirred into a quart of fresh blood will prevent coagulation."

SEE ALSO Black Pepper (1213 BC), Blackbird Pie (1549), Black Forest Cake (1915), Black Black (**1983**)

Black Pudding is a kind of sausage made by cooking blood with a filler. An early reference to food made with blood comes from Homer's Odyssey.

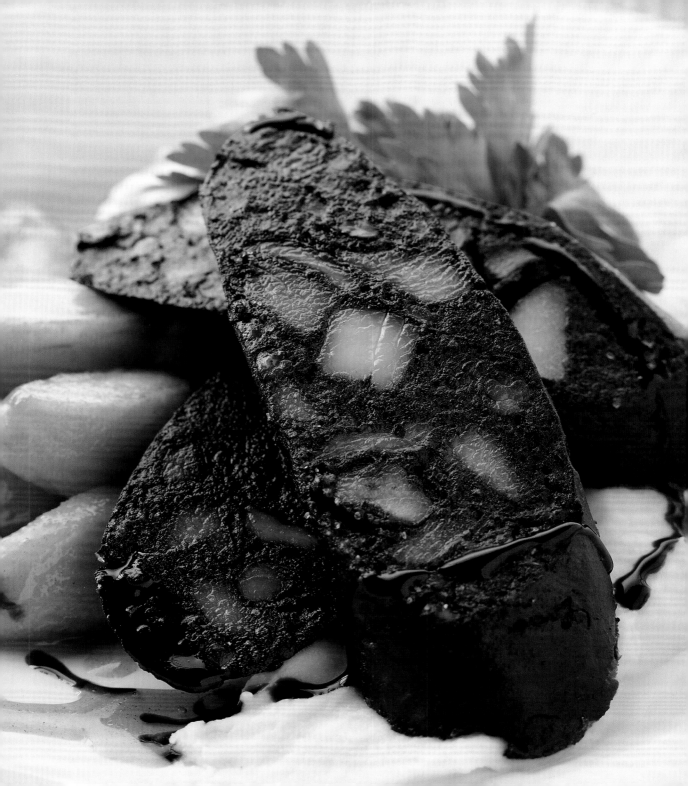

Outer Darkness

Herbert Lockyer (1886–1984)

The concept of Outer Darkness comes from the Christian New Testament Gospel of Matthew, which may have been written in the city of Antioch around the year 80 AD. Outer Darkness is mentioned three times in this Gospel and appears to refer to a location into which a person may be "cast out" and where there is a "weeping and gnashing of teeth" because the person is separated from God.

Religious expert and pastor Dr. Herbert Lockyer writes, "We do not know all that is implied by 'outer darkness,' or the darkness of the outside. We cannot see through the veil and penetrate the darkness, and tell of the sufferings within it. . . . Particulars of the torments of the wicked are not revealed. The only safety from them is to hide in His bosom."

On the concept of Outer Darkness according to the beliefs of Mormons, author and reporter Drew Williams had this to say: "Latter-day revelation notes that, having meted out all of the glory and mercy to even the lowliest of souls, God still needed a place for the most wicked of spirits, such as those who chose to follow Satan in defiance of the plan presented at the Grand Council . . . No spirit of God dwells in [the Outer Darkness]. Outer Darkness is the ultimate exile." According to Williams, those people who knew Jesus Christ as the Messiah, yet denied the truth, are condemned souls who "will suffer in eternal darkness and torment forever. These lost souls would rather have never been born."

But according to Pastor J. D. Faust, "Some modern Christians hold that this 'outer darkness' is a temporary prison in the heart of the earth where carnal Christians will spend the millennium. Others teach that 'outer darkness' is only a realm above ground *within* the kingdom . . . Some teach that there is *also* a further possibility of being cast down into the underworld depending on the degree of sin; but they would distinguish this underworld from 'outer darkness.'"

SEE ALSO Black Madonna (c. 1000), Black Lightning (1956)

In Christianity, a person may be cast out into Outer Darkness, which may either be a kind of hell or simply a separation from God. Shown here is an illustration from Les Très Riches Heures du duc de Berry, *by the Limbourg brothers, c. 1412.*

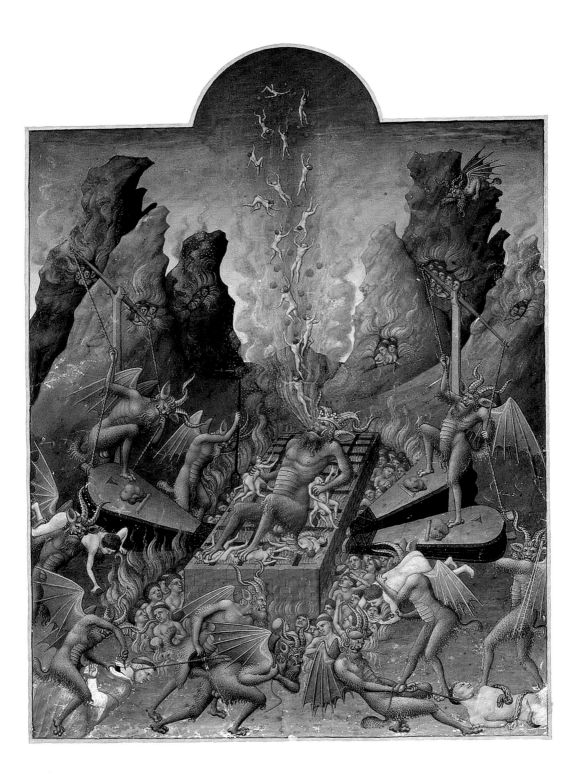

Black Mass

Saint Irenaeus, Bishop of Lugdunum (c. 120–c. 202), **Isaac Bashevis Singer** (1902–1991), **Richard Cavendish** (b. 1930)

Nobel Prize-winning author Isaac Bashevis Singer writes, "We are all black magicians in our dreams, in our fantasies, perversions, and phobias . . ." Singer refers, in part, to the mysterious powers sometimes associated with the Black Mass and other forms of dark ceremonial magic with origins that date back several centuries.

Black Masses are usually Christian Mass ceremonies performed in unholy ways. According to legend, one object of these ceremonies was to profane the Host during a Black Sabbath, a meeting of individuals practicing Satanism or witchcraft. The Roman Catholic Church teaches that the Host, a wafer made of flour, is changed into the Body of Christ through transubstantiation, once a priest consecrates the Host using the appropriate words.

Some of the earliest examples of Black Masses go back to the second century AD when, according to British historian Richard Cavendish, "St. Irenaeus accused the Gnostic teacher Marcus, 'an adept in magical impostures,' of what seems to have been a perversion of the Mass to the worship of a deity other than the Christian God."

Ironically, *faithful* Christians started the phenomenon of the Black Mass when they gradually came to use the Mass for extra-religious purposes. In the sixth century, Masses were conducted to bring good weather, to prevent cattle from getting sick, to clear or convict a person accused of a crime, or even to kill others. In the sixteenth century, a priest performed Mass on the "belly of a young nun to cure her of bewitchment." In the Middle Ages, priests were ordered to lock away the Hosts to prevent them from being stolen and used in black magic.

Although reports of Black Masses and Sabbaths may often be exaggerated or fabricated, numerous actual cases seem to exist, ranging from the late-1600s case of Father Tournet who said Mass over the young girl he had impregnated (in hopes of triggering her miscarriage) to more recent examples involving reversed Christian prayers, naked virgins, or groups of people surrounded by images of goats trampling on crucifixes.

SEE ALSO Black Magic (80,000 BC), *Dark Shadows* (1966), Black Sabbath (1969)

A painting in the Rila Monastery in Bulgaria, c. 1850, condemning witchcraft and folk magic.

Dark Ages

Howard Pyle (1853–1911), **Joseph Henry Dahmus** (1909–2005), **Francesco Petrarca** ("Petrarch") (1304–1374)

In 1888, American author Howard Pyle dramatically described the Dark Ages as "a time when the wisdom of the ancient times was dead and had passed away, and our own days of light had not yet come. There lay a great black gulf in human history, a gulf of ignorance, of superstition, of cruelty, and of wickedness. That time we call the dark or Middle Ages. Few records remain to us of that dreadful period . . ."

More recently, American historian Joseph Dahmus wrote that the "centuries from the sixth to the close of the tenth were the most turbulent and misery-laden that Europe has ever experienced . . . These were melancholy times [when] men feared the very bases of society would dissolve . . ."

The term "Dark Ages" usually refers to the Early Middle Ages of European history, between 476 and 1000 AD. In 1330, Italian scholar Petrarch referred to the years before him as being "surrounded by darkness and dense gloom," and later scholars used the term "dark" to refer to a seeming lack of primary information sources during this time and limited technological and cultural progress.

In the Dark Ages, political and economic development in Europe tended to be localized, and peasants were bound to the land and dependent on landlords for protection. The church served as an overarching European institution, although its authority tended to be diffused to the local bishops. Few people could read or write. Travel was often unsafe over any significant distance, which led to a decline in trade and manufacture for export.

Today, the term "dark" is often avoided, and historian Paul B. Newman writes, "Living in the Middle Ages was not as primitive and crude as it is so often portrayed. Though some parts of Europe temporarily lapsed into barbarism after the fall of Rome in 476 AD, Roman institutions and public works were such an integral part of European civilization that they rarely disappeared completely. Even during the worst years of the centuries immediately following the fall of Rome, the so-called Dark Ages, the legacy of Roman civilization survived."

SEE ALSO Greek Dark Ages (c. 1100 BC–750 BC), Black Death (1348)

Replica of a helmet found at Sutton Hoo in England, in the grave of an Anglo-Saxon leader, around 620 in the Early Middle Ages.

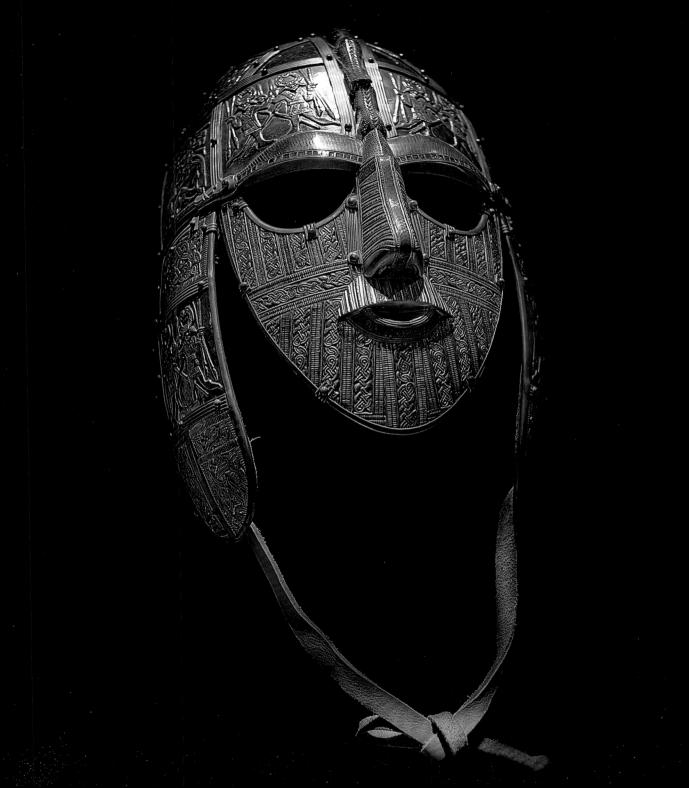

Black Stone

Muhammad (c. 570–632), **Cyril Glassé** (b. 1944)

Of the most sacred objects in Islam, scholar Cyril Glassé writes, "The Black Stone, because of its color, the absence of light lends itself especially to the symbolism of the essential spiritual virtue of poverty for God (*faqr*), that is, a *vacre deo*, an 'emptiness for God,' or the necessary extinction of the ego."

This ancient Muslim object of reverence is located in the Kaaba, a sacred building in Saudi Arabia toward which Muslims pray. The oval-shaped stone is embedded in its southeast corner, several feet from the ground—and is actually made of a dark red material, some 7 inches (17 cm) in diameter. The Black Stone may be the product of a meteor impact or a fragment from a meteorite that crashed to Earth approximately six thousand years ago.

Stone worship was common in pre-Islamic Saudi Arabia. Arab merchants, controlling lucrative trade routes, also managed lucrative religious rituals that centered on the Kaaba and its sacred Black Stone.

In 602, the Prophet Muhammad (before his prophetic revelations) is said to have been in Mecca during the rebuilding of the Kaaba. The Black Stone had been removed during the construction. Here, he settled a quarrel between clans by having all the clan elders simultaneously assist in resetting the Black Stone.

According to some Muslim traditions, the Kaaba was rebuilt ten times. The first Kaaba was erected at the dawn of history by angels from heaven and then later by Adam. The tenth and final rebuilding took place around 696, and this Kaaba is substantially the Kaaba of today.

Around 630 AD, Muhammad destroyed the idols in and around the Kaaba, but spared the Black Stone and sanctioned the kissing of it. He proclaimed Mecca the Holy City of Islam and he decreed that no unbeliever should be allowed to stand on its holy soil.

SEE ALSO Black Diamonds (c. 3 billion BC), Black Obelisk of Shalmaneser III (841 BC), Black Madonna (c. 1000)

Muslim pilgrims surround the Kaaba. The sacred Black Stone is embedded near one corner, several feet from the ground.

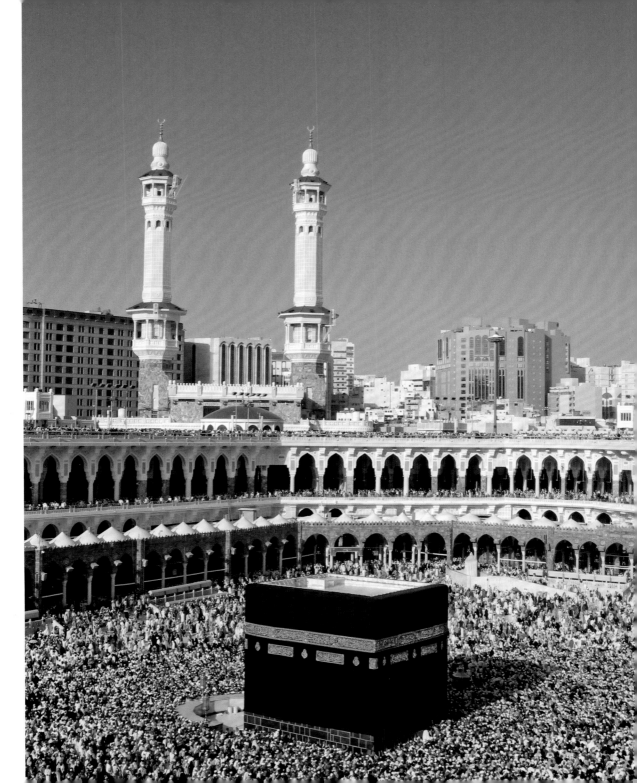

Black Madonna

Ivan Van Sertima (1935–2009)

Book reviewer Karen Smith writes, "Hundreds of statues of black women are venerated as the Virgin Mary throughout Europe The passionate devotion given them by the populace ensures a place in the church for the Black Madonna . . . [She is] more mysterious than comforting, authoritative rather than saintly . . ."

The original Black Madonnas of Europe, depicting Mary with black skin, are generally medieval in origin, with *statues* dating from between the eleventh and fifteenth centuries. Many of the famous Black Madonna *images* (thirteenth to fourteenth centuries) depict Mary and baby Jesus, black but with European facial features. About five hundred Black Madonnas exist in Europe, usually displayed in churches and shrines, with many more examples if more recent copies are counted. The highest concentrations exist in France and Italy.

Representations of the Black Madonna are claimed to facilitate miracles involving healing, fertility, and protection. Although many Black Madonnas appear to have been deliberately created with black skin, some of these Madonnas may have blackened over time, as a result of exposure to candle soot, or because they were constructed from dark wood. Some authors suggest that these creations were inspired by the Old Testament line in the Song of Songs (1:5): "I am black but comely, O daughters of Jerusalem . . ." Other authors suggest that the dark skin was meant to represent the color of fertile soil. Guyanese historian Ivan Van Sertima theorizes that "the Black Madonnas of Europe have a tradition which goes back hundreds of years before the advent of Christianity. The African Isis was the prototype for the Black Madonnas of Europe. As the worship of Isis was suppressed, the Virgin Mary was elevated into the European Christendom. Today, the African Isis is worshipped under the name of the Virgin Mary."

Some of the most famous Black Madonnas include Our Lady of Montserrat (Spain), Our Lady of Jasna Gora (Poland), Our Lady of Altötting (Germany), Our Lady of the Hermits (Switzerland), Our Lady of Guadalupe (Mexico City), and Our Lady of Tindari (Italy).

SEE ALSO Black Obelisk of Shalmaneser III (841 BC), Outer Darkness (c. 80), Black Stone (602), Black Crown (1339), Black Nazarene (1606)

Black Madonna at the Cathedral of the Holy Cross and Saint Eulalia, Barcelona, Spain.

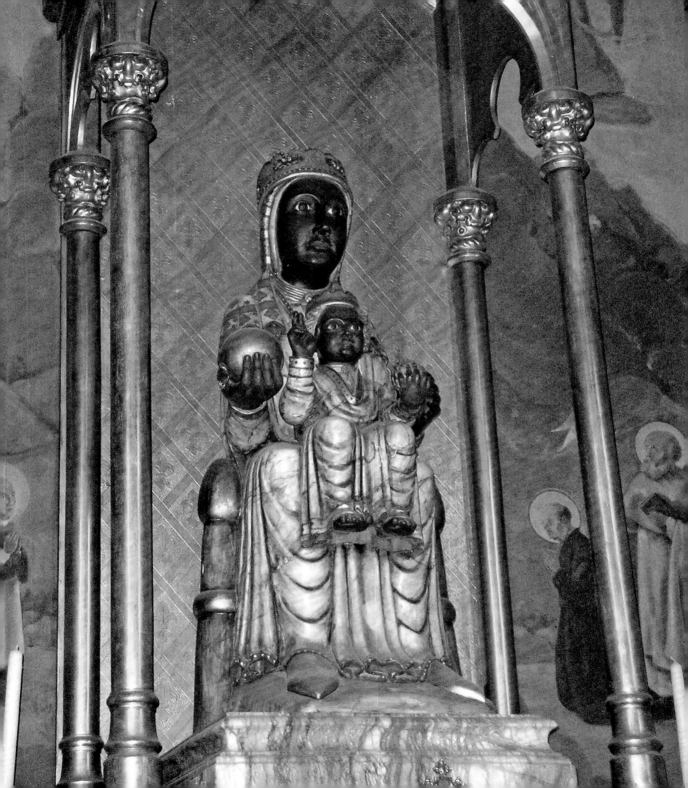

Black Cat Fear

Do black cats make you shiver? Records from the thirteenth-century Inquisition describe the prosecution of a group of people who believed that Lucifer had been wrongly expelled from heaven—and that sometime in the future, Lucifer and his followers would reclaim heaven as their home. The Roman Catholic Church referred to the group as Luciferans, who confessed while being interrogated that new members had to kiss the rear end of a black cat as part of the initiating ritual.

During the Middle Ages, belief in witchcraft became common, and some people thought that witches could change into black cats. The superstition that associates black cats with bad luck probably stems from this era. Most often, the "witches" were simply old women who lived alone and kept cats for companionship. Alas, some of these women were burned at the stake along with their cats, who were thought to be witches in another form. The editors of *Time-Life* write, "In France, there were monthly bonfires on which cats were killed, especially black ones. This grisly practice persisted into the seventeenth century, creating to this day a scarcity of black cats in Europe . . ."

Cats were not always thought of as harbingers of evil. In fact, throughout history, cats of all different colors were considered good companions. In fact, the ancient Egyptians revered a fertility goddess named Bast, often depicted in the form of a cat. It was illegal for ancient Egyptians to harm a cat. Pet cats were considered family members, and their deaths were deeply mourned.

Interestingly, the black cat is not a special breed of cat. The all-black coloration is of benefit to a cat as it hunts at night. One of the most famous black cats in history is the one that mysteriously walked onto the field at New York's Shea Stadium in 1969 and circled a Chicago Cubs player. This incident was followed by the downfall of the Cubs and the success of the Mets, who won the World Series.

SEE ALSO Black Magic (80,000 BC), Black Mass (c. 100), Black Pullet (1740)

During the Middle Ages, some people thought that witches could change into black cats. Some of the superstitions that associate black cats with bad luck probably stem from this era.

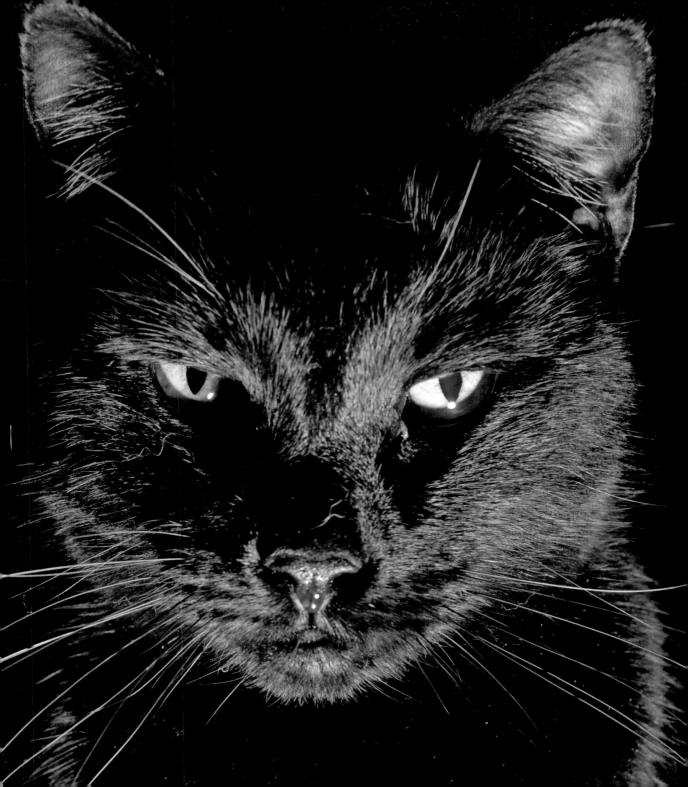

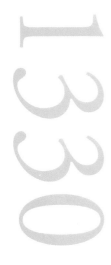

Black Prince

Edward III (1312–1377), **Edward of Woodstock, Prince of Wales** (1330–1376), **Thomas Fuller** (1608–1661), **Norman F. Cantor** (1929–2004), **Robin Hunter Neillands** (1935–2006), **Richard William Barber** (b. 1941)

British historian Richard Barber writes, "Edward of Woodstock, [known as] the Black Prince, is one of those heroes of traditional history books so impressive in his achievements as to seem slightly unreal. At sixteen, he played the leading part in the fighting at Crécy [France]; at twenty-six, he captured the king of France at Poitiers . . ." Indeed, few soldiers of the Middle Ages inspired such devotion from the English and abject horror among the French as the Black Prince.

The Black Prince was the eldest son of King Edward III of England, who was one of the most successful English rulers of the Middle Ages. However, the Black Prince died a year before his father and so never himself ruled as king.

English scholar and churchman Thomas Fuller claims that the prince earned the nickname "Black Prince" from his "dreaded acts," perhaps because he instructed knights to destroy the French countryside and massacre the peasants. According to historian Norman Cantor, the French peasants were "slaughtered like rabbits and their property looted." Although the Church taught that peasants had souls, these souls were believed to be of "lower grade and dirtier" than the wealthier members of society. Despite the seeming cruelty of the Black Prince, Cantor refers to him as "the most admired knight in Christendom," with many of the nobility honored to serve under him.

In 1355, while in Bordeaux, the Black Prince attacked the fortress city of Carcassonne. Although the walls of the town could not be surmounted, he burned the lower town, declaring, according to British writer Robin Neillands, "that no campaign could be judged successful unless it left the countryside in flames."

Although the title "Black Prince" was not used during his life, his fondness for black is well known. As Neillands describes, "he rode black horses, had a black field for his badge of ostrich feathers, and is said to have worn black armour. His 'black' reputation may have seemed to match that of the Black Death."

SEE ALSO Dark Ages (476–1000), Black Death (1348), Blackbeard (c. 1680)

Edward, the Black Prince, from Cassell's Illustrated History of England, Century Edition *(c. 1902).*

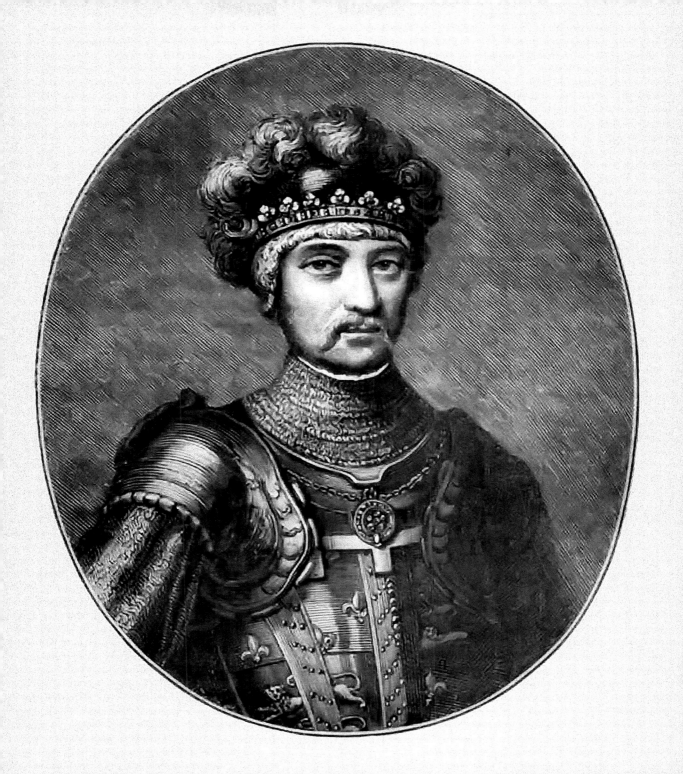

Black Crown

Yung-Lo, the Yongle Emperor (1360–1424), **Toghan Temür** (reigned 1333–1370), **Stephen Batchelor** (b. 1953)

"The Black Crown Ceremony links the mystical and material world for believers," writes journalist Lea Terhune, who explains that this Tibetan Buddhist ritual starts when the *gyaling* horns are blown, and the devout Karmapa sits on a high throne. The Karmapa is the head of the Karma Kagyu, a major school of Tibetan Buddhism. When the Karmapa places the beautiful Black Crown on his head, he repeatedly chants a mantra, then finally returns the crown to its protective box. The ceremony is finished with prayers. The crown symbolizes the Karmapa's power to benefit all sentient beings. Terhune suggests that simply witnessing a Black Crown ceremony can have a tremendous impact on the devout, "even severing links to lower rebirths and speeding progress toward enlightenment."

Author and former monk Stephen Batchelor informs us that "the first vision of the Karmapa wearing such a crown was beheld in the full moon early on the morning of 15 June 1339, by Toghan Temür, the last Mongol Emperor of China, the day after the death of his teacher, the third Karmapa." Years later, in 1407, Emperor Yung-Lo invited the fifth Karmapa to his court, where he saw "a crown woven from the hairs of one hundred thousand *dakinis* [female buddhas or deities], hovering about the Karmapa's head." Yung-Lo had a physical replica made of the Crown in his astonishing vision, and this crown, adorned with precious stones, was in the possession of the Karmapas for centuries.

In the early 1960s, the sixteenth Karmapa brought the Black Crown to the Rumtek monastery in Sikkim, India. Today, the location of the Black Crown is known only to a select few, and the identity of the seventeenth Karmapa is a subject of controversy. After the sixteenth Karmapa died in 1981, two different men claimed to be his successor; the debate continues as to which is the true Karmapa.

SEE ALSO Black Stone (602), Black Madonna (c. 1000)

Buddhism is steeped in fascinating ceremonies and ancient legends. Pictured here is Guanyin, a bodhisattva of compassion, who vows never to rest until she has freed all sentient beings from the cycles of life and death. Her thousand arms help her reach out to those in need.

Black Death

Jeuan Gethin (d. 1349), **Ibn Khaldun** (1332–1406), **Norman F. Cantor** (1929–2004)

Historian Norman F. Cantor writes, "The Black Death of 1348–49 was the greatest biomedical disaster in European and possibly world history." Arab historian Ibn Khaldun noted that "civilization both East and West was visited by a destructive plague that devastated nations and caused populations to vanish. It swallowed up many of the good things of civilization and wiped them out in the entire inhabited world."

The fourteenth-century Black Plague, also often called the Bubonic plague, probably began in Central Asia and entered England in 1348. Roughly 75 million people worldwide perished, and between one-third and two-thirds of Europe's population was killed. It is likely that the same disease visited Europe numerous times, with varying mortality rates, until the 1700s. The phrase "Black Death" for this plague didn't become commonly used until 1833.

Although scientists still debate whether all of the plagues were in fact the same disease, the cause is usually attributed to *Yersinia pestis* or its variants, which are carried by rodents and fleas. People who are infected by the plague display "buboes," or swellings of the lymph nodes, and afflicted individuals die within a few days. Europeans quickly developed theories as to the cause of the disease that ranged from astrological forces or God's wrath to the poisoning of wells by Jews. As a result, thousands of Jews were exterminated, many by burning, as were lepers and even individuals with severe acne or psoriasis.

Welsh poet Jeuan Gethin paints a vivid picture of the horror: "We see death coming into our midst like black smoke . . . a rootless phantom which has no mercy . . . a painful angry knob like the head of an onion . . . a grievous ornament that breaks out in a rash. The early ornaments of black death." Gethin's seven sons died of the plague, and he died of it in 1349.

SEE ALSO Dark Ages (476–1000), Black Prince (1330), Black Mold (1937)

The Triumph of Death (c. 1562), by Flemish painter Pieter Bruegel (1525–1569), is suggestive of a widespread epidemic that attacks all classes in Medieval Europe, from peasant to king.

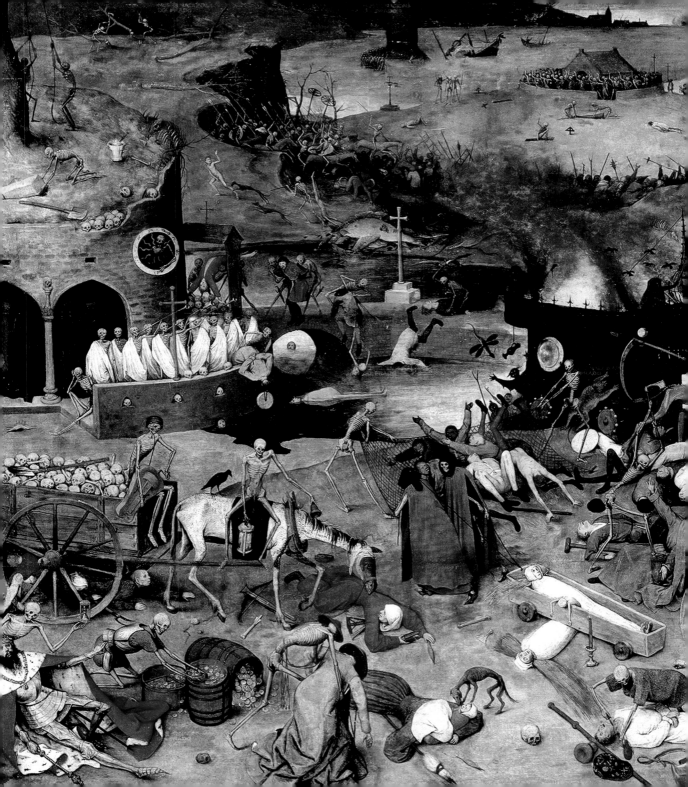

1549

Blackbird Pie

Many of you may have sung the old English nursery rhyme "Sing a Song of Sixpence" as children. The strange lyrics tended to scare me, and I was shocked about the possible cruelty of baking many blackbirds in a pie. I wondered how the birds could survive with limited oxygen and fly out when the piecrust was opened. The sanitary aspects of such a culinary endeavor also worried me. The rhyme starts:

> Sing a song of sixpence,
> a pocket full of rye.
> Four and twenty blackbirds,
> baked in a pie.
>
> When the pie was opened,
> the birds began to sing.
> Wasn't that a dainty dish
> to set before the king?

According to columnists at the "Straight Dope," the *Oxford Dictionary of Nursery Rhymes* mentions an Italian cookbook from 1549 that contains a recipe "to make pies so that birds may be alive in them and flie out when it is cut up." The *Oxford Dictionary* also mentions a cook from 1723 who describes this pie as being useful to cause amusement and diversion for guests at a banquet. The nursery rhyme was first published in 1744 in *Tommy Thumb's Pretty Song Book*, with slightly different lyrics.

The blackbird (*Turdus merula*) is common today in Europe, Asia, North Africa, Australia, and New Zealand. The first known written instance of the word "blackbird" that refers to these birds appeared in 1486.

SEE ALSO Black Pudding (c. 700 BC), Black Pullet (1740), Shooting of the Last Black Mamo (1907), Black Forest Cake (1915)

Book cover illustration by British artist Randolph Caldecott (1846–1886) for Sing a Song of Sixpence *(1880).*

PRICE ONE SHILLING.

SING A SONG for SIXPENCE

ONE OF R. CALDECOTT'S PICTURE BOOKS

Honey

GEORGE ROUTLEDGE AND SONS

Blackmail

Hans Speier (1905–1990), **Robin Hunter Neillands** (1935–2006)

According to *The Merriam-Webster New Book of Word Histories*, "Life was unfair for the seventeenth-century Scottish farmers. Not only did they have to struggle to cultivate their land and produce good crops, but they also had to contend with corrupt chiefs who forced them to pay for protection of their land." Indeed, if a farmer failed to pay the extortion money, his crops would be destroyed. The term "blackmail" arises in these ancient times in which "mail" came from the Scottish word for "rent." "Black" probably comes from the association of the word with evil or the undesirable. By 1601, the term "blackmail" had spread throughout England. Today, blackmail often involves one person threatening to expose another's secrets.

We've come a long way since the days of those Scottish farmers, and today blackmail often indicates a form of deterrence, as in the tactic of threatening nuclear war, referred to as "nuclear blackmail." During the cold war between the United States and the Soviet Union, several examples existed of nuclear threats used to gain an advantage in tense confrontations. In 1957, historian Hans Speier wrote in *World Politics*: "A government that is exposed to atomic threats in peacetime readily regards them as 'blackmail' whereas the threatening power is likely to call them 'deterrence'."

The concept of blackmail is popular in many movies in which one character threatens another. The first major movie to feature the word "blackmail" as the only word in its title was Alfred Hitchcock's 1929 *Blackmail*, the first "all-talkie" British film, in which a petty thief attempts to blackmail a Scotland Yard detective and his girlfriend. Most films before the late 1920s were silent and were not accompanied by the actors' voices. Hitchcock was told by the movie producer that a portion of *Blackmail* could feature sound; however, Hitchcock ignored him and filmed the *entire* movie with sound. The film became a critical and commercial success.

SEE ALSO Blacklist (1947)

"The Purloined Letter" by Edgar Allan Poe (1809–1849), illustrated by French artist Frédéric Lix (1830–1897). In this detective story, the French police attempt to find a stolen letter that is being used for blackmail. The letter turns out to be hidden in an unexpected place—in plain sight.

Black Nazarene

Philip Yancey (b. 1949)

Theologian Philip Yancey writes that "we humans search for clear-cut signs of God's presence, as if still yearning for the burning bush . . ." He goes on to describe his own visit to the Black Nazarene, a life-sized, dark-skinned sculpture of Jesus Christ that some Filipinos claim has miraculous powers, such as the power to heal or grant wishes. "Pilgrims crawl on their knees for miles to approach the statue . . . They used to kiss the toes, but wear and tear on the statue prompted the church to cover it in Plexiglas, with only a cutout for toes. Once a year the church allows the Black Nazarene to come outside in a public procession, and most years people get trampled to death in the frenzy."

Today, the Black Nazarene resides in the Minor Basilica of the Black Nazarene in Quiapo, Manila, Philippines. The original carver is an unknown Aztec carpenter who created the statue in the early 1600s. Augustinian friars shipped the statue to Manila in 1606. Several theories seem to exist as to how the Black Nazarene became so black, the most common being that the statue was blackened in a shipboard fire during its transport in 1606. Other theories include church fires in the 1700s, the use of a particular hardwood that turns dark with age, or even the statue's miraculous uptake of poison in order to save a Mexican priest from death!

In recent years, in order to protect the original statue, a replica (with or without several components from the original statue) is used in public processions of the Black Nazarene outside the church. In 2008, eighty thousand people participated in the procession, with some estimates placing the crowd swell close to two million people. Two people died, and roughly fifty injured followers of the Black Nazarene were rushed to hospitals or clinics for treatment.

SEE ALSO Black Stone (602), Black Madonna (c. 1000)

The Black Nazarene, in a public procession in Manila, Philippines.

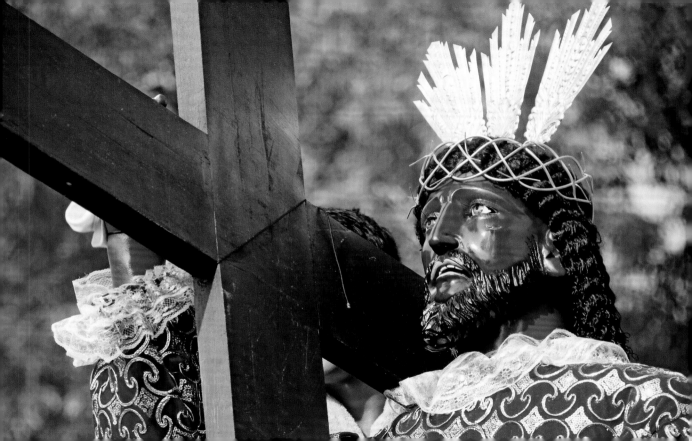

Blackbeard

Edward Teach (c. 1680–1718)

Author Dan Perry writes, "Blackbeard's extraordinary life of excess during the Golden Age of Piracy [1689–1718] ignited a reputation that struck terror into men's hearts from Virginia to Barbados . . . Blackbeard's life on the high seas, chasing wealth, freedom and power, ended in a bloody battle that ultimately marked a turning point in history."

Edward Teach, better known today as the English pirate Blackbeard, had most of his adventures in the Caribbean Sea and along the eastern U.S. coast. According to legend, he attached burning pieces of hemp to his hair during battles to intimidate his adversaries. Pirate expert and author Charles Johnson describes Blackbeard's awesome appearance: "[His] beard was black, which he suffered to grow to an extravagant length . . . In time of action . . . he stuck lighted matches under his hat which . . . made him altogether such a figure that imagination cannot form an idea of a fury, from hell, to look more frightful."

Teach began his life of piracy—in which he would rob valuables from ships, largely through a process of intimidation—sometime around 1713. Teach's centers of operations were in the Bahamas and the Carolinas. In 1718, his notoriety reached new heights with his successful blockade of Charleston, South Carolina, where he plundered five merchant freighters. Many of the local townspeople actually tolerated his presence because they bought stolen cloth and sugar from him, which was less expensive than buying from the British.

Teach finally met his end after a duel upon the ship of Robert Maynard, a lieutenant in the British Royal Navy. After Teach died, Maynard cut off Teach's head and hung it from the bow of his ship. According to some accounts, Teach had been shot and stabbed multiple times before he died from blood loss. During his period of piracy, Teach captured over forty ships, and his death is often used to mark the end of an era in the history of piracy in the Americas.

SEE ALSO Black Prince (1330), Blackmail (1601), Black Bart (1875)

Blackbeard engraving from General History of the Robberies and Murders of The Most Notorious Pyrates *(c. 1736), by Charles Johnson. Note Blackbeard's numerous weapons and burning hemp or matches attached to his hair.*

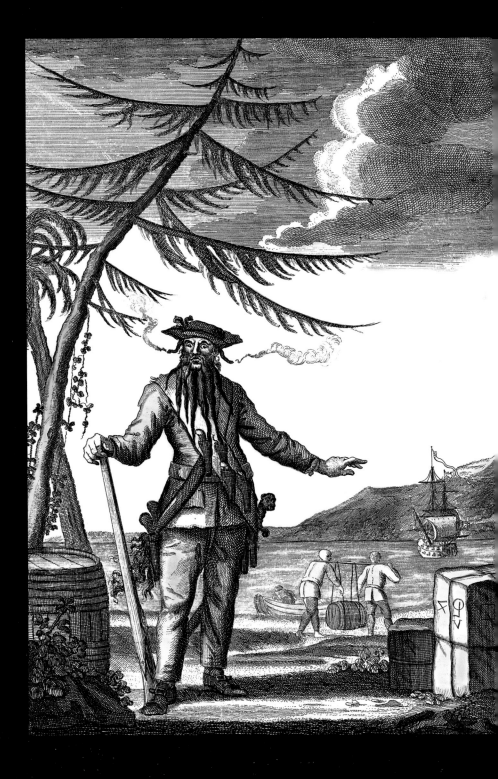

The Black Guard

Moulay Ismail (c. 1640–1727)

Moulay Ismail, the sultan of Morocco who reigned from 1672 to 1727, is "portrayed by Morocco historians as a leader, unifier, builder, and the creator of the formidable Black Guard, an elite corps composed of descendants of African slaves," according to journalist Marvine Howe. "European scholars, however, write of his barbaric cruelty to Christian prisoners, his megalomania, and his philandering; it is said that he fathered as many as 1,000 children." Today, we are not certain where to draw the line between the legend and the history of Moulay Ismail.

In 1930, *TIME* magazine colorfully described the genesis of the Black Guard: "In 1690 the Sultan Moulay Ismail was determined to breed a new, better army. He sent troops of Arab slave drivers to beat the forests of Senegal for blacks. From the roundup, 10,000 of the most perfect men, 10,000 of the soundest maidens were selected . . . The Negro men were told to pick their own brides and mate with them forthwith. The great mass-mating lasted for weeks [and] Moulay Ismail obtained as an eventual result the most powerful army in North Africa." At their height, the Black Guard numbered around 150,000 warriors.

The Black Guard was used to help Ismail fight the Europeans and also to crush rebellions from local Moroccan clans. According to legend, Ismail often surrounded himself with eighty men of the Black Guard for protection. Ismail is also said to have killed his black slave guards and attendants on a whim, for the slightest perceived infraction or for no infraction at all, such as when he murdered a Black Guard member simply to test the effectiveness of a new weapon's blade.

Sociologist Stefan Goodwin writes that the Black Guard "grew to be more influential in Morocco than European slaves who were also present in Morocco during much of the same time . . . Certain individuals descended from the [Black Guard] became influential enough to exercise powers that rivaled even those of the sultans."

SEE ALSO "Black is Beautiful" (1858), Black Codes (1865)

Moulay Ismail Ibn Sharif, the sultan of Morocco (from a 1719 engraving). At least 150,000 African men served in his elite Black Guard, also known as the "Masters of the Blackness."

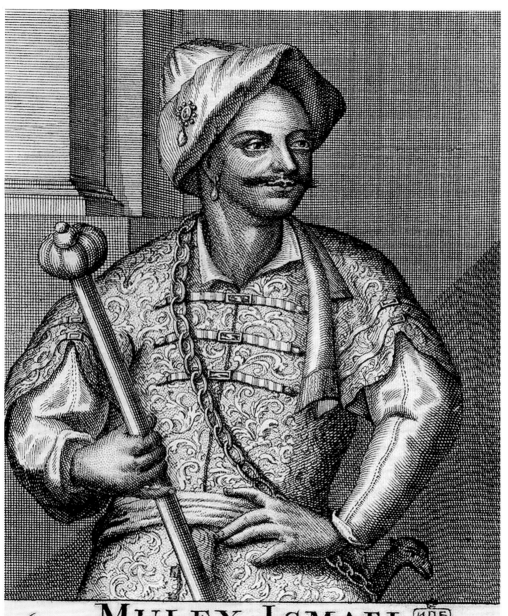

MULEY ISMAEL
Kayser von MAROCCO König von
TAFILET, FETZ, SUZ, und TARADUNT
LXXXII. Jahr alt.

Black Act

George I (George Louis, 1660–1727), **Harold Berman** (1918–2007), **George Monbiot** (b. 1963)

Journalist George Monbiot writes, "In 1723, the Black Act created fifty new hanging offences, for crimes as momentous as painting one's face or chasing deer. The aim of the new law—repressive even for those times—was to stamp out Britain's first recorded hunt saboteurs." The British Parliament passed the act during the reign of King George I. Historian Joyce Malcolm calls the act "one unique in the history of criminal law" and one that was partly meant to stop "men in disguise, and with their faces blackened, from destroying the game, fish, and trees" as a protest against the King. However, the law made it a capital offense merely to have a blackened face, without any other crime being committed or attempted. Interestingly, if a person was armed, this was not a capital crime—the blackening was what mattered.

The death sentence was also called for if a person was caught hunting a deer in the King's forest, stealing rabbits or fish, destroying fish ponds, or cutting down trees in an orchard or garden or along roads. Ironically, as a result of the Black Act, actual crimes were *underreported* because victims of crimes did not want the perpetrators to actually be killed for acts such as minor robberies.

American scholar Harold Berman writes that the Black Act was a kind of class war that codified the criminal law "concerning not only poaching (called 'blackening', as poachers often blackened their faces in order to disguise themselves) but also many other types of related crimes against landed property." Because the Black Act also made the intentional shooting or maiming of a person—even if the person survived—carry the same punishment as actually killing the person, there was even less incentive for a perpetrator to let a wounded victim live.

SEE ALSO Black Codes (1865), Black Museum (1875)

Falconry for hunting rabbits and other animals was practiced for centuries in England. At different times in British history, rules governed the kind of hunting bird that would be appropriate for kings, earls, priests, and servants.

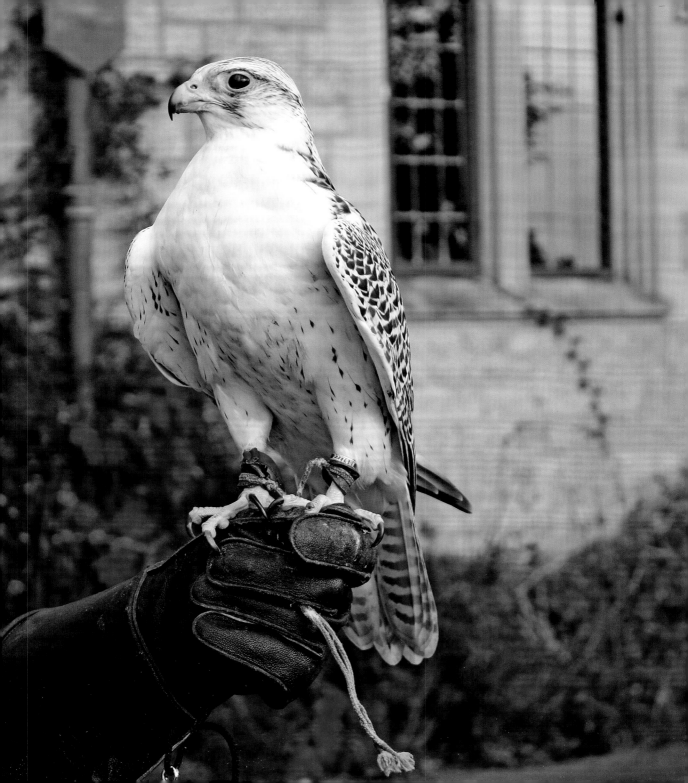

Black Pullet

Arthur Edward Waite (1857–1942), **James Lewis Thomas Chalmbers Spence** (1874–1955)

According to journalist and folklorist Lewis Spence, *The Black Pullet* refers to a "French magical publication supposedly printed in 1740, purporting to be a narrative of an officer who was employed in Egypt." While in Egypt, the narrator meets a magician who tells him how to create a magical black pullet, or young hen, which can be used to help find gold. To create the black pullet, one supposedly must place a hood over a black hen during the hatching of its eggs. The hen should also be placed in a box lined with black material.

The Black Pullet is a *grimoire*, or magic textbook, and also discusses such arcane topics as necromancy, magical talismans, and the Kabala. Scholar and mystic Arthur Waite actually suggests that the book may have been written in Rome by bored priests.

The back jacket of the Weiser edition, published in 2000, describes *The Black Pullet* as a "famous book of 'Black Magic' [that] first surfaced at the end of the eighteenth century. Although many similar magical *grimoires* were published at the time—books containing ancient hidden knowledge, but with no traceable history—*The Black Pullet* remains the most outstanding of these works. The anonymous author disavows any connection to Black Magic, yet details the construction of a series of talismanic rings and their uses in magical practice [to give readers] unique powers such as proficiency in all spoken languages, the power to discover hidden secrets, and invisibility."

At one point in the book, the narrator is shown a special symbol and told that "The talisman and ring will serve to transport you into whatever part of the world you judge appropriate without running any danger. Say merely these words: Raditus, Polastrien, Terpandu, Ostrata, Pericatur, Ermas. But I hope that you will not make use of these means to leave me without my consent. Promise it to me."

SEE ALSO Black Magic (80,000 BC), Black Cat Fear (c. 1200), Blackbird Pie (1549), Black Angus (1842), Shooting of the Last Black Mamo (1907)

The ancient and famous publication The Black Pullet *instructs the reader on how to create a magical black pullet, or young hen, that can be used to help find gold.*

Blackjack

Edward Oakley Thorp (b. 1932)

"There is no historical period or culture known when gambling for pleasure was not present," writes gaming expert Walter Thomason. "Dice, carved from animal bones and natural materials, seem to have been the choice among ancient Greek and Judaic cultures."

The popular gambling card game Blackjack, which involves an intriguing mixture of luck and skill, probably was not invented by a single person, and similar games, such as *Vingt-et-un*, meaning "21," may have been played as far back as the 1700s in France. According to freelance writer Ed Grabianowski, "The game was still called '21' when Nevada first made gambling legal in 1931. To attract more attention to the game, some casinos offered a special bet: A hand that featured the Ace of Spades plus either of the black jacks in the deck (the Jack of Clubs or the Jack of Spades) would pay 10-to-1 odds on the player's bet." Today, casinos no longer offer this special bonus payout, but the name "Blackjack" is still used.

The goal of the blackjack player is to obtain a set of cards with a value as close to 21 as possible; however, once the player exceeds a value of 21, the hand is considered a bust. Each player's goal is to beat the dealer by obtaining the higher, unbusted set of cards. A skillful player can sometimes attempt to keep track of the cards that have already been played, a process called "card counting." In this way, the player estimates when the cards remaining in the decks are likely to be advantageous.

Mathematics professor Edward Thorp's 1966 book *Beat the Dealer* refined the blackjack strategy and described a counting system. Of this system, author Jerry Patterson writes, "Now, for the first time, the sophisticated gambler could learn to play nearly even with the house, and perhaps with a slight edge in his or her favor. This scientifically developed information sparked a nationwide interest in blackjack that made it the number one table game in America beginning in the 1960s and continuing [even today.]"

SEE ALSO Black Sox Scandal (1919)

Winning blackjack hand. The dealer or player may count the Aces as either one point or eleven points. Face cards (Jacks, Queens, or Kings) are counted as ten points.

Black Hole of Calcutta

John Zephanian Holwell (1711–1798), Siraj ud-Daulah (1733–1757)

In 1732, surgeon John Holwell travelled to India as an employee of the East India Company, and in 1756, he attempted to defend Fort William, a British fort in Calcutta (today spelled Kolkata), against Siraj ud-Daulah, the ruler of Bengal, India. When the fort was surrendered, Holwell was thrown into a tiny prison room, the "Black Hole" of Calcutta. ("Black hole" was the common name for a military detention cell of the time.) According to Holwell's report, he was with 145 men through the night. The torturous heat and crushing conditions meant that only 23 survived the night. Holwell wrote of his ordeal:

> Figure to yourself, my friend, if possible, the situation of a hundred and forty-six wretches . . . crammed together in a cube of about 18 feet, in a close sultry night . . . I had, in an ungovernable fit of thirst, attempted drinking my urine; but it was so intensely bitter there was no enduring a second taste . . . In this plight from half an hour past eleven till near two in the morning, I sustained the weight of a heavy man with his knees in my back, and the pressure of his whole body on my head . . . But Oh! What words shall I adopt to tell you the whole that my soul suffered at reviewing the dreadful destruction round me? I will not attempt it and indeed tears stop my pen.

Today, some doubt exists as to the details of Holwell's report and the precise number of prisoners. Holwell said that the room measured 18 feet by 14 feet 10 inches (5.5 by 4.3 m). However, years ago, the Bengali landlord Bholanath Chunder performed an experiment by attempting to cram his tenants into a fenced area of approximately the same dimensions, and he could not get close to fitting 146 people. Nevertheless, the Black Hole incident outraged the British public, which subsequently allowed the East India Company to do as it wished in India, and the Company became the de facto ruler of the region.

SEE ALSO Black Act (1723), Black Holes (1783), Black War (1828)

The small prison room called the Black Hole of Calcutta, from Notions de Physiologie *(1886) by French author Louis Figuier (1819–1894). The heat and crushing conditions killed many of the prisoners.*

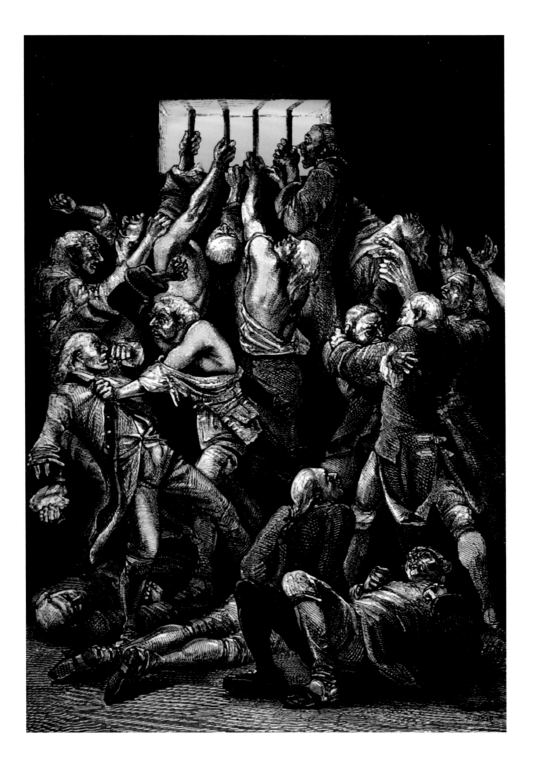

Black Drop Effect

Dante Alighieri (1265–1321), **Torbern Olof Bergman** (1735–1784), **James Cook** (1728–1779)

Italian poet Dante Alighieri, in his *Divine Comedy*, wrote, "The heavens call to you, and circle about you, displaying to you their eternal splendor, and your eye gazes only to earth." Indeed, the beautiful mysteries in our night sky captivate our hearts and minds, but it can take centuries to discover a coherent explanation for seemingly simple astronomical phenomena.

The mysterious black drop effect (BDE) refers to the apparent shape assumed by Venus as it transits across the Sun when observed from Earth. In particular, Venus appears to assume the shape of a black teardrop when "touching" the inside edge of the Sun. The tapered, stretched part of the teardrop can look like a fat umbilical cord or a dark bridge. The first detailed description of the BDE came in 1761, when Swedish scientist Torbern Bergman described the BDE in terms of a "ligature" that joined the silhouette of Venus to the dark edge of the Sun. Many scientists provided similar reports in the years that followed. For example, British explorer James Cook made similar observations of the BDE during the 1769 transit of Venus.

The precise reasons for the BDE require further study. Astronomers Jay M. Pasachoff, Glenn Schneider, and Leon Golub suggest it is a "combination of instrumental effects and effects to some degree in the atmospheres of Earth, Venus, and Sun." Because Mercury also exhibits a BDE, and Mercury has virtually no atmosphere, we know that BDE does not *require* an atmosphere on the observed body. Also playing a role is solar limb darkening, the darkening of the Sun toward its edge due to reduced density and temperatures near the Sun's surface.

During the 2004 transit of Venus, some observers saw the BDE while others did not. Journalist David Shiga writes, "So the 'black-drop effect' remains as enigmatic in the twenty-first century as in the nineteenth. Debate is likely to continue over what constitutes a 'true' black drop."

SEE ALSO Black Diamonds (c. 3 million years BC), Black Holes (1783), Black Eye Galaxy Discovery (1779), Dark Matter (1933), Dark Energy (1998)

Venus transits across the face of the Sun in June 2012, showing the black drop effect. (Photo was taken in Kecskemét, Hungary, and then rotated 90 degrees counterclockwise.)

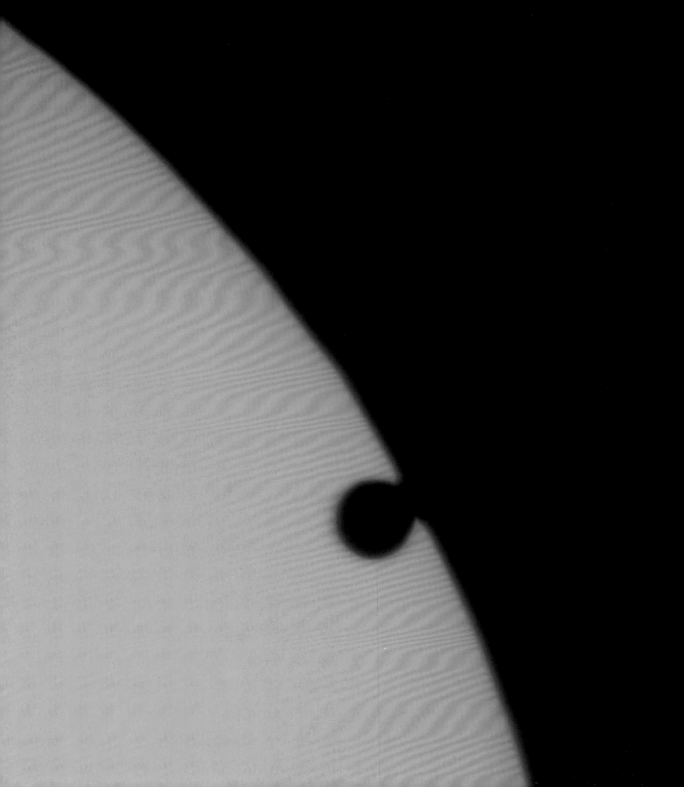

Black Eye Galaxy Discovery

Edward Pigott (1753–1825), **Johann Elert Bode** (1747–1826), **Charles Messier** (1730–1817)

As a child, I recall watching the first scary episode of *The Outer Limits* television show. It featured an American engineer who makes contact with a shimmering alien creature from the Andromeda galaxy, the nearest spiral galaxy to our own (the Milky Way) and about 2.5 million light-years from Earth. Much farther away, and perhaps even more mysterious, is the Black Eye Galaxy in the constellation Coma Berenices. Author and naturalist Stephen James O'Meara writes poetically of this famous galaxy with its "smooth silken arms [that] wrap gracefully around a porcelain core . . . The galaxy resembles a closed human eye with a 'shiner.' The dark dust cloud looks as thick and dirty as tilled soil [but] a jar of its material would be difficult to distinguish from a perfect vacuum."

Discovered in 1779 by English astronomer Edward Pigott, it was independently discovered just twelve days later by German astronomer Johann Elert Bode and about a year later by French astronomer Charles Messier. Such nearly simultaneous discoveries are common in the history of science and mathematics. For example, British naturalists Charles Darwin and Alfred Wallace both developed the theory of evolution independently and simultaneously.

Like a zany nested carnival carousel, the interstellar gas in the outer regions of the Black Eye Galaxy rotates in the opposite direction from the gas and stars in the inner regions. This differential rotation may arise from the Black Eye Galaxy having collided with another galaxy and having absorbed this galaxy over a billion years ago.

Author David Darling writes that the inner zone of the galaxy is about 3,000 light-years in radius and "rubs along the inner edge of an outer disk, which rotates in the opposite direction at about 300 km/s and extends out to at least 40,000 light-years. This rubbing may explain the vigorous burst of star formation that is currently taking place in the galaxy and is visible as blue knots embedded in the huge dust lane."

SEE ALSO Black Diamonds (c. 3 million years BC), Black Drop Effect (1761), Black Holes (1783), Dark Matter (1933), Dark Side of the Moon (1959), Dark Energy (1998), Lonely Black Sky (100 billion years AD)

Black Eye Galaxy, with image processing to create an artistic portrayal highlighting its darkened region. Interstellar gas in the outer regions of the galaxy rotates in the opposite direction from the gas and stars in the inner regions.

Black Holes

John Michell (1724–1793), **Karl Schwarzschild** (1873–1916), **John Archibald Wheeler** (1911–2008)

In Edgar Allan Poe's tale "A Descent into the Maelström," a man tells of his encounter with a massive whirlpool: "I became possessed with the keenest curiosity about the whirl itself. I positively felt a wish to explore its depths, even at the sacrifice I was going to make; and my principal grief was that I should never be able to tell my old companions on shore about the mysteries I should see." Such crepuscular whirls remind us of black holes in outer space, sucking in all things that come too close.

These black cosmological "sucking machines" exist in the centers of many galaxies. Such galactic black holes are collapsed objects having millions or even billions of times the mass of our sun crammed into a space no larger than our Solar System. According to classical black hole theory, the gravitational field around such objects is so great that nothing, not even light, can escape from their tenacious grip. Anyone who falls into a black hole will plunge into a tiny central region of extremely high density and extremely small volume, and the end of time.

Black holes can exist in many sizes. As some historical background, just a few weeks after Albert Einstein published his general relativity theory in 1915, German astronomer Karl Schwarzschild performed exact calculations of what is now called the Schwarzschild radius or event horizon. This radius defines a sphere surrounding a body of a particular mass. In classical black-hole theory, within the sphere of a black hole, gravity is so strong that light, matter, or any kind of signal cannot escape. For a mass equal to the mass of our Sun, the radius is a few kilometers in length. A black hole with an event horizon the size of a walnut would have a mass equal to the mass of the Earth. The actual concept of an object so massive that light cannot escape was suggested in 1783 by the geologist John Michell. The term "black hole" was coined in 1967 by theoretical physicist John Wheeler.

SEE ALSO Black Diamonds (c. 3 million years BC), Black Hole of Calcutta (1756), Black Drop Effect (1761), Black Eye Galaxy Discovery (1779), Dark Matter (1933), Black Hole Antiterrorism (c. 1987), Dark Energy (1998), Lonely Black Sky (100 billion years AD), Universe Fades to Black (100 trillion years AD)

Matter falling onto a black hole can form a swirling accretion disk around the hole, with jets shooting away. The jets may be composed of electrons, positrons, and protons.

Byron's "Darkness"

George Gordon Byron, 6th Baron Byron (1788–1824)

English poet Lord Byron wrote his famous and haunting poem "Darkness" in July of 1816. Upon a first reading, the poem seems to describe the end of the world, when the sun has gone out. However, when viewed in historical context, it is likely that the poem is also referring to emotions triggered by events in 1816, also called "the Year Without a Summer"—an actual dark year caused by the 1815 eruption of Mount Tambora in the Dutch East Indies (Indonesia). The ashes from this cataclysm caused strange weather patterns including record-cold temperatures in Europe, leading a number of religious people to wonder if the biblical end of the world was near. One European scientist proclaimed that the sun would be totally extinguished later in that year, which led to an increase in suicides and religious passion in Europe. The poem contains a number of frightening images, such as all of the world's dogs attacking their masters, and rivers and oceans coming to a standstill. Excerpts from this exceptional poem follow:

I had a dream, which was not all a dream.
The bright sun was extinguish'd, and the stars
Did wander darkling in the eternal space,
Rayless, and pathless, and the icy earth
Swung blind and blackening in the moonless air . . .

Ships sailorless lay rotting on the sea,
And their masts fell down piecemeal: as they dropp'd
They slept on the abyss without a surge—
The waves were dead; the tides were in their grave,
The moon, their mistress, had expir'd before;
The winds were wither'd in the stagnant air,
And the clouds perish'd; Darkness had no need
Of aid from them—She was the Universe.

SEE ALSO Browning's Dark Tower (1855), Conrad's *Heart of Darkness* (1902), "The Whisperer in the Darkness" (1931), Black Lightning (1956), *Dark City* (1998).

Artist's representation of the following lines of Byron's "Darkness": "All earth was but one thought—and that was Death, immediate and inglorious; and the pang of famine fed upon all entrails—men Died, and their bones were tombless as their flesh."

Goya's Black Paintings

Francisco José de Goya y Lucientes (1746–1828), Siri Hustvedt (b. 1955)

In 1819, when Spanish painter Francisco Goya was 73 and had become completely deaf, he purchased a country house and began painting dark, haunting imagery. Author and editor Christopher Murray writes, "The peculiar technique, which involved the direct painting of oil onto the plasters, and the obsessions with grim violence, age, pain, and the rituals of popular superstition, have made these paintings famous, seen as the product of an isolated but vivid imagination, and portents of the hold which the violent and the supernatural were to gain over the Romantic imagination."

Fourteen dark works created between 1819 and 1823 comprise Goya's Black Paintings, which he may have painted solely for himself and not in order to make money. During Goya's lifetime, no visitor reported seeing them. The most famous of the set is today referred to as *Saturn Devouring His Son*, which depicts the Roman god Saturn eating one of his children upon a background of utter blackness. Another famous Black Painting is *Witches' Sabbath*, showing witches with a black, goat-like devil. *The Dog* depicts a dog whose body is concealed up to its neck by an unidentifiable mass, gazing into emptiness.

The term *Black Painting* is used for several reasons. First, Goya was clearly expressing a mood of despair, depression, and death. According to art historian Mary Acton, they are also called the Black Paintings because Goya used a "black background and then superimposed the medium and light tones on top."

After the violence of the Napoleonic Wars (1803–1815) in Spain, Goya had become disenchanted with life and the human condition. Essayist Siri Hustvedt speculates on a possible stimulus for Goya's darkness: "We don't know what Goya saw during the war, only that he was prompted to work for years on etchings that treated its carnage. We know that illness brought him close to death twice. The insanity of war and the delirium of sickness merge in this work as a loss of borders and of secure ground."

SEE ALSO Black Velvet Paintings (1933), Reinhardt's Black Paintings (1953), Black Admiral Restoration (2006)

Saturn Devouring His Son, one of Goya's Black Paintings, *now residing in the Museo del Prado in Madrid.*

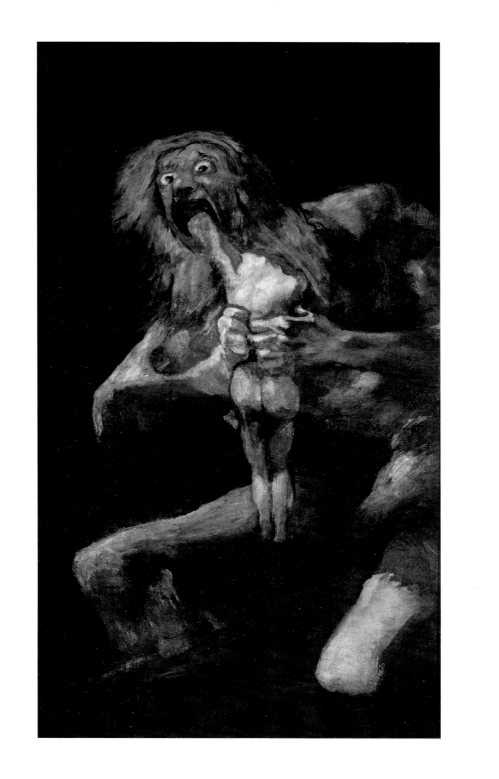

Black War

Truganini (c. 1812–1876), **Jared Mason Diamond** (b. 1937), **Mark Cocker** (b. 1959)

In the early 1800s, British settlers in Tasmania—a British colony that became part of the Australian Federation in 1901—began their brutal attacks on the islanders, often treating them as subhumans. Biogeographer and author Jared Diamond writes, "Tactics for hunting down Tasmanians included riding out on horseback to shoot them, setting out steel traps to catch them, and putting out poison flour where they might find and eat it. Shepherds cut off the penis and testicles of aboriginal men, to watch the men run a few yards before dying . . . One party of police killed 70 Tasmanians and dashed out the children's brains."

Author and naturalist Mark Cocker writes, "The all-male work-force on isolated Tasmanian farms . . . regularly kidnapped Aboriginal females in order to work off their frustrations. The standard practice was to chain them up and then turn on the charm, one suitor thrusting a burning stick into the skin of his would-be partner until she succumbed to his advances." One settler who wanted a native woman decapitated her husband, hung his head around her neck, and forced the woman to his home.

The dreaded Black War refers to the conflict that peaked roughly between the late 1820s and early 1830s. Fighting took place between the British colonists and black Tasmanian Aborigines, resulting in the nearly complete destruction of the native peoples.

Although some authors have suggested that the Aboriginal death toll and degree of violence on the part of colonial settlers has been exaggerated, others, like Cocker, write of how the Europeans "swept away" the indigenous animals and "gnawed incessantly" on the Aborigines through violence and kidnapping. The Aborigines fought back, but the Tasmanians' wooden clubs and spears were no match against British firepower.

In May 1876, Truganini, often considered as being among the last of the full-blooded Tasmanians, died at the age of 73. She is thought to have participated in the resistance to white settlement. Her mother had been stabbed to death by whites and her uncle shot to death. Her sisters were kidnapped and sold, and her fiancé was drowned in her presence while his murderers raped her.

SEE ALSO Black Hole of Calcutta (1756), Black Hawk War (1865)

Photograph of Truganini in 1866. The famous Trugernanner was the last living full-blooded tribal-born Tasmanian Aboriginal from the Oyster Cove community. After her death, her skeleton was callously exhumed by the Royal Society of Tasmania and later placed on display.

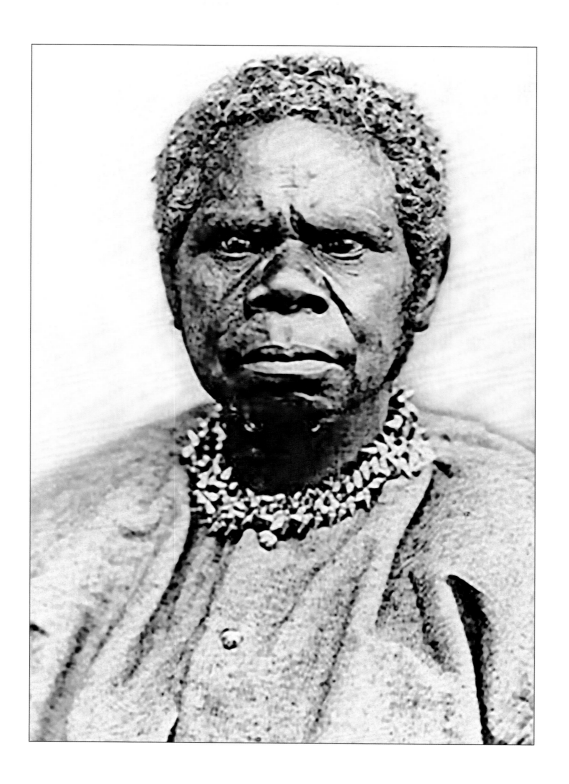

"Coal Black Rose"

George Washington Dixon (1801–1861), **Brooks D. Simpson** (b. 1957)

The folksong "Coal Black Rose" is significant both in the history of music and in the history of African Americans in America, as the song is often used to mark the origin of Blackface Theater in the United States. In particular, the song is among the earliest known songs to be sung in a theater by a man in blackface makeup. Historians David W. Blight and Brooks D. Simpson write, "In 'Coal Black Rose,' aspects of African American culture were for the *first* time integrated with the carnival and theatrical traditions of blackface."

The song was given broad exposure when American singer, stage actor, and newspaper editor George Washington Dixon performed the song in 1829 at New York theaters such as the Bowery Theatre, the Chatham Garden Theatre, and the Park Theatre. Other performers, such as Thomas Blakeley, also performed the song in 1829 in New York City.

The lyrics of "Coal Black Rose" describe a fight between Sambo and Cuffee, two black men who love the same woman. The song starts with Sambo expressing his love for Rose. Sambo arrives unexpectedly at Rose's cabin where he sees Cuffee, trying to hide in the corner of the dark room. The song then takes an angry tone:

> Oh Rose, take care Rose!
> I wish I may be burnt if I don't hate Rose,
> Oh Rose, you blacka snake Rose!

Musicologist Richard Crawford notes that when Sambo first comes to Rose's cabin, she makes him wait outside in the cold. "On the cover of the sheet music, which shows a squat, unlovely Rose, looking less like an ingénue than a fullback, Sambo holds his banjo in a way that anticipates the phallic implications of rock and roll." Most Americans of the time were not comfortable openly talking about sex, but songs involving black people on stage dealing with touchy topics "provided a way to approach a forbidden subject."

SEE ALSO Blackface (c. 1830), "Black is Beautiful" (1858), Black Codes (1865), Little Black Sambo (1899), "Black Magic Woman" (1968).

Sheet music for one version of "Coal Black Rose," c. 1827. The lyrics of "Coal Black Rose" describe a fight between Sambo and Cuffee, two black men who love the same woman.

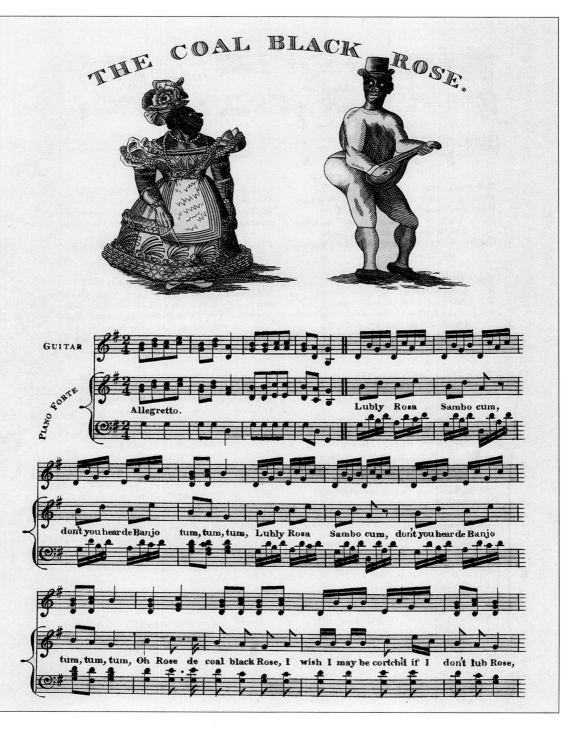

Blackface

Lewis Hallam Jr. (1740–1808)

In 1953, the American scholar Ralph Ellison wrote that African Americans in literature are seldom presented as "possessing the full, complex ambiguity of the human . . . [Often] the American Negro . . . emerges as an oversimplified clown, a beast or an angel." This simple, clownish image is typified in the phenomenon of blackface, which may refer both to the style of theatrical makeup or to the actor who uses the makeup. Some of the early American minstrel shows consisted of white performers who mocked the stereotypical behavior of blacks. Usually, the white actors blackened their faces with greasepaint made from burnt corks and sang and danced.

One of the early forms of theatrical blackface included the work of white American actor Lewis Hallam Jr., who played the role of "Mungo," an inebriated black man in *The Padlock*, a play that premiered in New York City in 1769. Blackface clowns gained popularity in the early 1800s. According to *Encyclopedia of the Harlem Renaissance*, one of the most popular blackface roles in the late 1820s and early 1830s was a "ragged, happy, southern plantation hand eager to please and serve his master." Another common role consisted of a black imitation of the refined white gentleman, or of a white man striving to belong to the aristocratic life. Blackface was common in films into the 1930s.

Professor Susan Willis reminds us of the complexity of blackface, in which not only white men portrayed black men but "black men portrayed white men portraying black men . . ." As degrading as blackface may appear, media expert W. J. Thomas Mitchell and other scholars feel that it "was never purely negative" and "it included elements of affection, love, and even envy." Author Antonia Petrash writes, "It is difficult today to understand the historic popularity of the blackface performer, a practice that present-day audiences would consider racially insulting. But from the years following the Civil War until the early days of the twentieth century it was an entertainment form popular with both white and black performers."

SEE ALSO "Coal Black Rose" (1829), "Black is Beautiful" (1858), Black Codes (1865), Little Black Sambo (1899), Black Admiral Restoration (2006)

Promotional poster from 1900 for William H. West's "Big Minstrel Jubilee," featuring "comical, eccentric, acrobatic black clowns."

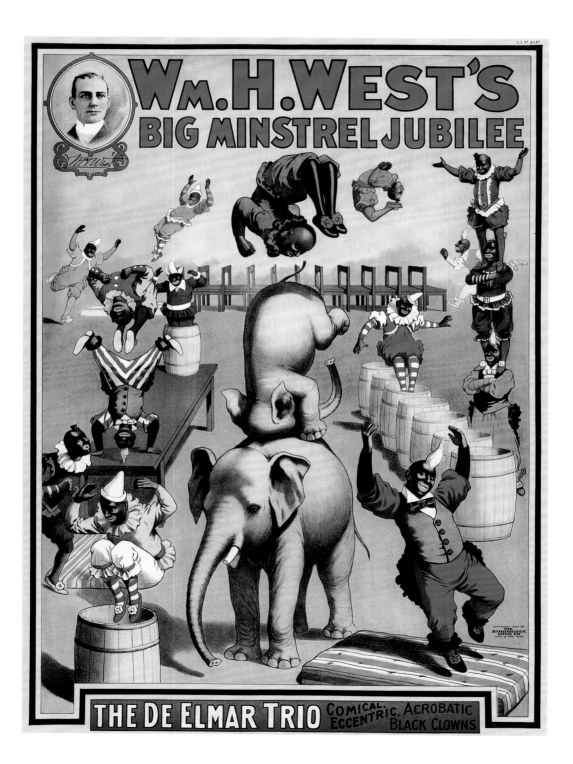

Black Angus

James Playfair (1738–1819), **William McCombie** (1805–1880)

Black Angus cattle are the most popular beef cattle in the United States. These big animals mature at around two years of age, have no horns, and are referred to as Aberdeen-Angus in the United Kingdom. Hornless cattle have existed since prehistoric times in the county of Angus, Scotland. In 1797, Scottish clergyman James Playfair wrote, "There are 1,129 horned cattle of all ages and sexes in the parish. I have no other name to them; but many of them are dodded, wanting horns." The Black Angus breed we know today originated in Scotland, thanks to Scotsman Hugh Watson, who selected his best black cows, including "Old Jock," born in 1842, and "Old Granny," who was born in 1824 and lived to age 35 after birthing 29 calves. Most of the Angus steaks on your dinner plate today can be traced to Jock and Granny. The average weight for a bull and cow is about 2,000 and 1,100 pounds, respectively.

Other cattlemen also contributed to the rise of the Black Angus. For example, Scottish agriculturist William McCombie of Tillyfour, Scotland, is considered "the preserver and great improver" of the Aberdeen-Angus breed through his planning of cattle matings and promotion. For example, at the 1878 International Exposition held at Paris, McCombie won the $500 grand prize for the best beef-producing animals bred by any exhibitor. The first great herds of Black Angus in America were created from the Scotland stock. Twelve hundred cattle were imported between 1878 and 1883. During 2007, 347,755 Angus cows were registered in the United States, with Montana having more Angus cows registered than any other state.

The American Aberdeen-Angus Association (today called the American Angus Association) was founded in 1883, and in 1917 the association prohibited the registering of red cows in order to promote an all-black creature. The Red Angus cattle can arise from a recessive gene.

SEE ALSO Black Pudding (c. 700 BC), Blackbird Pie (1549), Black Pullet (1740)

The modern Black Angus breed originated in Scotland, thanks to Scotsman Hugh Watson who selected his best black cows, including "Old Jock" (born in 1842) and "Old Granny" (born in 1824) who gave birth to 29 calves.

Black Ice

John Dryden (1631–1700), **Michael Faraday** (1791–1867), **Gabor A. Somorjai** (b. 1935)

"Beauty, like ice, our footing does betray," wrote English poet John Dryden. "Pleased with the surface, we glide swiftly on, and see the dangers that we cannot shun." One wonders what Dryden would have written about "black ice"—the clear water that has frozen on dark roadways and which poses a particular danger to motorists who are often unable to see the icy pavement. Interestingly, black ice sometimes forms without the presence of rain, snow, or sleet, because condensation from dew, mist, and fog on roadways can freeze. The frozen water of black ice is transparent because relatively few air bubbles are trapped in the ice. But why is ice slippery?

On June 7, 1850, English scientist Michael Faraday suggested to the Royal Institution that ice has a hidden layer of liquid water on its surface, which makes the surface slippery. To test his hypothesis, he simply pressed two ice cubes together and they stuck. He then argued that these extremely thin liquid layers froze when they were no longer at the surface.

Ice skaters can happily skate on ice because the friction between the skate blade and the ice may generate heat and cause some liquid water to temporarily form. Another recent explanation suggests that the water molecules on the surface vibrate more because no water molecules exist on top of them. This creates a very thin layer of liquid water on the surface, even if the temperature is below the freezing point of water. In 1996, chemist Gabor Somorjai used low-energy electron diffraction methods to prove that a thin layer of liquid water exists at the surface of ice. Faraday's 1850 theory seems to have been vindicated. Today, scientists are not quite sure whether this intrinsic layer of liquid water or the liquid water caused by friction plays a greater role in the slipperiness of ice.

Black ice continues to be one of the deadliest causes of winter accidents—but sometimes is missed as a cause, having quickly melted away by the time the police arrive.

SEE ALSO Black Diamonds (c. 3 billion BC), Death by Blackdamp (1862), Black Light (1903), Black Lightning (1956).

Sometimes, drivers of vehicles may believe that a shiny road surface is water, until their vehicles begin to slip on the black ice, which is one of the deadliest of all winter driving hazards.

Browning's Dark Tower

William Shakespeare (1564–1616), **Robert Browning** (1812–1889), **Margaret Atwood** (b. 1939), **Stephen King** (b. 1947)

The image of a Dark Tower occurs frequently in literature, and one of the most famous early images appears in Robert Browning's poem "Childe Roland to the Dark Tower Came," written and published in 1855. The actual phrase "Child Rowland to the dark tower came" originates in William Shakespeare's play *King Lear*, which was written around 1603. Stephen King's monumental Dark Tower series of novels was inspired by Browning's poem. In King's works, protagonist Roland Deschain undertakes a quest for a Dark Tower. Thus, in these examples, we may diagram the spread of the Dark Tower meme as Shakespeare → Browning → King. King includes the full text of the Browning poem in the final volume of his series. Interestingly, in Browning's poem, the reader is never quite sure for what the Dark Tower stands.

Shakespeare expert and author Robert Sawyer interprets the poem as describing "a young knight, a 'Childe,' on a quest to find the mysterious 'Dark Tower.' At the beginning of the poem, the quester watches as a 'hoary cripple, with malicious eye' points him in the direction of what may or may not be the 'ominous tract' leading to the Dark Tower." Along the way, Roland faces great challenges and dark, marshy wastelands. He dreams of his home and friends. The poem ends when he reaches the Tower and blows his horn.

Browning, an English poet, said that the entire poem came to him in a flash in a dream, and he wrote all 204 lines in a single day. Browning never said what he thought his nightmarish dream meant, which caused readers for years to ponder its Stygian depths. Author and literary critic Margaret Atwood believes that some kind of monster inhabits the Tower or that the Tower "holds for each individual what that person most fears." If the Tower doors were to open, Atwood says, Roland would find "that the monster inside the Dark Tower is Childe Roland himself."

SEE ALSO Byron's "Darkness" (1816), Conrad's *Heart of Darkness* (1902), "The Whisperer in the Darkness" (1931), Black Lightning (1956), *Dark City* (1998)

Browning's mysterious Dark Tower is described as being "built of brown stone, without a counterpart in the whole world." The final scene in the poem takes place during a "dying sunset."

"Black is Beautiful"

John Sweat Rock (1825–1866)

In 1858, John Rock, the first African American attorney to be allowed to argue before the Supreme Court of the United States, expressed his dream that once African Americans rose from poverty, racial harmony would prevail: "When the avenues of wealth are opened to us, we will become educated and wealthy, and then the roughest-looking colored man that you ever saw . . . will be pleasanter than the harmonies of Orpehus, and black will be a very pretty color. It will make our jargon, wit—our words, oracles; flattery will then take the place of slander, and you will find no prejudice in the Yankee whatsoever."

John Rock was an American doctor, dentist, lawyer, and abolitionist who is credited with originating the "Black is Beautiful" theme, which in the 1960s became an important cultural movement in the United States. This movement reinforced the notion that black skin color and facial features should be thought of as beautiful traits, thus encouraging African Americans to boost their self-images. Rock was born in 1825 to free black parents in New Jersey. When denied admission to medical school because of his race, he studied dentistry under the supervision of Dr. Harbert Hubbard and opened a practice in Philadelphia. He also studied medicine with local physicians and was awarded a medical degree in 1852 from the American Medical College in Philadelphia.

While practicing medicine and dentistry, he gave powerful lectures for antislavery groups. His "Black is Beautiful" theme was evident in his March 1858 speech, which he gave in Faneuil Hall in Boston, Massachusetts, where he also noted, "When I contrast the . . . beautiful, rich color . . . of the Negro with the . . . wan color . . . of the Caucasian, I am inclined to believe that when the white man was created, nature was pretty well exhausted . . ." His comment drew laughter from an audience of mixed races, and he went on to clarify that color distinctions should hold no meaning when judging people.

SEE ALSO "Coal Black Rose" (1829), Blackface (c. 1830), Black Codes (1865), Little Black Sambo (1899), Black Admiral Restoration (2006)

Illustration of John Rock from Harper's Weekly, *1865. Rock was the American doctor, dentist, lawyer, and abolitionist who is credited with originating the "Black is Beautiful" theme.*

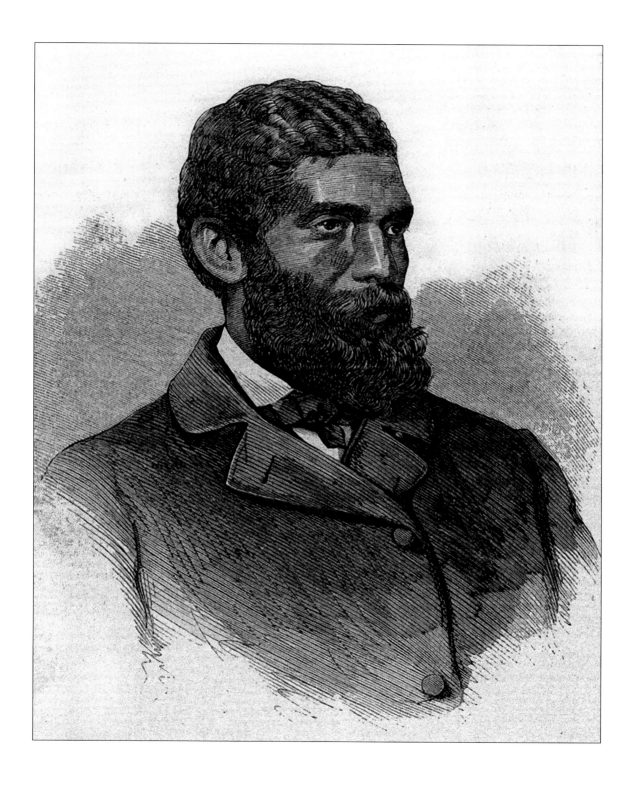

Death by Blackdamp

1862

Mining has always been a dangerous job, and as humans penetrated deeper into the Earth's dark bowels, one of the greatest hazards was a gas that became known as *blackdamp*. Authors Alan Jones and Renold Tarkenter write, "This gas, mainly nitrogen and carbon dioxide, is formed naturally by the oxidation of coal and other mineral or vegetable materials . . . Blackdamp threatens the miner if ventilation is lost for any reason, as at the Hester Pit, New Hartley, Northumberland [England], where, in 1862, 204 men and boys lost their lives." Although the presence of blackdamp might be detected by the diminished brightness of the miners' candles or lamps, or by difficulty breathing, there is not always sufficient time to return to the surface before the blackdamp kills. When a miner first notices the signs of blackdamp, death by blackdamp can occur in seconds.

The "damp" portion of "blackdamp" most likely comes from *dampf*, the German word for "vapors." As mentioned, coal in a mine tunnel absorbs oxygen and exudes carbon dioxide, a major contributor to blackdamp. According to occupational-safety expert Megan Tranter, blackdamp can be formed by the oxidation of the iron pyrites found in coal, along with other chemical reactions. Today, safety lamps may be used that employ flames that go out when the oxygen concentration declines to 18 percent, giving miners time to escape. Blackdamp may also be a danger in sewers and wells.

Historian Karen Buckley dramatically wrote of the horrors of trying to avoid the blackdamp after an explosion in which miners were in a passage that could not be traversed due to "an impenetrable wall of blackdamp." In such a situation, "they would probably retreat farther into the mine, barricade themselves in a room and wait for help. Miners all knew that if they were denied the mercy of instant death, and they somehow managed to evade the blackdamp," that their time would be spent in the maddening darkness, waiting for help and liberation from the horror of quiet deaths by blackdamp.

SEE ALSO Black Ice (1850), Black Mold (1937)

Engineers descending into a mine shaft in Le Creusot, France. By the time a miner first notices the signs of blackdamp, death by blackdamp can occur within seconds.

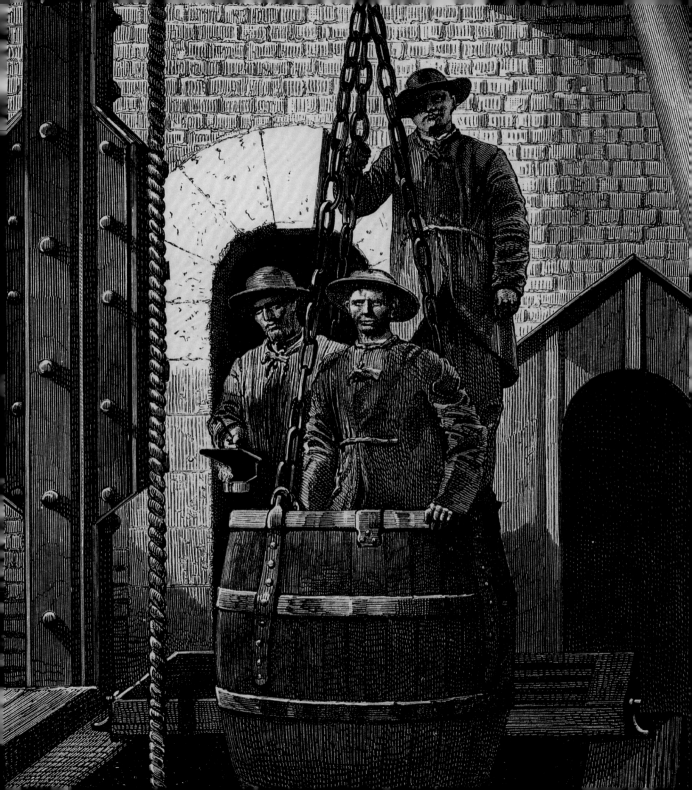

Black Hawk War

Antonga Black Hawk (1830–1870)

The Black Hawk War refers to a series of roughly 150 battles that took place between 1865 and 1872 between Mormon settlers and the Ute, Paiute, and Navajo Native American tribes led by Antonga Black Hawk, chief of the Ute tribe. The Mormons often could not distinguish between Native Americans with peaceful intent and those who were overtly hostile; thus, Native American women and children were sometimes indiscriminately killed.

Among the saddest incidents occurred in 1866 in the town of Circleville, where white settlers slaughtered a band of captive Paiute Indians. Historian W. Paul Reeve writes, "The women and children were brought from the cellar one at a time and killed [by throat slitting]. Three or four small children too young to talk were spared and adopted by local families."

Anthropologist Joseph Jorgensen writes, "In 1847, the first wave of Mormon settlers passed through the Bridger Valley and then into the Salt Lake Valley, where they squatted in Shoshone territory." Jorgensen continues to describe the domination of Native Americans in Utah by the Mormons: "The closest Ute settlements were in the Utah Lake valley, thirty miles to the south. Within ten years, Mormon pioneer communities comprising forty thousand people had been established."

Anthropologist Martha C. Knack writes, "Dedicated agriculturists, the Mormons rapidly diverted streams for irrigation, thus efficiently controlling the entire area . . . In addition to efforts to alter general Paiute behavior, Mormons also tried systematically to remove selected individuals, children of both sexes who were bought and raised within Mormon households, and nubile women who were married and brought into the settlements."

In 1867, Black Hawk made peace with the Mormons, although intermittent skirmishes continued until 1872, when federal troops were ordered to control the situation. Sadly for the Native American tribes, the white settlement of Utah destroyed traditional ecosystems of the area, causing many indigenous people to starve, while others died from European diseases. Black Hawk died in 1870 from tuberculosis.

SEE ALSO Black War (1828)

During the Black Hawk War, Indians were led by Antonga Black Hawk, chief of the Ute tribe. Shown here is Ute tribal rock art in Arches National Park, Utah, displaying riders on horseback, surrounded by bighorn sheep and dog-like animals. This was carved between 1650 and 1850.

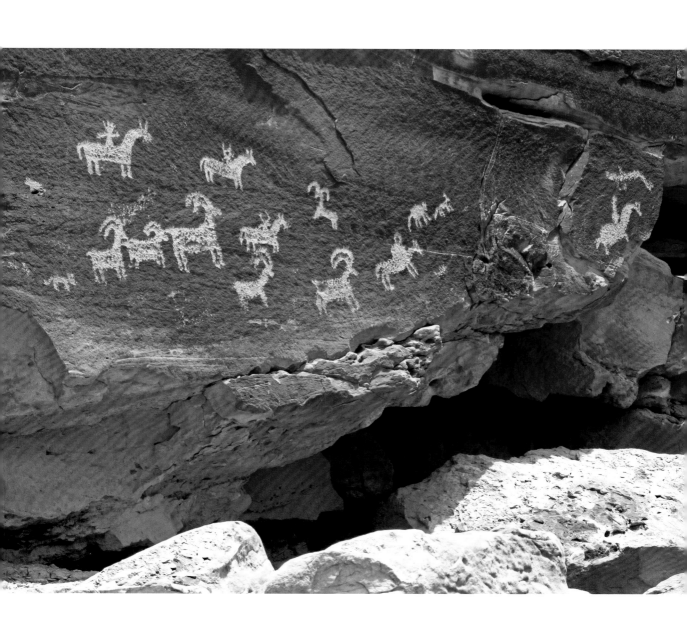

Black Codes

Angela Yvonne Davis (b. 1944)

The Black Codes were laws passed primarily in the Southern states of the United States to restrict the civil rights of African Americans and control their lives. The term is most often applied to such laws passed after the Civil War. The Thirteenth Amendment to the United States Constitution abolished slavery in 1865, but all former slave states implemented Black Codes.

In 1865 and 1866, Virginia passed Black Code vagrancy laws that made it a crime for black women and men to be without employers and prohibited black people from testifying against whites in a court of law. Historian Scott Nelson writes that although freed slaves were "hardly mentioned in the Black Codes, enforcement efforts targeted them. In some Virginia cities . . . the downtown slave pens were reestablished to hold these black 'vagrants' until their trials. Men and women without labor contracts could be picked up by police and auctioned off to the highest bidder for three months' labor."

"Particularly in the United States," writes political activist and university professor Angela Davis, "race has always played a central role in constructing presumptions of criminality. After the abolition of slavery, former slave states passed . . . Black Codes that proscribed a range of actions—such as vagrancy, absence from work, breach of job contracts, the possessions of firearms, and insulting gestures or acts—that were criminalized only when the person charged was black." So malevolent were the Mississippi Black Codes that vagrancy could be charged merely if an African American "handled money carelessly"!

"Criminal offense included using 'insulting' language and preaching the gospel without a license," write the authors of *Unto a Good Land: A History of the American Peoples*. "Rather than moving African Americans toward responsible citizenship, the Southern states seemed 'hell-bent' . . . on keeping them . . . at the 'bottom rail' of society."

SEE ALSO The Black Guard (1690), Black Act (1723), "Coal Black Rose" (1829), Blackface (c. 1830), "Black is Beautiful" (1858), Little Black Sambo (1899)

Message on a collection box of the Massachusetts Anti-Slavery Society. People dropped money into the box in order to contribute to the Abolitionist cause. Even after slavery ended, the rights of African Americans were severely restricted.

Black Bart

Charles Earl Bolles (1829–disappeared c. 1888), **Dale L. Walker** (b. 1935)

Reporter and editor George Hoeper writes, "Few Western outlaws with the possible exception of Jesse James [and] Butch Cassidy . . . stirred the public's imagination as did stagecoach robber Black Bart . . . Black Bart headed no bandit gang. Instead, for eight years he led a solitary life of outlawry . . . and never fired a shot in anger or injured a single victim." Black Bart was such a gentleman that while robbing one stagecoach, he handed a woman's purse back to her, telling her that he only robbed Wells Fargo and Company and not the passengers.

His real name was Charles Earl Bolles, nicknamed "the Gentleman Bandit" because of his politeness. His saga started around 1871, when he wrote to his wife about an incident with Wells Fargo and Company that angered him, and he promised revenge. He robbed his first stagecoach in 1875 in Calaveras County, California. At one of his robberies of 1877, he left behind this delightful poem:

> I've labored long and hard for bread, for honor, and for riches,
> But on my corns too long you've tread, you fine-haired sons of bitches.

Bolles called himself Black Bart after the name of a black-clad robber of Wells Fargo stagecoaches in a contemporary adventure story. Bolles was finally caught and sentenced to six years in San Quentin Prison, but his stay was shortened to four years for good behavior. He mysteriously disappeared shortly after his release from prison.

Nearly a year after her husband disappeared, his wife was interviewed by a newspaper reporter, and she said, "I believe he is engaged in mining in some secluded spot in the mountains, though of course I do not know. He may be dead . . ." Another theory is that in 1888, he attempted to rob a stagecoach headed for Reno, Nevada and was killed by shotgun blasts and buried at the side of the road. According to writer Dale Walker, when lawmen finally uncovered the corpse, it resembled photos of Black Bart. The mystery remains.

SEE ALSO Blackbeard (c. 1680)

Stagecoach robber Charles Earl Bolles, also known as Black Bart or the Gentleman Bandit because of his politeness.

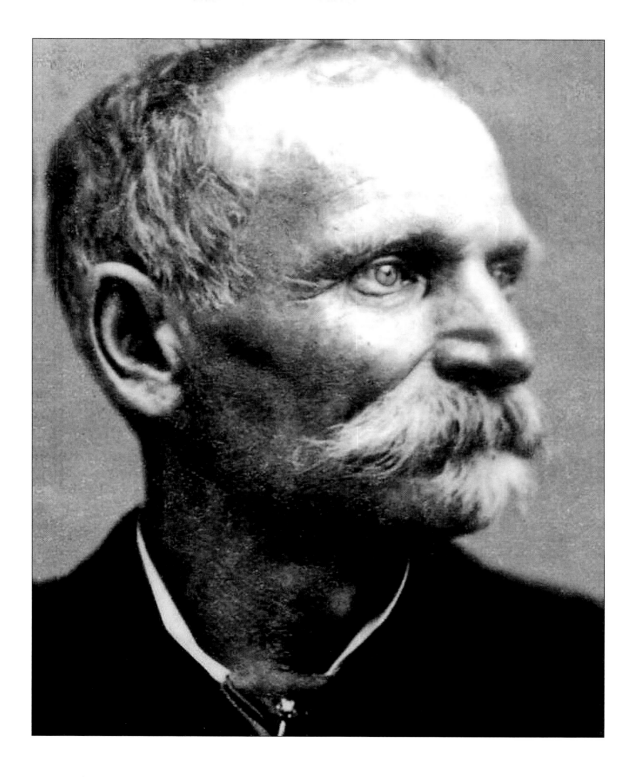

Black Museum

Joseph Gollomb (1881–1950), George Orson Welles (1915–1985)

Author Joseph Gollomb writes of this famous British collection of criminal memorabilia, "It was a cheerless emotion I felt at the sight of that Black Museum. Here was a depository of relics of remarkable crimes and their detection; a museum of the dark side of the human soul; history in blood-rusted razors, revolvers, and a whole arsenal of other implements of violence; the grimmest, queerest schoolroom conceivable."

The Black Museum opened in 1875, housing a collection of crime artifacts and serving to educate police officers. The word "black" has nothing to do with ethnicities but refers to the evil and dark nature of the artifacts in the Museum. The actual name "Black Museum" was coined in 1877 by a reporter. Today, one room of the museum contains numerous weapons that were used in actual murders or assaults in London, including various items that once belonged to Jack the Ripper. Death masks of hanged people sit on shelves.

Over the years, many famous people have visited the museum, including Sir Arthur Conan Doyle, Harry Houdini, and members of the Royal Family. Alfred Hitchcock was known for some of his dark interests, and he frequently visited the Black Museum, which biographer Donald Spoto referred to as "a police chamber of horrors . . ." Hitchcock himself noted that the Black Museum had "all the shoes of prostitutes from the gaslight era," and he was fascinated by the fact that "the color of every scarlet woman's shoes determined what her specialty was."

The Black Museum at Scotland Yard is the oldest museum in the world that focuses exclusively on artifacts and recordings of crime. In 1951, Orson Welles produced a radio program called "The Black Museum"—each week, he featured an item from the Black Museum and produced a lurid dramatization of the real-life story of the object. The show started by referring to the Black Museum as a "repository of death" that housed "everyday objects . . . a woman's shoe, a tiny white box, a quilted robe . . . all are touched by murder."

A letter (opposite), allegedly from Jack the Ripper, reads as follows: "From Hell. Mr Lusk, Sir I send you half the Kidne I took from one woman preserved it for you tother piece I fried and ate it was very nise. I may send you the bloody knif that took it out if you wate a whil longer."

SEE ALSO Black Act (1723), Dark Tourism (1996)

The famous 1888 "From Hell" letter, allegedly sent by Jack the Ripper to George Lusk along with half a human kidney, signed "Catch me when you can, Mishter Lusk."

From hell

Mr Lusk
 Sor I send you half the
Kidne I took from one women
prasarved it for you tother piece
I fried and ate it was very nise I
may send you the bloody knif that
took it out if you only wate a whil
longer
 signed Catch me when
 you can
 Mishter Lusk

Black Beauty

Anna Sewell (1820–1878)

Black Beauty, one of the most famous and successful animal stories ever written, was first published in 1877, just a few months before author Anna Sewell's death. A. Waller Hastings, professor of English, writes, "Sewell wrote only one book in her life, but it was one that was to have a significant impact in at least two areas: the humane treatment of animals and the future direction of children's literature." An injury to her leg at age fourteen left Sewell "an invalid for life; while the injury was real, the extent of her limitation may have reflected a degree of socially useful hypochondria." Although her publisher paid her only twenty pounds for the book, it later went on to be a best seller and has always been in print.

Black Beauty is told from the horse's point of view and involves its life, which ranges from happy times on a country estate to misery as a cruelly treated cab horse on the crowded London streets. According to Peter Hunt, a professor of English, "There are some books such as Harriet Beecher Stowe's *Uncle Tom's Cabin* (1851–2), which would be worth including in a literary canon . . . for their social consequences alone, but *Black Beauty* . . . is an extraordinary achievement in its own right. Written, as the author said, 'to induce kindness, sympathy, and an understanding treatment of horses,' it achieved its aim, especially with regard to the fashionable cruelty for the bearing-rein." This rein was a strap, popular in Sewell's day, to keep the horse's head unnaturally high with an attractive arched neck; however, when the rein was tight, it was painful, cruel, and damaging to a horse's neck. A horse with such a rein would often be unable to breathe properly and developed respiratory problems.

The few months Sewell lived after the publication of *Black Beauty* allowed her to get only the barest glimpse of the novel's eventual success. Since its publication, the book has sold over 30 million copies and has been adapted for several movie and television performances.

SEE ALSO Little Black Sambo (1899)

Black Beauty is a cruelly treated cab horse on the crowded London streets. Shown here are carriage horses beneath the Ludgate Hill railway bridge, with St Paul's Cathedral in the background (from The Illustrated London News, 1863).

Little Black Sambo

Helen Bannerman (1862–1946), Fred Marcellino (1939–2001)

The Story of Little Black Sambo is one of the most famous children's books in history—and also one of the most controversial. Written by Scottish author Helen Bannerman, the book was first published in London in 1899. In Bannerman's story, Sambo is a clever Indian boy who is able to escape from four dangerous tigers by offering them articles of his clothing. At the end of the tale, Sambo is at his home and happy as he eats 169 pancakes for dinner. One famous scene in the book depicts the tigers racing around a tree as they gradually melt into butter. The story was very popular for many decades, but gradually came to be seen as having racist elements.

One source of controversy stems from the use of the term "Sambo," which was sometimes used as a disparaging name for people of dark skin, including people of African or South Asian heritages. The original depictions of Sambo exaggerate the stereotypical characteristics of inky black facial features, bright red lips, and chaotic, curly hair. Unauthorized versions of *The Story of Little Black Sambo* were published through the years, and these versions occasionally had offensive depictions and language. A pirated version, with illustrations of Sambo being more African than Indian, sold over a million copies in Japan before the publisher terminated publication in 1988, after complaints about the book's possible racist tone and depictions.

In 1996, American illustrator and author Fred Marcellino published a bestselling version titled *The Story of Little Babaji*, with new illustrations and new character names. The remainder of Marcellino's text is essentially the same as the original. Artist and author Ellen Spitz writes of *The Story of Little Black Sambo*: "Books mean very different things in different generations . . . A deceptively simple little book like this can sharpen our awareness of the crucial role that adults have to play as mediators between our children and the images they encounter."

SEE ALSO "Coal Black Rose" (1829), Black Face (1830), "Black is Beautiful" (1858), Black Codes (1865)

Little Black Sambo and tiger, illustrated by Florence White Williams and published in 1918 by the Saalfield Publishing Company.

1900

Blackbody Radiation Law

Max Karl Ernst Ludwig Planck (1858–1947), **Gustav Robert Kirchhoff** (1824–1887), **Niels Henrik David Bohr** (1885–1962)

Danish physicist Niels Bohr once proclaimed, "Anyone who is not shocked by quantum mechanics has not understood it." Quantum theory, which suggests that matter and energy have the properties of both particles and waves, had its origin in pioneering research concerning hot objects that emit radiation. For example, imagine a heated horseshoe that glows brown and then red as it gets hotter. The Blackbody Radiation Law, proposed by German physicist Max Planck in 1900, quantifies the amount of energy emitted by blackbodies at a particular wavelength. Blackbodies are objects that emit and absorb the maximum possible amount of radiation at any given wavelength and at any given temperature.

Many of the hot objects that we encounter in our daily lives emit a large portion of their radiation spectrum in the infrared, or far-infrared, portion of the electromagnetic spectrum, which is not visible to our eyes. However, as the temperature of a body is increased, the dominant portion of its spectrum may shift so that we can see a glow from the object. In general, blackbody radiation has a continuous frequency spectrum and intensity that depends on the temperature of the body.

We can create a blackbody in the lab, using a hollow sphere, with a hole poked in its side. Radiation entering the hole reflects off the inner walls, dissipating with each reflection as the walls absorb the radiation. By the time the radiation exits through the same hole, its intensity is negligible. Thus, this hole acts as a blackbody. Planck modeled the cavity walls of blackbodies as a collection of tiny electromagnetic oscillators. He posited that the energy of oscillators is discrete and could assume only certain values. These oscillators both emit energy into the cavity and absorb energy from it via discrete jumps or packages called quanta. Planck's quantum approach involving discrete oscillator energies for theoretically deriving his Radiation Law led to his 1918 Nobel Prize. Today, we know that the universe was a near-perfect blackbody right after the Big Bang. German physicist Gustav Kirchhoff introduced the actual term "blackbody" in 1860.

SEE ALSO Black Light (1903).

A blacksmith can judge the approximate temperature of a metal by observing the color of its glow. Here, most emitted radiation has wavelengths beyond the visible range.

Black Dragon Society

Ryohei Uchida (1873–1937), **Marius Berthus Jansen** (1922–2000), **David E. Kaplan** (b. 1955)

According to journalists David E. Kaplan and Alec Dubro, "The ultimate objective of the Black Dragons was no less than the domination and control of all Asia. To the more fanatic visionaries, the society was destined for the calling of Hakko-ichi-u—the Eight Corners of the World under One Roof. The roof, of course, was that of the Emperor of Japan, descended from the Sun God in an unbroken line."

The Black Dragon Society of Japan was a famous nationalist, paramilitary, right-wing group—founded in 1901 by Ryohei Uchida under the name of Amur River Society ("Black Dragon River" in Chinese). According to Kaplan and Dubro, "the name of this secretive group hinted at its purpose: the expansion of Japanese power to the Amur River, the boundary between Manchuria and Russia." Its dream was to expel Russia from East Asia south of the Amur River.

Military historian Terry Crowdy writes, "initially the group recruited . . . from patriotic ronin [masterless samurai] and avoided criminal types . . . As word of their activities spread, other crusaders for the Japanese imperial cause sought membership. Although the society quickly boasted members in upper governmental and military circles, the group was not always in line with government policy, nor did it receive official sanction."

The Black Dragons were used by the Imperial Japanese Army during the Russo-Japanese War and other conflicts for the purposes of spying, propaganda, and assassination. In the 1930s, the Black Dragon Society had placed agents as far away as Africa, Turkey, Europe, South America, and the United States. In 1946, during the American Occupation of Japan after World War II, the Black Dragon Society was officially disbanded.

Historian Marius Jansen writes of the making of modern Japan, "Though oriented more toward action than thought, patriotic societies were numerous and everywhere. They seemed to thrive at the intersection of the respectable and disrespectable, the legal and illegal, exhorting and intimidating as the occasion demanded. The parent, and strongest, of these was the [Black Dragon] Society."

SEE ALSO Black Hand of Serbia (1911), Blackshirts (1919)

Samurai helmet and sword. In the late 1800s, dissatisfied former samurai established patriotic Japanese societies and intelligence-gathering groups, eventually leading to the Kokuryukai (Black Dragon Society), founded in 1901.

Conrad's *Heart of Darkness*

Joseph Conrad (1857–1924), **Chinua Achebe** (b. 1930), **Adam Hochschild** (b. 1942), **Francis Ford Coppola** (b. 1939)

"The offing was barred by a black bank of clouds, and the tranquil waterway leading to the uttermost ends of the earth flowed somber under an overcast sky—seemed to lead into the heart of an immense darkness." So concludes Polish-born writer Joseph Conrad in a novel that typifies the use of blackness and darkness to symbolize themes of isolation, evil, ignorance, uncertainty, madness, and mystery.

Although *Heart of Darkness* (*HOD*) received little attention from reviewers and the public during Conrad's life, today it is regarded as a classic of Western literature and often appears in lists of the greatest books ever written. *HOD*, published in 1902, follows the journey of an Englishman along the Congo River in Africa, where he encounters a frightening side of life. Years earlier, Conrad himself had dreamed of visiting central Africa; he finally became the captain of a Congo steamboat in 1890. His experiences led to the novel.

The possible themes of *HOD* are many, leading author Gene Moore to ask, "Is this a story about the horrors of African colonialism, . . . a symbolic modern descent into the hell of Virgil or Dante, the psychological or atavistic horror of unrestrained libido, or about the impossibility of storytelling? Was Conrad a 'bloody racist,' as Chinua Achebe had claimed, or the author of what Adam Hochschild describes as 'one of the most scathing indictments of imperialism in all literature?'"

In *HOD*, darkness comes in numerous guises. At the most prosaic level, Africa was often called the "dark continent" during Conrad's time, a phrase that referred to the dark-skinned natives, dark jungles, and mysterious native rituals. In *HOD*, the Europeans are also "dark," given their ignorant and cruel treatment of the natives. Similarly, darkness refers to the isolation of Mr. Kurz, a demonic ivory trader. The most famous artistic adaptation of *HOD* is Francis Ford Coppola's 1979 movie *Apocalypse Now*, which contains similar haunting themes but is set in Vietnam.

SEE ALSO Byron's "Darkness" (1816), Browning's Dark Tower (1855), Black Lightning (1956), Dark City (1998).

Men with ivory tusks, Dar es Salaam, c. 1900, about the time HOD was written. The plot of HOD involves ivory trade on the Congo River in Africa.

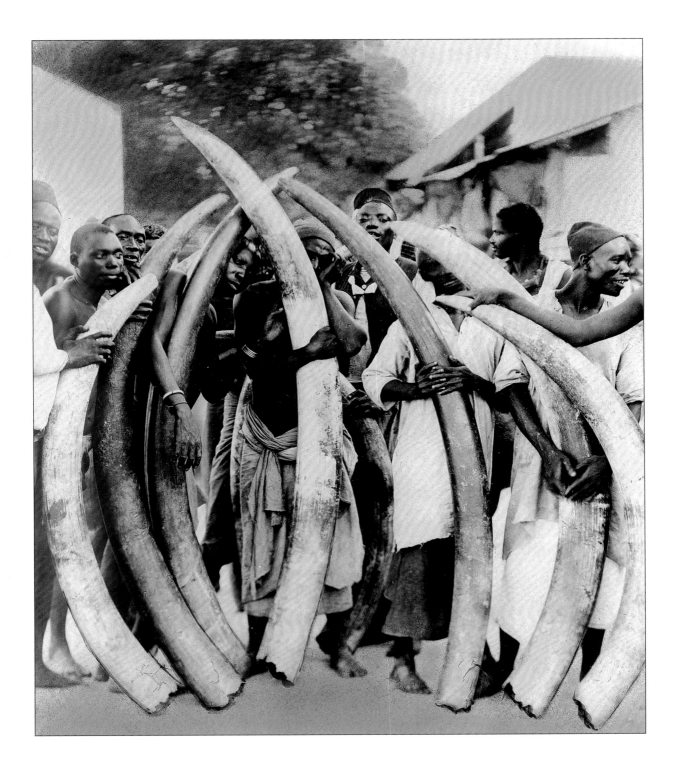

Black Light

Robert Williams Wood (1868–1955),
Peter Max (b. Peter Max Finkelstein, 1937)

During my youth, I papered my room with the psychedelic posters of Peter Max, the famous artist whose childhood began when he and his parents fled Nazi Germany to escape the Holocaust. His posters glowed in a swirl of otherworldly bold colors. Those readers old enough to remember the ubiquitous Max-inspired black-light posters of the psychedelic Sixties will appreciate author Edward Rielly's reminiscence: "Individuals tripping on LSD were fond of 'black lights,' which could be purchased in 'headshops' along with fluorescent paints and dyes. Fluorescent clothes or posters in the presence of black light bulbs created a visual counterpart [of] LSD." Today, black light "rave paint" is applied to the faces and bodies of dancers, with spectacular effects.

A black light (also called a Wood's lamp) emits electromagnetic radiation that is mostly in the near-ultraviolet range. To create a fluorescent black light, technologists often use Wood's glass, a purple glass containing nickel oxide, which blocks most visible light but allows ultraviolet light (UV) to pass through. The phosphor inside the light bulb has an emission peak below a wavelength of 400 nanometers. Although the first black lights were incandescent bulbs made of Wood's glass, these black lights were inefficient and hot. Today, one version of a black light is used to attract insects in outdoor insect killers; however, in order to reduce price, these lights omit the Wood's glass and therefore produce more visible light.

You and I can't see UV, but we can see the effects of fluorescence and phosphorescence when the light is shone upon appropriate objects, such as psychedelic posters. Thus, black lights have countless applications, including use in criminal investigations where the lights can be used to reveal trace amounts of blood and semen; and dermatological use, where they are used to detect various skin conditions and infections.

Although the black light was invented by chemist William H. Byler, black lights are most often associated with American physicist Robert Wood, the "father of ultraviolet photography" and inventor of Wood's glass in 1903.

SEE ALSO Blackbody Radiation Law (1900), Black Velvet Paintings (1933), Black Lightning (1956), Blackest Black (2008)

"Daemon of Solitude" (2010), a black-light painting by Belgian artist Natasja Delang. Her colors are vivid under ordinary light, but when illuminated by UV light, the glowing colors strongly reinforce the central motifs.

Shooting of the Last Black Mamo

William Alanson Bryan (1875–1942)

The Black Mamo (*Drepanis funerea*) was discovered in 1893 on Molokai, an island in the Hawaiian archipelago. This bird was a low flier, used its long curved bill for reaching nectar in flowers, and was relatively unafraid of people. Alas, it didn't have a chance of surviving once people encroached on its territory. The number of Black Mamos dwindled due to human destruction of the birds' habitats and the damage to forests from cattle and pigs.

In 1907, William Alanson Bryan, a collector for the Bishop Museum in Hawaii, searched through the mountains of Molokai to obtain specimens of the Black Mamo. After a long search for the "few remaining examples" of the bird, Bryan finally discovered its "coveted locality." Bryan wrote the following with respect to his shooting of the last Black Mamo ever seen, after he heard its "clear, gentle call" about fifty yards away:

> It was a moment of intense excitement. There was little doubt in my mind but that the note was that of the bird I had so long sought . . . I began to imitate the whistle call as best I could. To my delight, the curious black bird with the wonderfully curved bill . . . flew down and lit in a tree within ten feet of me! I pulled the trigger . . . To my joy, I found the mangled remains hanging in the tree in a thick bunch of leaves, six feet or more beyond where it had been sitting. It was, as I feared, badly mutilated. However, it was made into a very fair cabinet skin.

A little later in the day, Bryan found two more Black Mamos, one he referred to as a "perfect male specimen," and he killed them both. No further sightings of the bird on Molokai have ever been made. Even if Bryan did not literally shoot the very last Black Mamo, no large-scale searches definitively revealed the creature after 1907.

SEE ALSO Blackbird Pie (1549), Black Pullet (1740), Black Lion Tamarin Discovered (1971)

Black Mamo illustration by Dutch artist John Gerrard Keulemans (1842–1912), from Walter Rothschild's The Birds of Laysan, *1897.*

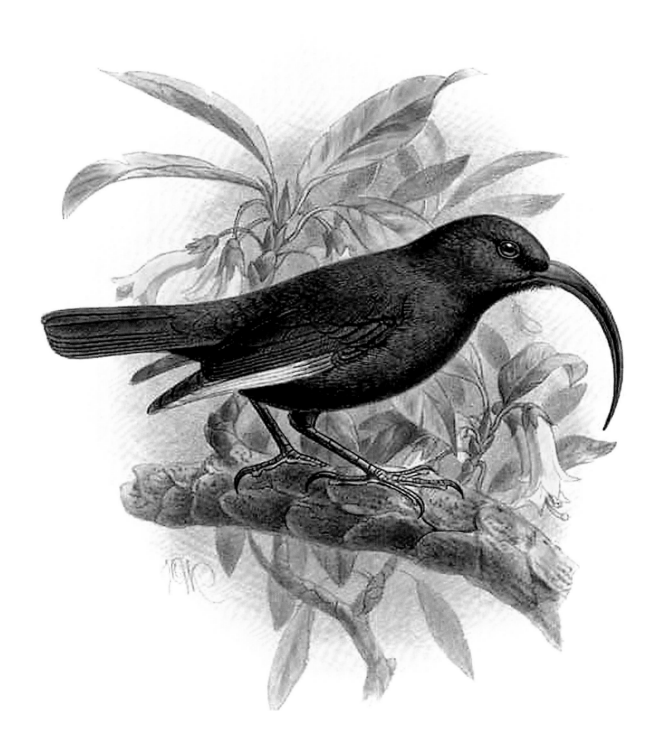

Black Hand of Serbia

Dragutin Dimitrijević (1876–1917), **Franz Ferdinand** (1863–1914), **Gavrilo Princip** (1894–1918)

"In the dark of early morning, June 11, 1903," writes military historian John Craig, "Captain Dragutin Dimitrijević, a large, muscular, twenty-six-year-old man known to his associates as 'The Bull' or 'Apis,' lay on the floor of King Alexander Obrenovic's Belgrade palace." Although the palace guard had shot Apis, he had managed to slaughter the Serbian king and his queen. Apis survived and in 1911 helped form the secret society known as the Black Hand. The goal of the Black Hand was to unite all Serbs, and their actions would forever change European history.

Apis asked young men infected with tuberculosis to join the Black Hand—men whose lives would be short anyway, and men likely to want to be remembered as helping Serbia by murdering its enemies and helping to overthrow Austro-Hungarian rule throughout the Balkans. Craig writes, "One of these pathetic tuberculins was the Bosnia-born Gavrilo Princip, a teenager whose assassination of the Austrian-Hungarian heir apparent, Archduke Franz Ferdinand, would help trigger the nightmare of World War I."

On June 28, 1914, Princip killed the Archduke and his wife. He apologized for killing the wife but considered the Archduke an enemy of the Serbs, and Austria a great evil. Austro-Hungarian leaders used this and other statements to trigger a war against Serbia, although there was no evidence that Serbia itself had anything to do with the assassination. Due to various alliances, World War I would soon start.

While in prison, Princip's tuberculosis worsened, and one of his arms had to be amputated due to infection. According to author Alan Axelrod, "on April 28, 1918, as the world war was consuming a fourth year, his jailers found Princip curled in a tight ball . . ." On the wall, before dying, Princip had managed to scratch these lines:

> Our ghosts will walk through Vienna
> And roam through the palace
> Frightening the lords.

SEE ALSO Black Dragon Society (1901)

Portrait of Archduke Franz Ferdinand by Austrian painter Wilhelm Vita (1846–1919). Gavrilo Princip assassinated Ferdinand in 1914, triggering World War I. In some sense, modern European history began with this event.

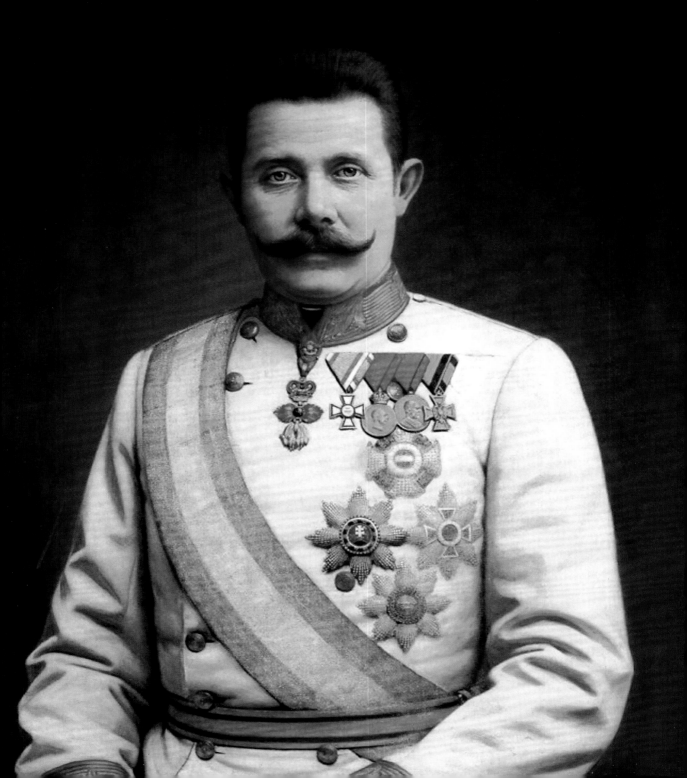

Black Forest Cake

Josef Keller (1887–1981)

Black Forest cake, also known in Europe as Black Forest Gateau, refers to a delicious treat that originated in southern Germany, where it is referred to as *Schwarzwälder Kirschtorte*, which literally means "Black Forest cherry cake."

Black Forest cake usually contains several layers of chocolate cake with whipped cream and cherries between each layer. Sometimes a clear brandy called *Kirschwasser* is added to the cake. *Kirschwasser* is made from the fermented juice of a small black cherry.

The origin of this famous cake is unclear. The confectioner Josef Keller claimed to have invented *Schwarzwälder Kirschtorte* in 1915 while at Café Ahrend (today called Agner), located in Bad Godesberg, a district of Bonn, Germany. After spending time in the military, Keller established his own café in the German town of Radolfzell. Keller gave his recipe book with his original recipe for Black Forest cake to August Schaefer, whose son, Claus Schaefer of the Triberg Café Schaefer, inherited the book.

The world's largest Black Forest cake—measuring 33 feet (10 m) in diameter and weighing three tons—was created in July 2006 in the German town of Rust. More than a dozen bakers made the cake, using more than 5,600 eggs, 185 gallons of cream, 1,750 pounds of cherries, and 120 liters of cherry liqueur. The cake was cut into 16,000 slices, with sales of the slices donated to charity.

Although Black Forest cake probably originated outside the Black Forest—a wooded mountain range in southwestern Germany—Black Forest tourism chief Christopher Krull raved about the cake in 2006: "Along with the cuckoo clock, Black Forest ham, Kirschwässerle cherry brandy, and traditional half-timbered homes, the Black Forest cake is an ambassador for our region all across the world."

SEE ALSO Black Pepper (1213 BC), Black Pudding (c. 700 BC), Blackbird Pie (1549)

Black Forest cake is a delicious treat that originated in southern Germany. The world's largest Black Forest cake measured 33 feet (10 m) in diameter and weighed three tons.

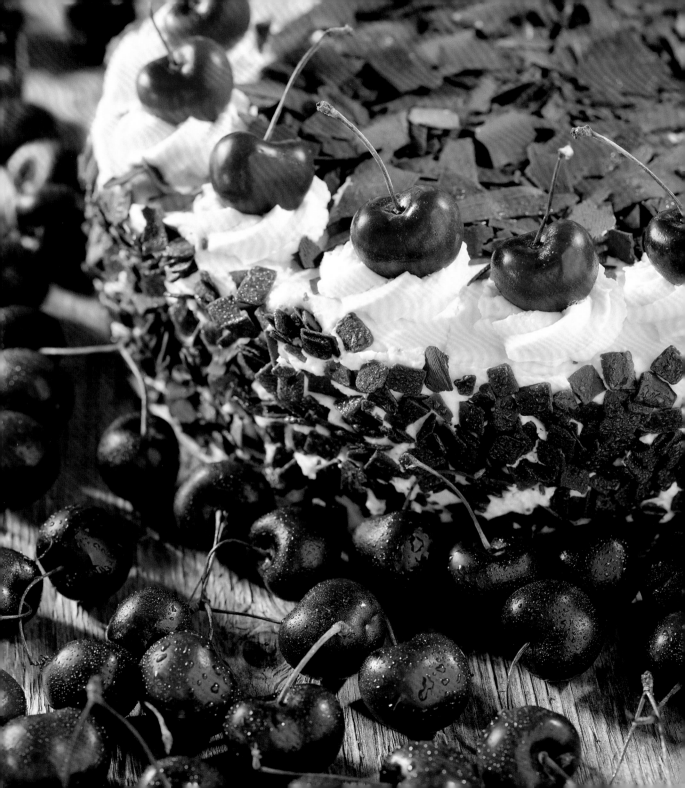

Blackshirts

Victor Emmanuel III (1869–1947), **Benito Amilcare Andrea Mussolini** (1883–1945), **Primo Michele Levi** (1919–1987), **George Seldes** (1890–1995)

"The Blackshirts had not just killed Turin's trade unionists, Communists and Socialists," wrote essayist Primo Levi of the 1922 horrors of the Blackshirts in Italy. "First they made them drink half a kilo of castor oil. In this way, a man is reduced to tatters, is no longer human . . . This is Fascism."

The Blackshirts were Fascist paramilitary groups in Italy between the end of World War I and the end of World War II. Organized by Benito Mussolini, prime minister of Italy from 1922 until 1943, the Blackshirt founders included former army officers and young landowners who opposed labor unions. The Blackshirts were established in 1919, and by 1923 became the Volunteer Militia for National Security.

In 1922, industry leaders met with Mussolini to plan and fund his "March on Rome." With the additional backing of Italy's top military officers and police chiefs, the fascist "revolution" took place—and the Blackshirts forced Victor Emmanuel III, King of Italy, to accept Mussolini's regime. Mussolini soon closed all opposition newspapers and crushed any opposing political parties.

Journalist Nicholas Farrell writes, "Mussolini was one of the most talked about figures of his age and most of that talk was favorable. Pope Pius XI called him the man 'sent by Providence' to save Italy; the American ambassador in Rome, Washburn Child, 'the greatest figure of his sphere and time'; and Churchill 'the Roman Genius.' But history is written by the victors and once Mussolini became a loser, his place as one of the very bad men of history was guaranteed."

Journalist and media critic George Seldes stated, "Everyone who visited Italy between 1919 and the time of the Fascist victory could not help noticing the blackshirts, . . . wearing black shirts and black fezzes and knives; they were loud and bellicose and not one of them far in his twenties . . . No one then expected these rowdy blackshirts would one day rule a large nation."

SEE ALSO Black Dragon Society (1901), Black Hand of Serbia (1911), The Black Sun (c. 1940), Black Hole Antiterrorism (c. 1987)

Benito Mussolini (center), during the March on Rome (October 28, 1922). Standing beside Mussolini are some of the leaders who were actively involved in the Fascist party.

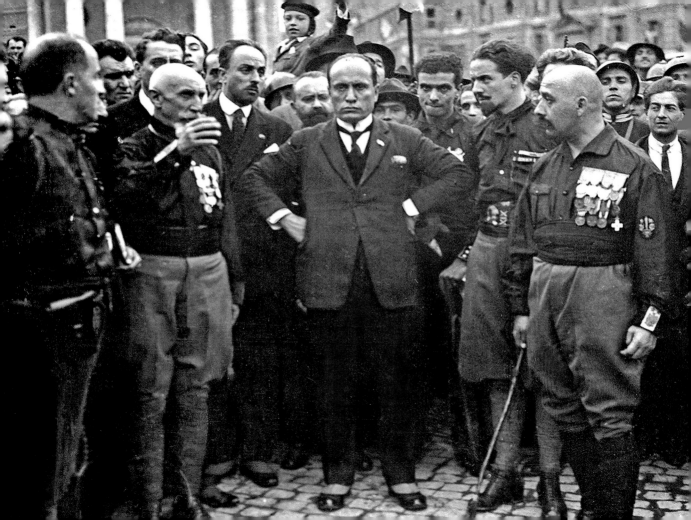

The Black Chamber

Johannes Trithemius (1462–1516), **Herbert O. Yardley** (1889–1958), **Henry Lewis Stimson** (1867–1950), **David Kahn** (b. 1930)

Government use of secret codes in order to send secure and sensitive messages dates back at least to the time of the Pharaohs. The first printed book on cryptography, *Polygraphiae Libri Sex* (*Six Books of Polygraphy*), was written by German abbot Johannes Trithemius and published in 1518 after his death. Trithemius's other famous work, *Steganographia*, was placed on the Catholic Church's "List of Prohibited Books" because it appeared to be a book about black magic, but in reality was just another book on codes.

Centuries later, American cryptologist Herbert Yardley would become a legend because of his establishment of the American Black Chamber, one of the first peacetime cryptanalytic organizations in the United States. Funded by both the Army and the State Department, the Black Chamber emerged immediately after World War I in New York City in order to facilitate the decryption of communications of both friendly and enemy nations. Today, the chamber is remembered mostly for its decipherment of Japanese diplomatic telegrams, which helped American negotiations with the Japanese. Historian David Kahn writes of the stressful working conditions in the Black Chamber: "[By 1922] the Black Chamber had turned out more than 5,000 solutions and translations. Yardley nearly suffered a nervous breakdown . . . and went to Arizona for four months to recover his health. Several of his assistants already had trouble in this regard. One babbled incoherently; a girl dreamed of chasing around the bedroom a bulldog that, when caught, had 'code' written on its side."

The Black Chamber was finally closed on October 31, 1929, two days after the famous stock market crash of Black Tuesday. Secretary of State Henry L. Stimson partly justified the closure by saying, "Gentlemen do not read each other's mail." In 1931, Yardley wrote *The American Black Chamber*, a very popular book that detailed the exploits of the people in the Black Chamber, who decoded more than 45,000 telegrams involving various codes used by over twenty countries.

SEE ALSO Black Museum (1875), Black Tuesday (1929)

The Black Chamber emerged immediately after World War I and is remembered for its decipherment of Japanese diplomatic telegrams. Shown here is a piece of the Purple diplomatic cryptographic machine, which started to be used by the Japanese Foreign Office just before World War II.

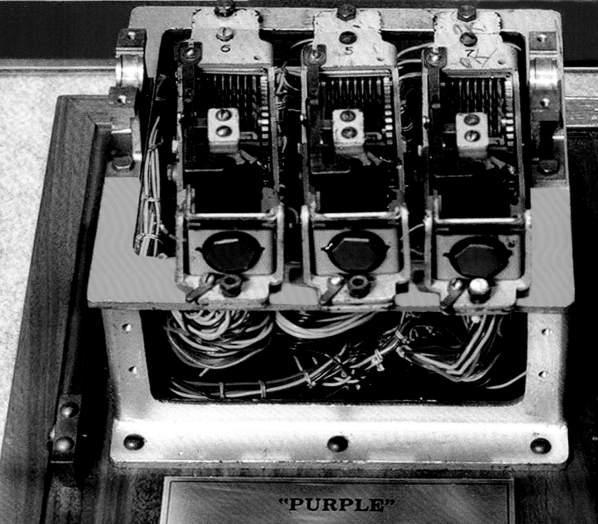

"PURPLE"

THIS IS THE LARGEST OF THREE SURVIVING PIECES OF THE FAMOUS JAPANESE DIPLOMATIC CIPHER MACHINE. IT WAS RECOVERED FROM THE WRECKAGE OF THE JAPANESE EMBASSY IN BERLIN, 1945.

PURPLE

Black Sox Scandal

Charles Arnold "Chick" Gandil (1888–1970), Abraham Washington Attell (1884–1970)

The 1919 Black Sox Scandal is one of the greatest scandals in the history of sports. "Numerous books have been written about the Black Sox scandal," writes author Daniel Ginsburg. "Two major motion pictures have been made . . . and millions of words have been written in newspapers . . ." that describe how this baseball scandal affected the American people. "In spite of all this attention, the story of the Black Sox Scandal is still unclear today. Exactly how was the baseball scandal organized? Which players truly took part in it?"

The Black Sox Scandal refers to events that led to the banning of eight members of the Chicago White Sox team for intentionally losing the 1919 World Series game. The "fix" was arranged by White Sox player Charles "Chick" Gandil and professional gambler Joseph "Sport" Sullivan. Abe Attell, a former featherweight boxing champion, likely supplied the money to bribe the team members. The term "Black Sox" may derive not only from the corruption involved but also because the owner of the team is alleged to have refused to pay for cleaning of the team uniforms, and the team protested by wearing dirty uniforms.

Historians Robert Grant and Joseph Katz explain the reason why the scandal had such an effect on America: "In 1919, baseball was the undisputed national pastime. Around it had developed a reverential dogma promoted by publicists, team owners, and baseball heroes. Unlike businessmen and politicians, who might be corruptible, baseball players, in the public mind, were ruggedly honest, their profession untarnished by commercialism. President William Howard Taft had described baseball as 'a clean, straight game,' but many Americans ranked respect for baseball with respect for religion and motherhood."

Sports historian Daniel A. Nathan writes, "From the very beginning, the Black Sox scandal was constructed by the press as a labyrinthine story of deception, betrayal, and moral disorder. In the media's hands, it was a story that touched on issues at the heart of American culture."

SEE ALSO Blackjack (c. 1750).

Photo of Charles "Chick" Gandil of the Chicago White Sox baseball team (c. 1917). Gandil was one of the key leaders of the Black Sox conspiracy, and he was later permanently banned from organized baseball by the Commissioner of Baseball.

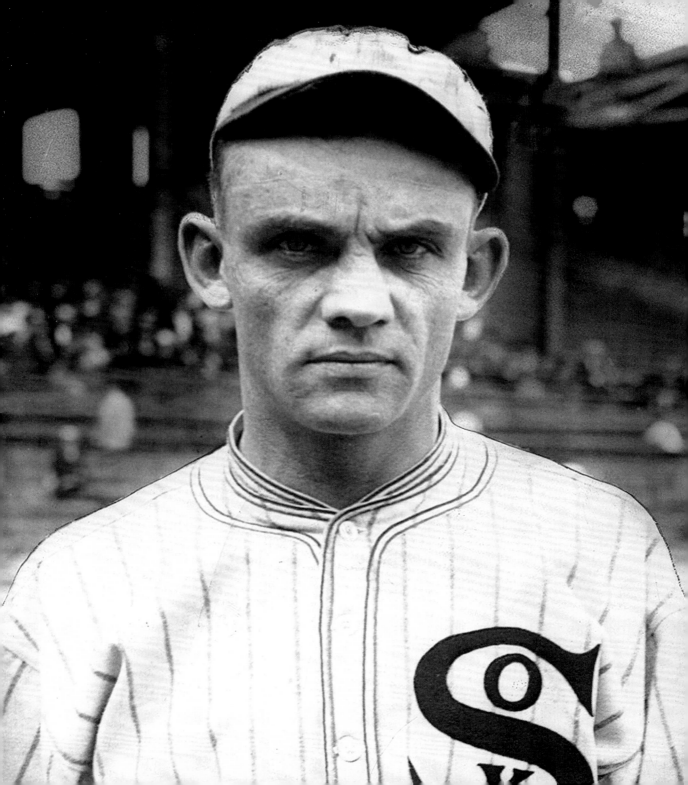

Black Market

Eric Schlosser (b. 1959)

"The workings of the Lord," writes journalist Eric Schlosser, are found "not in the pages of a holy book . . . but in the daily, mundane buying-and-selling of the marketplace. Each purchase might be driven by an individual desire, but behind them all lay 'the invisible hand' of the Divine . . . that represented the sum of all human wishes." Indeed, this free market has served to advance technology, improve agriculture, and provide entertainment. The same invisible hand has produced an invisible economy, or Black Market, with its own supply, demand, and prices—through transactions that are unreported, untaxed, and unlawful.

No one really knows how large this underground, multibillion-dollar enterprise is, which ranges from the paying for services in cash, so that the payment is unreported, to the selling of sex, narcotics, medicines, guns, exotic animals, rare fossils, babies, organs, nuclear materials, stolen merchandise, and bluefin tuna for sushi. A single horn from a black rhinoceros can sell for $30,000 on the black market—a huge sum in countries where per capita income can be less than $1,000 a year.

Perhaps the most famous, colorful, and violent Black Market in modern American history involved the illegal sale of alcohol during the Prohibition period between 1920 and 1933. According to Schlosser, during the height of this national Prohibition, Americans spent $5 billion in a single year on alcohol, which corresponded to 5 percent of the U.S. gross national product of the time. During the Second World War, rationing and price controls led to even larger Black Markets in which 20 percent of the meat sold was purchased illegally.

According to historian Roger Chickering, during World War I in Germany, "rationing had merely driven the free market underground and colored it black. The prolongation of the conflict fed the black market to the point that it became far more than just a supplement . . . Germans were purchasing fully one-third of all food on the black market by war's end."

SEE ALSO Black Tuesday (1929)

Some poachers kill black rhinoceros for their horns, which are sold on the black market for East Asian traditional medicines and other purposes. The price of the horns rivals the price of gold.

Black Tuesday

"Something happened to America in the 1920s and throughout the '30s," writes journalist Eric Burns, "that no one who lived through it would ever forget . . . Even the children of victims would bear scars, and the children's children's children would hear tales that they could scarcely believe were true in a land of plenty like the United States."

October 29, 1929, or "Black Tuesday," is infamous for marking the worst day for the U.S. stock market in terms of long-term effects. In all, 16.4 million shares were traded, and lives were shattered. Several days of financial plummeting led to this dark day; for example, a day earlier, the stock market had suffered a record one-day loss of 13 percent. The October 29, 1929 edition of the *Seattle Times* wrote about Black Tuesday: "A veritable bedlam of activity reigned in leading stock brokerage houses . . . as the greatest avalanche of security selling known to history was launched on New York exchanges. Executives and clerks [worked constantly], and with little respite gained by the Saturday afternoon and Sunday intermission, breasted the great tide of buying and selling orders with philosophical resignation."

For historians, Black Tuesday often denotes the moment at which the jubilant Roaring Twenties ended and the Great Depression began. Banks failed, and people lost their jobs, savings, and dreams. Burns writes that in 1932 alone, "at least 25,000 families, no longer having a place to call their own, were drifting from one town to another, begging for food . . ." The market did not return to pre-1929 levels until 1954.

Directly preceding the stock-market crash was a period of exuberant financial speculation in which many Americans borrowed money to invest in the stock market. However, toward the end of October 1929, the market finally began to decline, and investors panicked and started selling. Some likened the economy to a house of cards that collapsed when people suddenly saw stock prices falling after a steady period of financial gain—and they wanted out of the market, no matter what the cost.

SEE ALSO Black Market (1920)

The economic and social repercussions of Black Tuesday continued to be felt during the Great Depression that followed. Shown here are job seekers at an employment agency on Sixth Avenue in New York City, photographed in 1937 by Arthur Rothstein (1915–1985).

"The Whisperer in the Darkness"

Howard Phillips Lovecraft (1890–1937)

H. P. Lovecraft's short story "The Whisperer in the Darkness," published in 1931, owns a special place in *The Book of Black* due not only to its dark themes, but also to the numerous references to blackness and darkness within the text itself.

Albert Wilmarth, the narrator of the story, is initially a skeptic when he hears reports of strange things seen floating in the rivers of Vermont. He soon comes to learn of the existence of extraterrestrials that have established a base in the Vermont hills. When he visits a man named Akeley, who claims to have photos of the creatures, Wilmarth finds Akeley immobilized in a chair. Slowly, Wilmarth realizes that the man with whom he had been talking was an alien who had somehow found a way to use Akeley's face and hands as a disguise. The story concludes:

> The three things were damnably clever constructions of their kind, and were furnished with ingenious metallic clamps to attach them to organic developments of which I dare not form any conjecture. I hope—devoutly hope—that they were the waxen products of a master artist, despite what my inmost fears tell me. Great God! That whisperer in darkness with its morbid odour and vibrations! . . . The things in the chair, perfect to the last, subtle detail . . . were the face and hands of Henry Wentworth Akeley.

The story overflows with blackness. We hear of "black truths," "gaping blackness," and a "dark world of fungoid gardens and windowless cities." There are "dark hints of strange, small, and terrible hidden races of troglodytes and burrowers." Light hurts the creatures because light "does not exist at all in the black cosmos outside time and space where they came from originally." And the reader shivers at the "black rivers of pitch that flow under those mysterious cyclopean bridges—things built by some elder race extinct and forgotten before the beings came to Yuggoth from the ultimate voids."

SEE ALSO Byron's "Darkness" (1816), Browning's Dark Tower (1855), Conrad's *Heart of Darkness* (1902), Black Lightning (1956), Black Triangles (1997)

In "The Whisperer in the Darkness," beings can surgically remove a human brain and place it in a canister for space travel. "For the winged fungus-beings, to carry the brain-cylinders intact through space was an easy matter."

Dark Matter

Fritz Zwicky (1898–1974), **Vera Cooper Rubin** (b. 1928)

"A glorious cosmic census [shows that] the stars and galaxies that we can see are only a tiny fraction of all the matter that exists in the Universe," writes astrophysicist Evalyn Gates. "The rest is invisible to our telescopes, composed of new kinds of particles called *dark matter* that are far more exotic than anything we have ever seen or created in even our most sophisticated laboratories." Whatever the composition of dark matter is, it does not emit or reflect sufficient light or other forms of electromagnetic radiation to be observed directly. Scientists observe its existence from its gravitational effects on visible matter, such as the rotational speeds of galaxies.

Most of the dark matter probably does not consist of the standard elementary particles—such as protons, neutrons, electrons, and known neutrinos—but rather hypothetical constituents with exotic-sounding names such as sterile neutrinos, axions, and WIMPs (Weakly Interacting Massive Particles, including neutralinos), which do not interact with electromagnetism and thus cannot be easily detected. The hypothetical neutralinos are similar to neutrinos, but heavier and slower. Theorists also consider the wild possibility that dark matter includes gravitons, hypothetical particles that transmit gravity, leaking into our universe from neighboring universes. If our universe is on a membrane "floating" within a higher dimensional space, dark matter might be explained by ordinary stars and galaxies on nearby membrane sheets.

In 1933, the astronomer Fritz Zwicky provided evidence for the existence of dark matter through his studies of the motions of the edges of galaxies, which suggested a significant amount of galactic mass was undetectable. In the late 1960s, astronomer Vera Rubin showed that most stars in spiral galaxies orbit at approximately the same speed, which implied the existence of dark matter beyond the locations of stars in the galaxies.

Dark matter may have lit up the first stars in our universe. Astrophysical models suggest that dark matter particles might have interacted to produce huge amounts of heat to form so-called "dark stars," which also produce significant quantities of radiation.

SEE ALSO Black Diamonds (c. 3 billion BC), Black Drop Effect (1761), Black Eye Galaxy Discovery (1779), Black Holes (1783), Dark Energy (1998).

Artistic map of dark-matter distribution in the universe, created from Hubble Space Telescope data. Distance from the Earth increases from top to bottom. The more recent universe, represented at top, appears to show clumping of dark matter.

Black Velvet Paintings

Edgar William Leeteg (1904–1953)

"Velvet paintings have a bad name, and most of them deserve it," writes journalist Kristian Kofoed. "Crude, mass-produced pictures of Elvis, JFK, and dogs playing pool are the norm. But velvet is a difficult medium to work with, and Edgar William Leeteg had a facility with it that approached genius." Painting on velvet requires a special touch, and Leeteg's thin, light strokes, along with a limited palette of only six or seven colors and white, allowed him to create works that seemed to glow when properly illuminated.

Leeteg, an American painter, rendered his most impressive works between 1933 and 1953, when he was killed in a motorcycle accident. His paintings often featured Tahitian women. Leeteg received fame and fortune after a chance meeting with Honolulu art gallery owner Bernard Davis, who became his most ardent supporter. To increase the hype around Leeteg and boost sales, Davis had the painter sign each artwork with "Leeteg of Tahiti," and referred to Leeteg as "America's Gauguin."

Although Leeteg gave black velvet painting a kick-start in 1930s America while he was in Tahiti, journalists Martin Smith and Patrick Kiger note that, "The Chinese used the plush fabric as an art medium as far back as the 1200s, and a century later Marco Polo saw black velvet paintings in India." In the 1960s, "production of black velvet art already had shifted from Tahiti to Mexico" when Texas businessman Doyle Harden began buying truckloads of velvet and sent the velvet to Juárez, Mexico, "a city that became to black velvet what Florence was to the Renaissance." Harden's large factory employed Mexican artists who were paid a few dollars per painting. Sometimes an individual artist would work on a portion of each painting, allowing for efficient mass production of black velvet paintings that could still be considered as handmade. Favorite subjects for the Juárez-based art included unicorns, Jesus Christ, tigers, Native Americans, and Elvis Presley. Today, a genuine Leeteg can be worth over $15,000.

SEE ALSO Goya's Black Paintings (1819), Black Light (1903), Reinhardt's Black Paintings (1953), Black Admiral Restoration (2006)

Black velvet paintings frequently have "kitsch" themes. Shown here is The Widow *(c. 1875), a funny and popular mass-produced rendering by American painter Frederick Dielman (1847–1935). This version was later altered to provide a dark velvet-like background.*

Black Mold

August Carl Joseph Corda (1809–1849)

"During their lengthy history," writes botanist Nicholas P. Money, "black molds and other fungi have perfected a method for transforming dense plant tissues into syrup, [enabling] them to thrive on plant products inside homes, including wallpaper, paper-wrapped drywall, and particle board . . . When we add the astonishing spore-producing potential of the molds to this picture of biochemical virtuosity, it is evident that we are in conflict with an invincible group of organisms." Although people strive to combat mold damage in their homes, fungi do play a beneficial ecological role, along with bacteria, to decompose organic matter, thereby recycling nutrients in complex food webs.

One of the most infamous species of black molds, *Stachybotrys chartarum*, sometimes referred to as "toxic black mold," is often associated with fungal growth within moist buildings. This mold can produce various poisons called mycotoxins that sometimes lead to fatigue and fever, and if an individual is particularly sensitive, then vomiting and bleeding in the lungs is a possible response. Some black mold toxins inhibit protein synthesis, while others are immunosuppressive agents.

Stachybotrys chartarum was first characterized by the Czech mycologist (fungus expert) August Carl Joseph Corda after observations of a house wall in Prague in 1937. Before becoming one of the world's leading mycologists, Corda practiced surgery at the General Hospital in Prague. In 1938, Russian scientists determined that a certain disease of horses—which caused a decrease in leukocytes, hemorrhaging, and death—was associated with *S. chartarum* that grew on straw and grain that the horses ate.

In recent years, numerous news reports have appeared about toxic molds and so-called "sick buildings." Black molds have resulted in substantial damage and multimillion-dollar litigations involving homeowners, building managers, builders, and insurers. In some cases, insurance companies have paid out large amounts of money to have houses nearly rebuilt in order to remove the black mold. Many lawsuits continue, even in cases for which the clinical relationship between the mold and an occupant's illnesses may be uncertain.

SEE ALSO Black Fly (c. 200 million BC), Black Death (c. 1340), Death by Blackdamp (1862)

One of the most infamous species of black molds, Stachybotrys chartarum, *sometimes referred to as "toxic black mold," is often associated with fungal growth within moist buildings. This mold can produce various poisons called mycotoxins.*

The Black Sun

Heinrich Luitpold Himmler (1900–1945)

The Black Sun (*Schwarze Sonne* in German) is a Nazi emblem that may be constructed by placing three swastikas atop one another and rotating them with respect to one another. The symbol plays a role both in Germanic mysticism and in modern Neo-Nazism, and can be found in the design of a floor mosaic at the Wewelsburg Castle in Germany (built in 1603), which Nazi politician Heinrich Himmler intended to make the "world center" for the Nazi Party. The mosaic is located in a ground-floor room in the Obergruppenführer Hall, which was under construction during the years 1939 to 1943. Writer and educator Jennifer Emick notes that Himmler's symbol comes from an old Aryan emblem and was meant to be suggestive of the Round Table of Arthurian legends. Spokes of the Black Sun may have represented the most important officers of the SS—officers referred to as the "Obergruppenführer."

According to Emick, the Black Sun "and its attendant mythology has fueled a number of bizarre conspiracy theories involving UFOs, secret societies, and the hollow earth . . . The Wewelsburg sun should not be confused with the alchemical black sun, . . . a symbol of hidden spiritual potential."

Today, we do not know for sure whether the Black Sun was placed in the marble floor of Wewelsburg Castle before or after Himmler took charge of the castle, but many scholars suggest that it was placed there during Himmler's time because we know that the stone ceilings of the room were created during the Third Reich. Equally mysterious is the origin of the name Black Sun for the symbol. Professor Nicholas Goodrick-Clarke suggests that it may have come from "a series of cryptic religious revelations written for Himmler in the 1930s" that described a now-extinct star, a second sun that "shone 230,000 years ago upon the Hyperboreans in the North Pole and prompted their spiritual development."

SEE ALSO Black Dragon Society (1901), Blackshirts (1919)

The Black Sun is constructed by placing three swastikas atop one another and rotating them. The symbol plays a role in Germanic mysticism and is found in a floor mosaic at the Wewelsburg Castle in Germany.

Black Dahlia

Elizabeth Short (1924–1947)

"When the nude body of curvy, movie-struck Elizabeth 'Beth' Short was found, [completely] severed at the waist, in a weed-strewn lot on Jan. 15, 1947," writes journalist Joseph McNamara, "it spawned one of the great manhunts in the history of Los Angeles. The gruesome slaying of the raven-haired beauty, nicknamed the Black Dahlia, touched a romantic nerve in postwar America, launched a flood of headlines nationwide, and called forth a procession of weirdoes and publicity nuts." Other aspects of her body, organ, and facial disfiguration and torture are too gruesome to mention in this book.

The still-unsolved murder of the 22-year-old aspiring actress eventually became the inspiration for books and movies. The murder investigation was the largest in decades for the Los Angeles Police Department and involved the interviews of thousands of people. Roughly sixty people confessed to the murder. According to various sources, Short's nickname comes from either her fondness for wearing sleek black clothing and her long black hair, and/or the name was inspired by the 1946 film noir hit *The Blue Dahlia*, the screenplay for which was written by the famous mystery writer Raymond Chandler.

Public outrage grew as the police attempted to force confessions from two of her last acquaintances; however, both passed polygraph tests, had alibis, and were obviously innocent. Despite early accusations that Short was promiscuous, this is unlikely, as her autopsy showed that she had an abnormally developed vaginal area that made it difficult for her to have a normal sex life.

Writer Paul Hansom concludes, "While Short's killer was never found, her brutal mutilation and flighty life became an unspoken morality tale of the dangers surrounding Hollywood glitz and glamour. The sultriness, mystery, and utter ambiguity surrounding the Black Dahlia was woven into the mesh of Los Angeles myth, becoming alternatively a symbol of innocence corrupted, a confirmation of the existence of predatory maniacs, and proof of police ineffectiveness."

SEE ALSO Dark Tourism (1996)

A 1943 police photo of Elizabeth Short, the "Black Dahlia," taken for underage drinking in Santa Barbara, California.

Blacklist

Dalton Trumbo (1905–1976), **Otto Ludwig Preminger** (1906–1986), **Patricia Bosworth** (b. 1933)

The term "blacklist" often refers to a list of people who are to be denied a particular consideration or privilege, such as access to certain jobs. One of the most famous examples is the Hollywood Blacklist of 1947 that resulted from investigations by the House Un-American Activities Committee (HUAC) into possible Communist influences on the American motion picture industry. One fear was that Communist sympathizers would plant propaganda in films. "Essentially, the blacklist was a conspiracy of silence," journalist Patricia Bosworth writes. "Explanations were never given, never asked for . . . Before the blacklist ended, it had spilled out into television, the universities, unions and the government. Hundreds of families were disrupted, careers were ruined, and many men and women took their lives. By the time the blacklist era was over, more than 15,000 people had been directly affected."

People whose reputations and careers were damaged by the blacklist include the "Hollywood Ten," most of them screenwriters. For example, writer Dalton Trumbo was prevented from openly working in Hollywood for over a decade after the Ten refused to give testimony to HUAC, believing that their party affiliation should be of no concern, given that Communist Party membership had never been illegal.

The number of blacklisted writers, directors, and actors grew, although a few blacklisted individuals were able to write for Hollywood using the names of friends who pretended to be the actual writers. The blacklist started to lose meaning in 1960 when Trumbo was acknowledged as the screenwriter of the 1960 film *Spartacus* and when director Otto Preminger announced that Trumbo was the screenwriter of his forthcoming film *Exodus*. Since 1947, Trumbo had actually written numerous screenplays for movies but without credit.

According to author Dan Georgakas, "Liberalism, not Communism, may, in fact, have been the true target of the HUAC investigators. The Right wished to discourage any Hollywood impulse to make films advocating social change at home or critical of foreign policy. The task of intimidation was focused on the role Communists played as screenwriters."

SEE ALSO Blackmail (1601)

Los Angeles Times photo from December 11, 1947, showing nine of the Hollywood Ten. Starting from the left, the following people were charged with contempt of Congress: Robert Adrian Scott, Edward Dmytryk, Samuel Ornitz, Lester Cole, Herbert Biberman, Albert Maltz, Alvah Bessie, John Howard Lawson and Ring Lardner Jr.

Men in Black Conspiracy

Lowell Cunningham (b. 1959)

Author Stephen Spignesi writes that the Men in Black (MIB) are "mysterious men in black suits and sunglasses who may or may not be aliens, and who usually show up unbidden to 'interview' people who have had a UFO sighting or abduction experience." Conspiracy theorists sometimes suggest that MIB are government agents who do not want people to know about alien encounters or who intentionally dress strangely in an attempt to ensure that UFO witnesses are not taken seriously when reporting UFO encounters to the press.

In 1947, seaman Harold Dahl gave the first official account of his encounter with MIB, whom he said visited him a day after he had seen a UFO discharging a mysterious material into the ocean off the coast of Washington. According to Spignesi, Dahl's story was later revealed to be a likely hoax, but conspiracy theorists continued to believe in the MIB.

In 1953, Connecticut resident Albert Bender, who ran an International Flying Saucer Bureau, claimed that he was visited by three MIB after he talked too much about his UFO theories. Bender did give an interview to a local paper, saying that he was "scared to death" after the MIB ordered him to stop publishing articles about flying saucers. This "Bender Mystery" is taken to be the official start of the Men in Black legend. According to subsequent stories, the MIB tend to drive older model cars, usually Cadillacs, Lincolns, or Buicks. Bender wrote in his 1962 book *Flying Saucers and the Three Men* that the MIB "looked like clergymen, but wore hats similar to Homburg style." Other subsequent accounts discuss MIB intimidating reporters in order to persuade them to stop writing articles on either UFOs or the MIB themselves.

All of this speculation about the MIB led to the 1997 science-fiction movie *Men in Black*, starring Tommy Lee Jones, Will Smith, and Vincent D'Onofrio. The movie, based on a comic book series by Lowell Cunningham, was a huge hit, grossing over $580 million worldwide.

SEE ALSO Black Volga Legend (c. 1970)

In popular culture, Men in Black are mysterious men in black suits who are possibly aliens. They interview people who have seen UFOs or have encountered aliens.

Reinhardt's Black Paintings

Adolph Dietrich Friedrich Reinhardt ("Ad" Reinhardt) (1913–1967),
Robert Rauschenberg (b. Milton Ernst Rauschenberg; 1925–2008),
Mark Rothko (b. Marcus Rothkowitz; 1903–1970), **Frank Stella** (b. 1936),
Mark C. Taylor (b. 1945)

Imagine that you are walking through an infinite paint store, filled with every shade of paint that your eye can distinguish. If you could have only one can of paint with which to render your last painting, would you choose black? If so, you may enjoy the works of American artist Ad Reinhardt, who used black nearly exclusively from around 1953 until his death in 1967.

According to media expert Ben Highmore, Reinhardt achieved his special blackness by mixing oil paint with turpentine and a specific kind of glue. After viewers stare at the paintings for several seconds, colors sometimes seem to emerge out of the darkness. "And when the colors do emerge," writes Highmore, "they will have a dark luminosity that can literally pull you in, which resulted in damage being done to the paintings when oily noses touched the surface."

Philosopher and cultural critic Mark Taylor tells us that Reinhardt's Black Paintings are not uniformly colored, but that "each surface is created by the subtle interplay of different hues. Shades of deep reds, browns, blues and lavender mingle to produce a darkness." As one gazes at the canvas with its velvety, suede-like texture, "shifting patterns begin to form and withdraw." According to Taylor, startling forms such as the figure of a cross can materialize from the shades of darkness. "The question that remains is whether this is the space of resurrection or of crucifixion."

We should note that in the late 1940s, several famous artists—including Robert Rauschenberg, Ad Reinhardt, Mark Rothko, and Frank Stella—were all curious about the color black, which resulted in numerous, nearly monochromatic black paintings that today are parts of the most prestigious museum art collections. Author Stephanie Rosenthal writes, "Black Paintings mark . . . the end of painting as illusion, as a window onto the world, and the beginning of painting as the mode for the creation of self-sufficient perceptual objects—a change that granted new roles to both artist and viewer."

SEE ALSO Goya's Black Paintings (1819), Black Velvet Paintings (1933), Black Admiral Restoration (2006)

In the twentieth century, numerous artists were curious about the color black, which resulted in nearly monochromatic paintings, based on blackness, that today are included in the most prestigious museum art collections.

Black Lightning

Sir William Gerald Golding (1911–1993), **Terence Francis Eagleton** (b. 1943)

The frightening and powerful image of black lightning was made famous in William Golding's 1956 novel *Pincher Martin*, in which the protagonist is the only survivor of a torpedoed ship destroyer during the Second World War. Martin is shipwrecked on a remote rocky island and tries to survive by finding small water puddles and sea plants. During the climax of the book, he encounters a storm with black lightning. Terry Eagleton, Professor of English Literature, writes that if we have failed to be giving people in life, then we "will be trapped like . . . Pincher Martin in a hell which is the inability to die. By the end of Golding's novel, Martin has dwindled to a pair of huge, lobster-like claws tenaciously protecting his dark centre of selfhood from the 'black lightning' of God's ruthless mercy."

The reader comes to realize that Martin has actually died in our real universe early in the book, giving the reader a haunting, mystical shock when considering the possibility of persistence of consciousness after death, and of the tenuous nether regions that may exist somewhere between heaven and hell. According to author Philip Redpath, "black lightning is a manifestation of divine power and for God to be compassionate and merciless at the same time . . . Golding is obscure because words fail to render for him what the truth is behind divine justice and retribution. Paradox is the closest he can get to capturing the truth." Golding describes the black lightning as probing the claws and "wearing them away in a compassion that was timeless and without mercy."

In a radio interview, when Golding was asked to explain his mysterious ending, he replied, "To achieve salvation, individuality—the persona—must be destroyed. But suppose the man is nothing but greed? His original spirit . . . is hopelessly obscured by his thirst for separate individual life. What can he do at death but refuse to be destroyed [and] inhabit a world he invents from half-remembered scraps of physical life?"

SEE ALSO Outer Darkness (c. 80), Byron's "Darkness" (1816), Browning's Dark Tower (1855), Conrad's *Heart of Darkness* (1902), Black Light (1903), "The Whisperer in the Darkness" (1931), The Dark Side (1977), *Dark City* (1998)

A rendering of "black lightning," over Brasilia, Brazil, 2006. This artistic depiction was created simply by using the negative image of the original photograph.

Hoyle's Black Cloud

Sir Fred Hoyle FRS (1915–2001), Freeman John Dyson (b. 1923)

Physicist Freeman Dyson once noted that it takes about 10^6 years to evolve a new species, 10^7 years to evolve a genus, 10^8 years to evolve a class, 10^9 years to evolve a phylum, and less than 10^{10} years to evolve all the way from the primeval slime to *Homo sapiens*. If life continues in this fashion in the future, it is impossible to set any limit to the variety of physical forms that life may assume. What changes could occur in the next 10^{10} years to rival the changes of the past? Dyson keeps an open mind and believes it is possible that in another 10^{10} years, life could evolve away from flesh and blood and become embodied in other strange mediums, such as an interstellar black cloud, as presented in astrophysicist Fred Hoyle's 1957 science-fiction novel *The Black Cloud*. Dyson notes, "We cannot imagine in detail how such a cloud could maintain the state of dynamic equilibrium that we call life. But we also could not have imagined the architecture of a living cell of protoplasm if we had never seen one."

Hoyle's black cloud consists of molecules, organized into a living entity that heads directly for our Sun, seeking the energy of the Sun for nourishment. Unfortunately for Earthlings, the black cloud shields us from the light of the Sun, thereby freezing to death a quarter of the world's population.

Could a life form like the black cloud really exist? Hoyle's black cloud is vast and intelligent, containing a large amount of interstellar hydrogen. It has a complex central neurological system, consisting of patterns of molecular chains forming brains. The brains, in turn, are surrounded and interconnected by the cloud's electromagnetic flow and circulating gases that provide energy for the brains and waste removal. By condensing hydrogen in a small area of the cloud, and producing a fusion reaction, the cloud creates an explosive jet of gases, allowing the cloud to move through space.

SEE ALSO Black Mold (1937), Black Lightning (1956)

Composite of visible and near-infrared images of the dark cloud Barnard 68. The cloud is opaque at these wavelengths due to dust particles. With a radius of about 0.25 light-years, its mass is about twice the Sun's mass.

Dark Side of the Moon

Sir John Frederick William Herschel (1792–1871), **Howard Phillips Lovecraft** (1890–1937), **William Alison Anders** (b. 1933)

The creepy "moon-beasts" in the fiction of H. P. Lovecraft are described as living on the "dark side" of a faraway moon. As a boy, I read of these shape-changing "great greyish-white slippery" creatures and had always wondered what might reside on the far side of our own Moon.

Due to the particular gravitational forces between the Moon and the Earth, the Moon takes just as long to rotate around its own axis as it does to revolve around the Earth, so that same side always faces the Earth. The "dark side of the Moon" is the phrase commonly used for the far side of the Moon that can never be seen from Earth. It was not until 1959 that we had our first glimpse of the far side, when it was first photographed by the Soviet Luna 3 probe.

This far side is actually not always dark, and both the side that faces us and the far side receive similar amounts of sunlight. Curiously, the near and far sides have vastly different appearances. In particular, the side toward us contains many large "maria" (relatively smooth areas that looked like seas to ancient astronomers). In contrast, the far side has a blasted appearance with more craters. Perhaps increased volcanic activity existed around three billion years ago on the near side, which created the basaltic lavas of the mares. The far side crust may be thicker and thus was able to contain the interior molten material. Also, some scientists have suggested that the differences between the two hemispheres were caused by debris from a collision with a smaller second moon that may have once circled the Earth.

In 1968, humans finally gazed directly on the far side of the Moon during America's Apollo 8 mission. Astronaut William Anders, who traveled to the Moon, described the view: "The backside looks like a sand pile my kids have played in for some time. It's all beat up, no definition, just a lot of bumps and holes."

SEE ALSO Black Diamonds (c. 3 billion BC), Black Drop Effect (1761), Black Holes (1783), Dark Matter (1933), Dark Energy (1998)

In 1959, humanity had its first glimpse of the "dark side" of the Moon when the Moon was photographed by the Soviet Luna 3 probe. In this more recent image, highest elevations, above 20,000 feet, are in red and the lowest areas in blue.

"Baby's in Black"

Sir James Paul McCartney (b. 1942), **John Winston Lennon** (1940–1980), **Stuart Fergusson Victor Sutcliffe** (1940–1962), **Astrid Kirchherr** (b. 1938), **Barry Miles** (b. 1943), **Richard Meltzer** (b. 1945), **Richie Unterberger** (b. 1962)

John Lennon and Paul McCartney of the Beatles co-wrote "Baby's in Black" and released the song in 1964. The song's lyrics may be about Astrid Kirchherr, who often dressed in black and was mourning the death of her fiancé, Stuart Sutcliffe. In 1962, Sutcliffe, the Beatles' first bass player, died of a brain hemorrhage in an ambulance with Kirchherr by his side.

Music critic Richard Meltzer writes, "Perhaps the most far-fetched of the interpretations of this song treats the girl as a nun waiting for Christ's second coming. And for the purposes of the song, even the inevitability or impossibility of the second coming of Christ is no more awesome an imposition upon man than the longings of a metaphoric widow."

To ensure that the rendition of the song captured some of the feeling of a live performance, Lennon and McCartney simultaneously sang their vocal parts through the same microphone during the recording, which features two simultaneous melodies, each one sung by Lennon or McCartney. In an interview, McCartney said, "John and I wanted to do something bluesy, a bit darker, more grown-up . . . as in mourning . . . Our favorite color was black, as well."

According to music historian Richie Unterberger, "The biggest hook of 'Baby's in Black' is its unusual guitar sound: a particularly dour low strangled George Harrison line with a twang that wavers on the final note like a telephone wire does after it's hit by a flying object. John Lennon and Paul McCartney's dual harmonies were rarely closer than they were throughout this tune, a love lament for a grieving girl that was perhaps more morose than any previous Beatles song."

Authors Barry Miles and Keith Badman describe the song as "one of the last genuine Lennon/McCartney collaborations—composed during a head-to-head session over acoustic guitars, the way they'd been doing since the late '50s . . . Numbers like this, which invested a little romantic difficulty with the importance of world crisis, gradually faded from The Beatles' repertoire over the next twelve months."

SEE ALSO "Paint It, Black" (1966), "Black Magic Woman" (1968), Black Sabbath (1969)

"Baby's in Black" may be about Astrid Kirchherr, who often dressed in black while mourning the death of the Beatles' first bass player. Other experts have creatively suggested the song involves a woman waiting for Christ's second coming.

Dark Shadows

R. Daniel Curtis (1927–2006)

"Housewives, who'd always been the core audience of soap operas, got caught up in *Dark Shadows*," writes media expert Craig Hamrick. "Hordes of young children ran home from school to watch the spooky soap opera too." Heroin and LSD freaks watched while high. "By the late '60s, *Dark Shadows* had evolved into a pop culture phenomenon."

Dark Shadows was a popular and haunting TV soap opera that originally aired on weekdays from 1966 to 1971. Dan Curtis, the show's creator, said that he was inspired by a nightmare he had in which a girl took a long train ride to a dark, isolated town where she visited a mansion and knocked on its forbidding door. His TV show featured a similar traveler, Victoria Winters, an orphaned governess who worked at a spooky Maine mansion called Collinwood. Along with its colorful human cast, the show also featured ghosts, vampires, zombies, and travel into the past and parallel worlds. In fact, only when vampire Barnabas Collins came to Collinwood did ratings for the show soar. Along with its supernatural story lines, the eerie music helped catapult viewer emotions into strange realms.

One of the show's story lines featured a "flashback" to the year 1795, and to a TV story line that lasted for five months. In order to motivate this temporal shift, Victoria Winters traveled back in time as a result of a séance, which allowed TV viewers to learn more about the origins of Barnabas's vampirism.

According to media expert Harry M. Benshoff, "The popularity of *Dark Shadows* must be set against the countercultural movements of the late 1960s: interest in alternative religions, altered states of consciousness, and paranormal phenomena such as witchcraft. *Dark Shadows* regularly explored those areas through its sympathetic supernatural creatures, while most of the true villains of the piece turned out to be stern patriarchs and hypocritical preachers."

SEE ALSO Black Magic (c. 80,000 BC), Black Mass (c. 100)

Collinwood Mansion is the spooky home featured in Dark Shadows, *constructed in the 1700s and replete with secret passages. (In reality, the exterior view of this fictional home showed Carey Mansion in Newport, Rhode Island.)*

"Paint It, Black"

Sir Michael Philip "Mick" Jagger (b. 1943), **Lewis Brian Hopkin Jones** (1942–1969), **Bill Wyman** (b. William George Perks, 1936), **Stanley Kubrick** (1928–1999)

The Rolling Stones' 1966 hit song "Paint It, Black," about a man mourning his dead girlfriend, is significant not only because it reached number-one status on both the United States and UK sales charts, but also because popular-music critics often rank the song among the greatest songs of all time. In fact, the conductor and composer Leonard Bernstein called "Paint It, Black" one of the greatest compositions of the twentieth century.

Guitarist Brian Jones contributed the song's haunting signature sitar theme. Vocalist Mick Jagger commented on the sitar: "'Paint It, Black' has that Turkish groove that was really out of nowhere and something to do with Brian helping the song move along by playing sitar, which gave the record a particular flavor."

Music historian Maury Dean describes the sense of mystery he feels when listening to "Paint It, Black," a song that "sinks into the Tartarean black quicksand of a vast spiritual wasteland. With the coal black darkness of the River Styx in the midst of some vast desert, Mick Jagger booms baritone with macho intensity. You hear the haunted echoes of Hieronymus Bosch's lost souls hanging over the Pit of Dante's *Inferno*. Mick Jagger paints one gloomy dark abyss of chaos and despair. Black. Ebony. Desolate."

A younger generation often associates the song with the Vietnam War because "Paint It, Black" is used for the music in several video games dealing with the war, in the ending credits of Stanley Kubrick's film *Full Metal Jacket*, and during the opening shots of the TV drama series *Tour of Duty*, which concerned the lives of Vietnam War soldiers. According to author James Hector, the original advertisements for the "Paint It, Black" song promised a "different kind of single," with associated promotional appearances featuring Brian Jones cradling a sitar. The song was "a bass-heavy lunge into gypsy-style exoticism, with [bass guitarist] Bill Wyman on his knees operating the bass pedals on a Hammond organ to great effect."

SEE ALSO "Baby's in Black" (1964), "Black Magic Woman" (1968), Black Sabbath (1969)

The dark emotions conjured by "Paint It, Black" have reminded some listeners of the gloomy abysses and the lost souls in Dante's Inferno. *A Gustave Doré illustration for the work is shown here. Doré (1832–1883) was a French artist and engraver.*

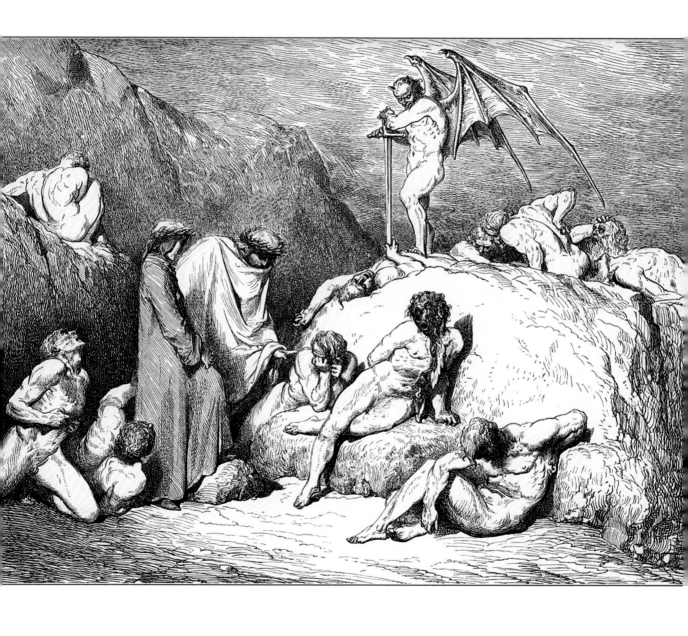

"Black Magic Woman"

Gábor Szabó (1936–1982), Peter Green (b. 1946), Carlos Augusto Alves Santana (b. 1947)

The song "Black Magic Woman" was written by British guitarist Peter Green and performed by Fleetwood Mac in 1968. Two years later, it skyrocketed to fame when rock guitarist Carlos Santana's rendition climbed to number four on the U.S. song charts. The song appeared on Santana's *Abraxas* album, which became number one on the U.S. music charts and achieved quadruple platinum status in 1986, partially due to this song's popularity.

Santana's version differs significantly from Fleetwood Mac's because of Santana's use of percussion instruments, including conga and timbales, to provide complex Latin rhythms. The song describes a woman who uses black magic in order to cast spells on a man and who is "trying to make a devil" out of him. Oddly enough, the song has special literal significance in the twenty-first century. For example, in the year 2000, a court sentenced a woman from the United Arab Emirates to four months in jail for casting a spell. The woman, angry with her ex-spouse for divorcing her, had hired a magician from a neighboring country to place a spell on her former husband. The husband soon came to believe that he was possessed by demons, sued his ex-wife, and won.

Santana's version, the full title of which is "Black Magic Woman/Gypsy Queen," also had musical themes from the 1967 song "Gypsy Queen," written by jazz guitarist Gábor Szabó. When Santana, the award-winning rock musician and guitarist, was asked about his inspiration for the song from other artists, he replied, "We all borrow from everybody; the beautiful thing is that there is room in the blues to get your own fingerprints . . . Your fingerprints are your tone and the way you phrase. That's what we encourage young people to do—learn from B.B. King, use your tape recorder, but after a while, put all that stuff away and just play by yourself in the dark."

SEE ALSO Black Magic (c. 80,000 BC), "Coal Black Rose" (1829), "Baby's in Black" (1964), "Paint It, Black" (1966), Black Sabbath (1969)

"Black Magic Woman" describes a woman who uses black magic in order to cast spells on a man and who is "trying to make a devil" out of him.

Black Sabbath

John Michael "Ozzy" Osbourne (b. 1948), Frank Anthony "Tony" Iommi (b. 1948)

"Formed in Birmingham, England, in the late 1960s," journalist Ian Christe writes, "Black Sabbath is the originator of heavy metal, the first loud guitar band to step outside time and explore the moody dimensions unique to the explosive new sound." Songs such as "War Pigs" included occult themes such as "witches at black masses" and "sorcerers of death's construction."

The band members first played together under the name of "Polka Turk" and changed their name in 1969 to "Black Sabbath" after learning of the popularity of the Boris Karloff horror film *Black Sabbath* and after the band's bass player read a book on the occult. One of the band's unique sounds came from the guitar technique of Tony Iommi, a technique that was influenced by an industrial accident in which he lost the tips of two fingers. According to radio show host Steve Taylor, Iommi wore prosthetic tips on his fingers that, along with loose, detuned strings, gave Iommi's work a distinctive sound. The strings vibrated more and for greater lengths of time than usual. Iommi also sometimes made use of a dissonant musical interval, or tritone, known to musical historians as "The Devil's Interval." Black Sabbath's 1968 personnel included Ozzy Osbourne (vocals), Tony Iommi (guitar), Terence "Geezer" Butler (bass), and Bill Ward (drums). *Paranoid* was the name of their 1971 quadruple-platinum album.

Radio host and author Steve Taylor writes that "Black Sabbath may well have killed the sixties. [They] discovered that guitar, bass, and drums could combine to produce a sound so dark and intense that it actually made listening an uneasy experience. Put that together with satanic and death-obsessed narratives . . . and you've got . . . a new development in popular music." According to Christe, Black Sabbath songs described reality "not in the flower patches of Donovan and Jefferson Airplane, but in the grim reality of battlefields and human ovens. Ozzy Osbourne delivered these lyrics as if in a trance, reading messages of truth written in the sky."

SEE ALSO Black Mass (c. 100), "Baby's in Black" (1964), "Paint It, Black" (1966), "Black Magic Woman" (1968)

The song "Black Sabbath" (1969), by the band of the same name, describes a dark Satan watching rising flames. The band's bassist, Geezer Butler, actually painted his apartment black, decorated it with depictions of Satan, and had a Satanic dream that inspired the song.

Black Volga Legend

Jan Harold Brunvand (b. 1933)

"Black Volga" refers to a Polish urban legend that was popular in the 1960s and 1970s and continues to this day. The legend typically involved a black Volga limousine, a Russian-made vehicle, with occupants who abducted children so that their body parts or blood could be used by rich Europeans suffering from diseases. In the 1960s, Volga cars were considered prestigious and were used by party officials and various security forces. Sometimes, the Volgas that were used for the alleged kidnappings had curtains over the windows.

The Black Volga story circulated so widely that it is known by virtually all Poles. Folklorist Jan Harold Brunvand writes that in one version of the legend "someone dressed as a priest or nun would supposedly lure small children into a black limousine by promising them candy. The unfortunate children were never seen alive again. Supposedly, the kidnappers drained the blood from their victims to sell abroad, and then disposed of the children's bodies in garbage cans."

The notion of mysterious black vehicles on the prowl for victims apparently has great allure. For example, the Czechs had a legend of Black Ambulance abductions, a legend that was so widespread that in the 1980s the Czechoslovakian press had to go to great lengths to quell the growing fears.

J. Michael Waller, a professor of International Communication, writes that the body parts myth was spurred "by advances in organ transplantation that made organ theft seem more plausible . . . Other advances in technology have led to similar urban legends [that] give a narrative story form to widespread hopes and fears, which is why they are believed." Waller goes on to tell of the legend of someone surviving the World Trade Center bombing by "surfing" a large piece of debris from the 80th floor to the ground. "This false report circulated, reflecting the hope that some of the people trapped high in the towers could have miraculously survived their collapse."

SEE ALSO Men in Black Conspiracy (1953)

According to legend, mysterious people in black Volga limousines abducted children so that their body parts or blood could be used by rich Europeans suffering from diseases.

Black Lion Tamarin Discovered

The black lion tamarin (BLT)—scientific name *Leontopithecus chrysopygus*—is an endangered "miniature monkey" so named because of its fine black mane of hair. According to the Durrell Wildlife Conservation Trust, BLTs "have brains as well as beauty—in proportion to their body size, they have more grey matter than humans!" Only three percent of the BLT's original habitat remains, consisting of small fragments of Brazilian forests that are too small to ensure the creatures' survival.

Conservation scientists Claudio and Suzana M. Padua write, "The black lion tamarin was considered extinct from the beginning of the twentieth century until 1971, when it was re-discovered by a Brazilian researcher, Adelmar Coimbra-Filho, in . . . São Paulo [Brazil]." During the 1970s and early 1980s, scientists determined that "only 100 individuals existed in the wild." Researchers have since found several hundred more. In order to avoid predators, the creatures almost never come down from the trees. Therefore, to help the species, conservationists have sometimes built bridges between clumps of trees that have become isolated as a result of forest clearing and road building in Brazil.

"Although they are no larger than house cats," writes wildlife expert Mary C. Pearl, "tamarins have brains that are surprisingly big for their size and a family life organized like our own . . . When a mother bears young, she usually produces twins, and . . . it is most often the father who carries them around in the trees, where the families feed on fruits, insects, lizards, and birds' eggs." At night, tamarin groups sleep together in a tangle of vines or in other safe spaces in the trees.

BLTs produce a variety of birdlike sounds, including whistles and clucks. They live for around ten years in the wild and sometimes more than double this when in captivity.

SEE ALSO Shooting of the Last Black Mamo (1907)

The black lion tamarin is an endangered "miniature monkey." The creature was considered extinct from the beginning of the twentieth century until 1971.

Black Smoker Discovery

Black smokers are portions of hydrothermal vents on the ocean floor that spew extremely hot water along with dissolved minerals including sulfides. When the hot minerals cool due to contact with the surrounding ocean, the minerals form black chimneys. The chimneys grow rapidly, up to 30 feet (9 meters) in 18 months. One behemoth chimney in the Pacific Ocean reached the height of a 15-story building!

Dudley Foster, the pilot of the undersea vehicle *Alvin*, described his 1977 discovery of black smokers as he suddenly felt the *Alvin* behaving strangely: "The water was much cloudier than usual. Then suddenly a tall chimney-like spire came into view; belching out its top was a dense black fluid resembling billowing clouds of smoke. It looked like a steel factory."

As Foster maneuvered the *Alvin* for a closer view, driving became difficult. An updraft from the black fluid pulled him toward the smoker. He lost visibility and suddenly collided with the chimney, knocking it over "like a giant fallen tree." Foster noticed that the chimney was hollow and lined with crystals. The next day, when the *Alvin* was cautiously driven to a black smoker, one of the observers said, "They seem connected to hell itself." The fluid was an incredible 662 °F (or 350 °C), "hot enough to melt lead, let alone our Plexiglas viewports [of the *Alvin*]."

Although sunlight does not penetrate to the depths of black smokers, the smokers are the center of amazing and complex ecosystems. The creatures that can survive under such extreme conditions of darkness and heat are called extremophiles, and they are able to obtain their energy from the ambient heat, methane, and sulfur compounds. Huge tubeworms on the sea floor feed on the tiny extremeophiles. Some of the bizarre bacteria near the smokers can actually convert the faint glow from the smoker into energy using photosynthesis. Some scientists suggest that life on Earth may have begun in extreme environments such as those near black smokers.

SEE ALSO Black Hills (c. 1.8 billion BC), Black Tusk (c. 1.2 million BC)

A vast collection of tube worms cover the base of this black smoker in the northeast Pacific Ocean. An acoustic hydrophone is positioned near the top of the mound.

The Dark Side

Sir Alec Guinness (1914–2000), George Walton Lucas Jr. (b. 1944)

"The Dark Side" refers to an aspect of the powerful force that plays a key role in the *Star Wars* universe of screenwriter George Lucas. The term was first mentioned in the 1977 film *Star Wars Episode IV: A New Hope*. This mysterious force allows certain evil, aggressive individuals, such as Darth Vader, to perform psychokinesis ("mind over matter") and other supernatural acts. Obi-Wan Kenobi, played by Alec Guinness, describes the Dark Side: "Vader was seduced by the Dark Side of the Force . . . The Force is what gives the Jedi his power. It's an energy field created by all living things. It surrounds us, it permeates us, it binds the galaxy together."

Professor of Anthropology Marcel Danesi notes that "the unifying theme of all the *Star Wars* episodes is the universal mythic struggle between evil (the Dark Side) and good (the Force) . . . Darth Vader stands out from the foot soldiers by dressing in black . . . He is leader, after all, of the Dark Side."

Educators and authors John Lawrence and Robert Jewett write that "the notion that the Light Side must battle against the Dark Side is a hoary artifact of European- and American-style crusades against evil." They note that *Star Wars* captivates religious people and quote from a *Christian Century* film review: "*Star Wars* strikes so many of us as a breath of fresh air not only because we need to believe that the good can triumph but because lately we have had such difficulty in identifying the good . . . from the evil . . . The alternative vision of *Star Wars* . . . strikes us with the force of stepping from the cave into bright sunlight."

John Lyden, Professor of Religion, claims that the real enemy in the *Star Wars* movies is ". . . the threat we pose to ourselves, that we may give in to our own 'dark side' by losing our human nature to greed and selfish desires for power. It is not coincidental, either, that this dark side is expressed by monstrous technological creations that represent massive human power without ethical boundaries."

SEE ALSO Byron's "Darkness" (1816), Browning's Dark Tower (1855), Conrad's *Heart of Darkness* (1902), "The Whisperer in the Darkness" (1931), *Dark City* (1998)

Boba Fett, a bounty hunter hired by Darth Vader to find the Millennium Falcon *spacecraft. This scene is actually from a parade at DragonCon 2006, a convention for fans of science fiction, fantasy, and comic books.*

Black Black

Shin Kyuk-Ho (b. 1922), **Jean-Claude Van Damme** (b. 1960)

Black Black is a famous brand of caffeinated chewing gum produced by the Lotte Company, which has its corporate headquarters in Seoul, South Korea and Tokyo, Japan. The company, founded by businessman Shin Kyuk-Ho, began selling chewing gum to children in postwar Japan. Today, the packaging of the gum touts its "Hi-Technical Excellent Taste."

Black Black has a dark charcoal color and has been offered to consumers since 1983. The product was popularized in Japan by TV commercials featuring Jean-Claude Van Damme, the well-known Belgian martial artist and movie actor. The gum also gained an exuberant following after *WIRED* magazine mentioned the gum in 2003. Ingredients include: sugar, starch syrup, grape sugar, erythritol (a sweetener), oolong tea extract, ginkgo extract, chrysanthemum flower extract, gum base, flavorings, coloring agents (cacao and gardenia), caffeine, and nicotinamide.

The U.S. Army has recently tested other caffeinated gums so that troops in the field can avoid fatigue, and such gums are now available through military supply channels. The gums tested contain 100 mg of caffeine, about the same amount found in a cup of coffee. The caffeine in caffeinated chewing gum is absorbed through the tissues in the mouth and can deliver caffeine to the body much faster than liquid or pill forms. The military tested gums with and without caffeine and demonstrated that alertness and marksmanship were maintained or improved using the caffeinated forms.

In the United States in the early 1900s, chewing gum was made from chicle, a tree gum imported from Mexico. Throughout the twentieth century, demand soared, and the difficulties in obtaining chicle encouraged the search for synthetic substitutes. According to social theorist Michael Redclift, "Most commercial chewing gums today are made of vinyl resins or microcrystalline waxes, similar to the vinyls used for the covers of golf balls."

SEE ALSO Black Pepper (1213 BC), Black Pudding (c. 700 BC), Blackbird Pie (1549), Black Forest Cake (1915)

Black Black is a famous brand of caffeinated chewing gum produced by the Lotte Company. The packaging of the gum touts its "Hi-Technical Excellent Taste."

LOTTE
BLACK BLACK
HI-TECHNICAL EXCELLENT TASTE AND FLAVOR
60th ANNIVERSARY
強力ミントで眠気スッキリ!
眠気スッキリ!!
9 GUM STICKS

Black Hole Antiterrorism

Terrorism involving computer networks is a growing concern. Historians Thomas Mockaitis and Paul Rich write, "With the West leading the world in information technologies and the Information Revolution sweeping large parts of the globe, the vulnerability of these states to cyber-based IO [information operations] . . . has increased markedly. Ironically, the more the world digitizes, the more vulnerable it becomes." Cyberterrorism not only has dramatic effects on financial and commercial transactions but it is also a concern for the military that increasingly relies on computer networks for communications and weapons-targeting systems. According to Steven Myers, if satellite networks stopped working, "the global economic system would probably collapse, along with air travel . . . Your cellphone wouldn't work. Nor would your A.T.M."

One form of cyberterrorism is the Denial-of-Service (DoS) attack, one of the most dreaded of computer network attacks. Computer-security experts Susan Young and Dave Aitel write that this attack is "successful against nearly every network-based device [and can] completely remove or stop a given network device from performing its intended task, essentially obliterating it from the network." In a *distributed* DoS attack, many different hostile computers are enlisted to attack a victim's computer or network with an overwhelming flood of malicious signals.

One way to combat DoS involves *black hole filtering* (BHF), for which the term *black hole* refers to a network location in which incoming traffic is silently discarded, as if dropped into a black hole. For example, an Internet service provider may direct information packets away from the Internet IP address of a server under attack. The sender of the information is not informed that the data has been cast into oblivion before it has reached its intended target. In some implementations, the black hole routing technique drops all packets coming from all sites on a black list, with little impact to the network performance of a router. According to security consultant Barry Greene, black hole filtering on a single network router has been used in the industry since the late 1980s.

SEE ALSO Black Holes (1783), Blackshirts (1919), Darknets (2002), Blackout (2003)

Creative depiction of black hole filtering *(BHF) in which incoming computer network traffic is "silently" discarded, as if dropped into a black hole.*

Dark Tourism

Dark tourism is a cultural phenomenon that is growing in popularity. Also called *black tourism*, this form of entertainment, remembrance, or education involves traveling to locations associated with suffering or death, such as the sites of assassinations or mass killings.

Stephanie Yuill, a dark-tourism expert, enumerates some of the more famous locations: "Today, numerous sites of death and disaster attract millions of visitors from all around the world: Auschwitz-Birkenau, Anne Frank's House, Graceland, Oklahoma City, Gettysburg, Vimy Ridge, the Somme, Arlington National Cemetery." The term *dark tourism* became popular after several researchers had applied labels to this phenomenon, including travel and tourism experts J. John Lennon and Malcolm Foley, who first used the term around 1996. Tony Seaton, Professor of Tourism Behavior, coined the term *thanatourism* in 2002, and tourism expert C. Rojek developed the concept of *black spots* (which includes the commercialization of grave sites) in 1993. Today, such sites as Ground Zero in New York City are popular destinations for visitors.

Of course, a fascination with calamity is nothing new, as evidenced by the popularity of public executions or tours of morgues in Victorian England. Lennon reminds us that "The Battle of Waterloo in 1815 was observed by nobility from a safe distance, and one of the earliest battlefields of the American Civil War (Manassas) was sold the next day as a visitor attraction site."

"How dark does real-world dark tourism get?" asks *New Scientist*. "Consider the James Dean fanatics who 're-enact' the actor's death each year at the place and time it happened, often driving cars similar to his, to experience his final moments for themselves. What they are seeking is anyone's guess." Lennon reminds us that black locations are important "testaments to the consistent failure of humanity to temper our worst excesses." If these sites are managed properly, we can "learn from the darkest elements of our past. But we have to guard against the voyeuristic and exploitative streak that is evident at so many of them."

SEE ALSO Black Museum (1875).

Dark tourism may include visits to cemeteries and other places associated with death. The grave markers, sense of the macabre, and emotional settings often increase the depth and memory of the experience.

Black Triangles

Paul Kurtz (1925–2012), **George Ralph Noory** (b. 1950), **George Knapp** (b. 1952)

Radio show host George Noory writes, "Night after night on my show 'Coast to Coast AM,' I take phone calls from people whose lives have been touched by the paranormal. People have seen and been transfixed by huge, slow-moving black triangles floating noiselessly overhead." Investigative reporter George Knapp notes that, "Eyewitnesses all over the country are reporting glimpses of something large, dark, and mysterious in the skies above big cities and busy highways. The crafts are often described as triangular, . . . and they've been seen here in southern Nevada. It looks like these mystery craft might be a secret military project, but if so, why are they flying around in the open?"

Black triangles are Unidentified Flying Objects (UFOs) that have been reported by hundreds of people through the decades. Some of the earliest reports started in the 1940s, but attention grew in the late 1990s and included reports from multiple witnesses of triangles in the skies of America, Europe, and Russia. The objects often have a light at each corner of the triangle. Many still remain mystified as to the origin of these UFOs.

If these are indeed secret, advanced aircraft being developed by air forces around the world, UFO buffs continue to wonder why there is no extreme attempt to hide them. In fact, the flashing lights and use near population centers almost seem to suggest a possible desire to be noticed. Perhaps the objects represent routine and open deployment of low-altitude surveillance platforms. More imaginative observers suggest that the black triangles carry extraterrestrials or beings from another dimension. Philosopher and skeptic Paul Kurz writes, "UFO mythology is similar to the message of the classical religions where God sends his Angels as emissaries who offer salvation to those who accept the faith and obey his Prophets. Today, the chariots of the gods are UFOs. What we are witnessing in the past half century is the spawning of a New Age religion."

SEE ALSO "The Whisperer in the Darkness" (1931), Dark Side of the Moon (1959), Lonely Black Sky (100 billion years AD)

This 1990 photo was once alleged to be of a black triangle observed in Wallonia, Belgium. Image processing is performed to reduce noise in the original image. Some triangle photos have been shown to be fakes.

Dark Energy

Michael S. Turner (b. 1949), **Saul Perlmutter** (b. 1959), **Brian P. Schmidt** (b. 1967), **Adam Guy Riess** (b. 1969)

The breathtaking discovery that the universe is expanding at a faster and faster rate, like a race car with its accelerator pedal stuck to the floor, led to the 2011 Nobel Prize in Physics for American-born astrophysicists Saul Perlmutter, Brian Schmidt, and Adam Riess. About five billion years ago, writes journalist Dennis Overbye, it was "as if God had turned on an antigravity machine . . . and galaxies began moving away from one another at an ever faster pace." The cause appears to be dark energy—a form of energy that may permeate all of space and that is coaxing the universe to accelerate its expansion.

In 1998, astrophysical observations of certain kinds of distant supernovae (exploding stars) showed they are receding from us at an accelerating rate, which was possible evidence for dark energy. In the same year, American cosmologist Michael Turner coined the term *dark energy*.

Imagine the shocking implications of dark energy. If the acceleration of the universe continues, galaxies outside our local supercluster of galaxies will no longer be visible, because their recessional velocity will be greater than the speed of light. Perhaps dark energy will eventually exterminate the universe in a "Big Rip" as matter is torn apart. However, even before the Big Rip, the universe will become a lonely place. Astrophysicist Neil deGrasse Tyson writes, "Dark energy . . . will, in the end, undermine the ability of later generations to comprehend their universe." Through their observations, "future astrophysicists will know nothing of external galaxies . . . Dark energy will deny them access to entire chapters from the book of the universe . . . [Today] are we, too, missing some basic pieces of the universe that once was, [thus] leaving us groping for answers we may never find?"

Perlmutter stated at his Nobel acceptance speech, "We mortal, limited humans joining together in teams . . . become capable of just glimpsing one additional bit of how the universe works. It is exhilarating."

SEE ALSO Black Diamonds (c. 3 billion BC), Black Drop Effect (1761), Black Eye Galaxy Discovery (1779), Black Holes (1783), Dark Matter (1933), Lonely Black Sky (100 billion years AD)

Dark energy may control the fate of our universe and eventually cause matter (in forms ranging from atoms to planets and stars) to be torn apart.

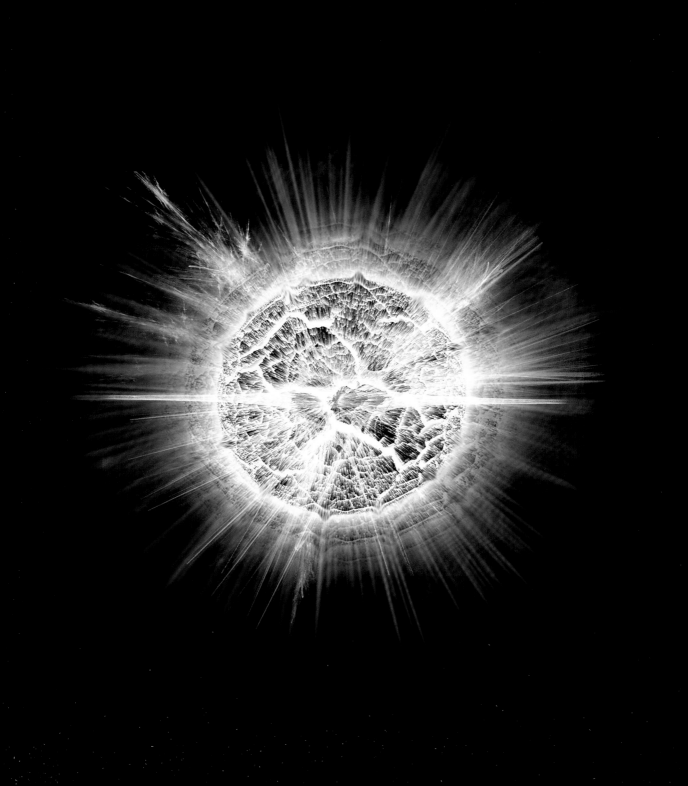

Dark City

Alex Proyas (b. 1963), **Roger Joseph Ebert** (1942–2013)

"*Dark City* by [film director] Alex Proyas is a great visionary achievement," writes film critic Roger Ebert, "a film so original and exciting, it stirred my imagination like *Metropolis* and *2001: A Space Odyssey* . . . Not a story so much as an experience, it is a triumph of art direction, set design, cinematography, special effects—and imagination."

Although *Dark City* was named the best film of 1998 by Ebert—and winner of the 1998 Bram Stoker Award for Best Screenplay and 1999 Saturn Award for Best Science Fiction Film—many ordinary movie watchers in America seem to have never heard of the film! Nevertheless, the movie is beginning to develop a large cult following.

Dark City begins with the protagonist, John Murdoch, waking in a hotel room with no memory. He soon comes to realize that his city is not what it appears to be and that space, time, and memories are shifting in mysterious ways. For example, the darkly atmospheric city appears to exist in a perpetual night—making it an ideal entry for *The Book of Black*. Murdoch's labyrinthine quest is to understand the nature of the city and the strangers that seem to run it.

Media experts Kurt Lancaster and Thomas Mikotowicz write that *Dark City* is "profound in its confrontation with universal issues . . . Who are we? Where do we come from? Are we the only beings in the universe? Who is in control of this universe? . . . The story operates on the premise that memory is what makes us human, because so much of our memory is connected to emotion." However, in the movie, memory is twisted and morphed as spooky beings experiment with the very fabric of reality and as Murdoch journeys in a shattering odyssey of self-discovery. Ebert remarks that *Dark City* "has been created and imagined as a new visual place for us to inhabit. It adds treasure to our notions of what can be imagined."

SEE ALSO Byron's "Darkness" (1816), Browning's Dark Tower (1855), Conrad's *Heart of Darkness* (1902), Black Light (1903), "The Whisperer in the Darkness" (1931), Black Lightning (1956), The Dark Side (1977).

Dark City begins with John Murdoch waking in a hotel with no memory. Fragments of memories slowly fall into place, like pieces of a puzzle, and he soon comes to realize that his city and entire reality are redolent with mystery.

2002

Darknets

The growing popularity of darknets for the illegal exchange of digital information is reminiscent of trafficking in drugs. As just one example, in 1985, the U.S. State Department said that the Peruvian government had destroyed 7,500 acres of coca plants used to make cocaine, but that narcotic trafficking was nonetheless flourishing. In 2005, Peru destroyed 25,000 acres of coca, but coca cultivation continued to rise. The first year after the United States overthrew the Taliban, opium poppy production doubled. In 2004, opium production tripled.

Similar kinds of characteristics and concerns involve darknets, private computer networks in which users often connect only to people they trust to exchange both legal and illegal digital content. In some sense, one might think of darknets as networks cordoned-off from the more traditional networks so they can avoid being monitored by others. However, darknets are not separate *physical* networks; rather, they make use of special applications that use traditional networks. Organizations such as the Recording Industry Association of America (or RIAA) and universities are concerned with the illegal distribution of copyrighted music through darknets that operate in a so-called peer-to-peer framework. These kinds of darknets require no centralized scheme or computer for managing the flow of content. Pedophiles often use darknets to distribute images of naked children.

Of course, darknets can serve many lofty or legitimate purposes, including business use or sharing of scientific data, and individuals in countries with repressive regimes find them useful to exchange information, or simply chat, in a private or anonymous fashion. The term was originally coined in the 1970s when referring to secure networks that were isolated from ARPANET, a network of the United States Department of Defense. The use of the word *darknet* took on renewed interest and greater significance following the publication of a 2002 article "The Darknet and the Future of Content Distribution" that discussed the challenges of protecting copyrighted materials given the prevalence of darknets.

SEE ALSO Black Hole Antiterrorism (c. 1987)

Darknets sometimes make use of "onion routing" for anonymous communication over a computer network. Reminiscent of the successive layers of an onion, messages are repeatedly encrypted. Shown here is a diagram from US Patent No. 6266704 (1998) for onion routing.

Blackout

"August 14, 2003, began as a rather ordinary summer day," writes energy expert Richard Munson. "The Midwest and Northeast were hot but not that hot . . . Yet the electricity-delivery system was uncoordinated and stressed, and by late that afternoon a series of rather small problems cascaded into a massive blackout that left 50 million people without power and would cost an estimated $10 billion."

The electrical blackout of 2003 was the largest blackout in North American history and affected parts of the Northeastern and Midwestern United States, as well as Ontario, Canada. During the blackout, more than seven hundred generating units and power plants shut down, twenty-two of which were nuclear power plants.

Although many wired and cell phone systems continued to work, the increased amount of phone calls overloaded many circuits. Many railroad and airplane transportation systems were shut down. Some water systems lost pressure without active pumping systems, which led to concerns about possible water contamination.

As with many events in history, seemingly small actions can lead to dramatic and unpredicted consequences. The primary cause of the blackout was the failure of FirstEnergy, an Ohio-based energy company, to trim certain trees. At precisely 2:02 p.m., one of their power lines made contact with a tree in Walton Hills, Ohio. This contact was followed by several others. When high-voltage power lines come into contact with trees, power control systems may disconnect these lines when they detect a short circuit. A second cause was a computer software bug in the computer systems of FirstEnergy that prevented operators from seeing certain alarms, and thus the operators did not take appropriate action or warn other control centers in a timely manner.

"Desperate for electricity," Munson continues, "northern Ohio tried to pull from Michigan a massive 2,000 megawatts of power, the equivalent of three larger generating plants. Michigan could not supply the load on short notice . . ." In seconds, other East Coast generators went offline to protect themselves. The electrical grid could not stabilize, and a cascading blackout eventually occurred at 4:11 p.m.

SEE ALSO Black Hole Antiterrorism (c. 1987), Darknets (2002), Black Swan Theory (2007)

The India blackout of July 2012 was the world's largest power failure. Shown here is a composite satellite image of India from 1992–2003 (2003, red; 1998, green; 1992, blue). For example, red indicates regions that only appeared in 2003. White represents nighttime illumination present through the entire period.

Black Admiral Restoration

Rembrandt Harmenszoon van Rijn (1606–1669)

The authenticity of paintings has long been a concern of art connoisseurs. As just one example, paintings by students of the Dutch artist Rembrandt have often been sold by unscrupulous art dealers as actual Rembrandt paintings. Journalist Bijal P. Trivedi notes, "Today there is at least an order of magnitude difference in price between a Rembrandt and a creation by one of his pupils."

Although not nearly the value of a Rembrandt, but perhaps just as historically significant, a 1700s painting called the "Black Admiral" has grown in popularity. This best-known portrait of a black mariner in a U.S. naval uniform from the Revolutionary War era has been featured in history books such as historian Gary Nash's *The Unknown American Revolution*, which notes that "the seagoing African American was not at all uncommon" and then describes the painting as depicting a "black sailor [who] very likely served on a privateer that took many enemy prizes, because only his share of the prize money would have allowed him to dress in such finery."

When the "Black Admiral" was about to be featured in a museum in an exhibit on the theme "Fighting for Freedom: Black Patriots and Loyalists," Peter Williams, an art conservator, began a restoration and cleanup of the painting and discovered that the sailor in the original painting was actually white, but had been painted over, probably in the 1970s.

Although this detection of fraud was rather easy to determine, by removing some of the black paint with solvent, painting frauds can often be quite difficult to discover. Legal expert Ronald D. Spencer notes that even as "demand for opinions on the authenticity of art is increasing, fewer experts are willing to render these opinions for fear of being sued by a seller, buyer, or owner . . . An art scholar authenticating a work may not ethically charge a fee related to the value of the art. For a $500 fee, why should the expert risk a million-dollar lawsuit for product disparagement or negligence?"

SEE ALSO "Black is Beautiful" (1858), Black Velvet Paintings (1933), Reinhardt's Black Paintings (1953)

The Black Admiral, *the best-known apparent portrait of a black mariner in a U.S. naval uniform from the Revolutionary War era, has been featured in history books. In 2006, while being restored, the famous painting was discovered to be fraudulent.*

Black Swan Theory

Nassim Nicholas Taleb (b. 1960)

Black Swan Theory (BST), promoted by mathematical finance expert Nassim Taleb, revolves around high-impact, unpredictable, and rare events that shape our world, from the rise of religions to the everyday decisions we make that alter our lives. Taleb writes that "life is a cumulative effect of a handful of significant shocks" that makes it impossible to predict the course of history. The term *BST* comes from the early Western notion that all swans were white. In the seventeenth century, when the West finally discovered black swans in Australia, this reinforced the importance of considering unexpected events. Taleb's theory and book on the subject are notable in integrating various material and examples, and demonstrating how these ideas are related to the black swan.

Some aspects of BST remind me of chaos theory, which teaches us that our slightest actions can cause reality to change in profound ways. This "butterfly effect" suggests the flapping of the wings of a Monarch butterfly in New Jersey can change the weather in Asia a few weeks later—and maybe even cause the downing of a power line, the fall of a repressive regime, and the blossoming of peace. If Cleopatra had had an ugly but benign skin growth on her nose, caused by a mutation of a single skin cell, the entire cascade of historical events could have been different. Obviously, history is contingent on the tiniest of forces.

Of course, BST has differences with chaos theory in that BST is concerned more with profoundly anomalous occurrences, whereas chaos theory reminds us that tiny, ordinary events can have striking consequences. Taleb writes, "How would an understanding of the world on June 27, 1914, have helped anyone guess what was to happen next? The rise of Hitler, the demise of the Soviet bloc, the spread of Islamic fundamentalism, the Internet bubble: not only were these events unpredictable, but anyone who correctly forecast any of them would have been deemed a lunatic (indeed, some were)."

SEE ALSO Shooting of the Last Black Mamo (1907), Blackout (2003)

Many in the West had once believed that all swans were white. When black swans were finally observed, this reinforced the importance of considering unexpected events.

Blackest Black Color

Anyone familiar with Arthur C. Clarke's *2001: A Space Odyssey* cannot help but be impressed by the flat, black rectangular solids, discovered throughout the solar system, whose dimensions are in the precise ratio of 1:4:9 (the squares of the first three positive integers). Built by extraterrestrials, these dark objects never seemed to reflect the slightest light. It turns out that actual man-made materials, even asphalt and charcoal, reflect some amount of light—but this has not prevented futurists from dreaming of a perfect black material that absorbs all the colors of light while reflecting nothing back. In 2008, reports began to circulate about a group of U.S. scientists who had made the "blackest black," a superblack—the "darkest ever" substance known to science. The exotic material was created from carbon nanotubes that resemble sheets of carbon, only an atom thick, curled into a cylindrical shape. Theoretically, a perfect black material would absorb light of any wavelength shined on it at all angles.

Although Arthur C. Clark's black monoliths resisted all attempts to analyze their composition, here on Earth, researchers continue to construct and study microscopic carpets of the nanotubes. In some sense, we can think of the "roughness" of these carpets as being adjusted to minimize the reflectance of light.

Early superblack carpets contained tiny nanotubes that reflected only 0.045 percent of all light shined upon the substance. This black is more than one hundred times darker than black paint! This "ultimate black" may one day be used to more efficiently capture energy from the Sun or to design more sensitive optical instruments. To limit reflection of light shining upon the superblack material, the researchers made the surface of the nanotube carpet irregular and rough. A significant portion of light is "trapped" in the tiny gaps between the loosely packed carpet strands.

Materials that block or highly absorb a variety of wavelengths of electromagnetic radiation may one day be used in defense applications for which the military seeks to make objects difficult to detect. The race to produce the blackest black never ends, and various researchers have since created materials that absorb nearly every photon of a wide range of tested wavelengths.

SEE ALSO Blackbody Radiation Law (1900), Black Light (1903), Black Velvet Paintings (1933), Black Lightning (1956)

A B-2 Spirit (Stealth Bomber) moves into position for refueling from a KC-135 Stratotanker military aircraft. Carbon-nanotube paints may one day be used on a range of flyers, increasing their concealment in a wide range of wavelengths of light.

Lonely Black Sky

Clive Staples "Jack" Lewis (1898–1963), **Gerrit L. Verschuur** (b. 1937), **Haruki Murakami** (b. 1949), **Lawrence M. Krauss** (b. 1954)

"Why do people have to be this lonely?" writes author Haruki Murakami in *Sputnik Sweetheart*. "Millions of people in this world, all of them yearning, looking to others to satisfy them, yet isolating themselves. Why? Was the earth put here just to nourish human loneliness?" Will we ever meet intelligent beings from beyond our Earth with whom we can share our hopes and dreams?

If we never encounter alien visitors, perhaps space-faring life is extremely rare and interstellar flight is extremely difficult. Astronomer Gerrit Verschuur believes that if extraterrestrial civilizations are, like ours, in their infancy, then no more than 10 or 20 of them exist at this moment in our visible universe, and each such civilization is a lonely 2,000 light-years apart from another. "We are," says Verschuur, "effectively alone in the galaxy." In fact, C. S. Lewis, the Anglican lay theologian, proposed that the great distances separating intelligent life in the universe is a form of divine quarantine to "prevent the spiritual infection of a fallen species from spreading."

Our cosmic isolation is increasing. The expansion of our universe may be pulling galaxies away from one another faster than the speed of light and causing them to become invisible to us. Our descendants will observe that they live in a blob of stars, which results from gravity pulling together a few nearby galaxies into one supergalaxy. This blob may then sit in an endless and seemingly static blackness. This sky will not be totally black, because the stars in this supergalaxy will be visible, but telescopes that peer beyond will see nothing. Physicist Lawrence Krauss and Robert Scherrer write that in 100 billion years, a dead Earth may "float forlornly" through the supergalaxy, an "island of stars embedded in a vast emptiness." Eventually, the supergalaxy itself will disappear as it collapses into a black hole.

In 1973, radio astronomer John A. Ball proposed the zoo hypothesis about which he wrote that "the perfect zoo . . . would be one in which the fauna do not interact with, and are unaware of, their zookeepers." Are we now being watched and our isolation a mere façade?

SEE ALSO Black Eye Galaxy Discovery (1779), Black Holes (1783), Dark Matter (1933), Dark Energy (1998), Universe Fades to Black (100 trillion years AD)

The larger Whirlpool Galaxy and its smaller companion galaxy are united in a cosmic dance of collisions through time. Our descendants may eventually live in a blob of stars that results from gravity pulling together a few nearby galaxies into one supergalaxy.

Universe Fades to Black

Joseph Addison (1672–1719), **Fred Adams** (b. 1961),
Stephen William Hawking (b. 1942)

English poet Joseph Addison once wrote, "The stars shall fade away, the sun himself grow dim with age, and nature sink in years. But thou shalt flourish . . . amidst the wars of elements, the wrecks of matter, and the crush of worlds." The ultimate destiny of our universe depends on its geometrical shape, the behavior of dark energy, the amount of matter, and other factors. Astrophysicists Fred Adams and Gregory Laughlin have described the dark ending as our current star-filled cosmos eventually evolves to a vast sea of subatomic particles, while stars, galaxies, and even black holes fade.

Imagine one possible Cosmic Play in which the death of the universe unfolds in several acts. In our *current* era, the energy generated by stars drives astrophysical processes. Even though our universe is about 13.7 billion years old, the vast majority of stars have barely begun to shine. Alas, all stars will die after 100 trillion years, and star formation will stop because galaxies will have run out of gas—the raw material for making new stars. At this point, the stelliferous, or star-filled, era draws to a close.

The Cosmic Play continues with a *second era* in which the universe continues to expand while energy reserves and galaxies shrink—and material clusters at galactic centers. Brown dwarfs, objects that don't have sufficient mass to shine as stars do, linger on. Gravity has drawn together the burned-out remains of dead stars, and these shrunken objects will have formed superdense objects such as white dwarfs, neutron stars, and black holes. Eventually, even these white dwarfs and neutron stars will disintegrate due to the decay of protons.

Now, the curtains are closing. The *third era*—the era of black holes—is one in which gravity has turned entire galaxies into invisible, supermassive black holes. Through a process of energy radiation described by astrophysicist Stephen Hawking, black holes eventually dissipate their tremendous mass. This means a black hole with the mass of a large galaxy will evaporate completely in 10^{98} to 10^{100} years. Could any beings live in such a desolate universe?

SEE ALSO Black Eye Galaxy Discovery (1779), Black Holes (1783), Dark Energy (1998), Lonely Black Sky (100 billion years AD)

Even the supermassive black holes that continue to exist far in our future will eventually evaporate away through a process known as Hawking radiation. Energy may also be emitted near the edge of a rotating black hole when it is in a strong magnetic field that causes a braking effect.

Notes, Acknowledgments, and Further Reading

For further information, images, and context for several of the physics entries in this book, such as Black Holes, Black Diamonds, and Blackbody Radiation, please see my book *The Physics Book: From the Big Bang to Quantum Resurrection* (Sterling Publishing)—for the related entries on these topics. (A complete list of entries in *The Physics Book* can be found at tinyurl.com/6xxkuxh.) Please see my *The Medical Book: From Witch Doctors to Robot Surgeons* (Sterling Publishing) for a related entry on Black Death.

 I've compiled the following reference list that identifies some of the material I used to research and write this book. Occasionally, I also provide a few extra notes (♪) of clarification in this section, which includes information culled from books, journals, and Web sites. As many readers are aware, Internet Web sites come and go. Sometimes they change addresses or disappear completely. The Web site addresses listed here provided valuable background information when this book was written. You can, of course, find numerous other Web sites relating to these dark marvels and milestones using standard Web-search tools. On-line sources such as *Wikipedia* (en.wikipedia.org) are a valuable starting point for any quest such as this one, and I sometimes used this site as a launch pad, along with many other Web sites, books, and research papers.

 If I have overlooked an interesting or pivotal moment in this history, science, and sociology of "black" that you feel has never been fully appreciated, please let me know about it. Just visit my Web site, *pickover.com*, and send me an e-mail explaining the idea and how you believe it influenced the world. Perhaps future editions of the book will include black marvels or historical topics such as: 1) *Black Athena*, a work by Martin Bernal that suggests that the cultural heritage of ancient Greece stems from Afro-Asiatic (Egyptian and Phoenician) cultures; 2) the *Dark Triad*, a collection of antisocial personality traits that nevertheless ensure that a man has a prolific sex life; 3) *Dark Flow*, the mysterious possible movement of a group of galactic clusters—perhaps towards cosmic megastructures beyond our visible universe; and 4) the *Black September Organization*, responsible for the kidnapping and murder of Israeli athletes and officials during the 1972 Summer Olympics.

 Finally, I would like to thank Teja Krašek, Dennis Gordon, and Pete Barnes for their comments and suggestions.

Introduction

Dalal, F., *Race, Colour and the Processes of Racialization: New Perspectives from Group Analysis, Psychoanalysis and Sociology* (East Sussex, United Kingdom: Brunner-Routledge, 2002).

Freud, S., *A General Introduction to Psychoanalysis*, translated by Joan Riviere (New York: Pocket Books, 1953).

Jacobs, A. J., *The Know-It-All* (New York: Simon & Schuster, 2004).

Osho, *Intimacy: Trusting Oneself and the Other* (New York: St. Martin's Griffin, 1971).

Osho, *The Book of Secrets* (New York: St. Martin's Griffin, 1974).

Pickover, C., *The Physics Book: From the Big Bang to Quantum Resurrection* (New York: Sterling Publishing, 2011).

Shermer, M., *Why People Believe Weird Things: Pseudoscience, Superstition, and Other Confusions of Our Time* (New York: Holt Paperbacks, 2002).

Yang, Zu-Po, Ci, Lijie, Bur, James A., Lin, Shawn-Yu, and Ajayan, Pulickel M. "Experimental Observation of an Extremely Dark Material Made By a Low-Density Nanotube Array," *Nano Letters*, 8(2): 446–451 (2008).

Black Diamonds (c. 3 billion years BC)

♪ Ideas on the origin of carbonados continue to be debated, and many hypotheses still exist.

Garai1, J., Haggerty, S., Rekhi, S., and Chance, M., "Infrared Absorption Investigations Confirm the Extraterrestrial Origin of Carbonado Diamonds," *The Astrophysical Journal*, 653: L153–L156 (December 20, 2006).

Pickover, C., *The Physics Book: From the Big Bang to Quantum Resurrection* (New York: Sterling Publishing, 2011).

Seligson, S., "Black Diamonds," *Synergy: Research and Scholarship at the University of Massachusetts, Amherst*, http://tinyurl.com/8f2nbr3.

Tyson, P., "Diamonds in the Sky," *NOVA Online*, http://tinyurl.com/9arehok.

Young, K., "Rare Black Diamonds May Have Come from Space," NewScientist.com News Service, January 15, 2007, http://tinyurl.com/8gomby7.

Black Hills (c. 1.8 billion years BC)
♪ Today, the forests and grasslands around the Black Hills are home to American bison, bighorn sheep, and mountain lions. The Crazy Horse Memorial, when finished, is expected to be the world's largest sculpture.

Sanford, J. I., *The Black Hills Souvenir: A Pictorial and Historic Description of the Black Hills* (Denver, Colorado: The Williamson-Haffner Engraving Company, 1902).

Black Slug (c. 300 million BC)
♪ Relatives of the modern land snails are rare before the Cretaceous period (about 100 million years ago).

Curtis, T., Editor, *The London Encyclopaedia or Universal Dictionary of Science, Art, Literature, and Practical Mechanics* (London: Thomas Tegg, 1829).

Shipley, A. E. and Harmer, S., *The Cambridge Natural History* (New York: Macmillan and Company, 1895).

Black Widow Spider (c. 250 million BC)
♪ The web of black widows usually resembles a tangled mass or cobweb.

Ayoub, N., Garb, J., Tinghitella, R., Collin, M., and Hayashi, C., "Blueprint for a High-Performance Biomaterial: Full-Length Spider Dragline Silk Genes," *PLoS One*, http://tinyurl.com/96nskcn.

Black Fly (200 million years BC)
The Encyclopedia Americana: A Library of Universal Knowledge (New York: Encyclopedia Americana Corp., 1918).

Howard, L. O., *The Insect Book: A Popular Account of the Bees, Wasps, Ants, Grasshoppers, Flies, and Other North American Insects* (New York: Doubleday, Page & Company, 1902).

Waldbauer, G., *What Good are Bugs? Insects in the Web of Life* (Cambridge, Massachusetts: Harvard University Press, 2003).

Black Swallowtail (190 million BC)
♪ Black Swallowtails live only about ten to twelve days, although some have been known to live as long as forty days.

Comstock, A. B., *Handbook of Nature Study* (Ithaca, New York: Cornell University Press, 1986), originally published in 1911.

Fountain, H., "Of Evolution, Physics and Butterflies," *The New York Times*, November 22, 2005, http://tinyurl.com/9k6cv56.

Black Mamba (c. 150 million BC)
♪ When attacking, the black mamba often rears high off the ground and can attack the person's body, neck, and head.

Capstick, P. H., *Death in the Long Grass* (New York: St. Martin's Press, 1978).

Nagami, P., *Bitten: True Medical Stories of Bites and Stings* (New York: St. Martin's Press, 2004).

Black Iris (c. 125 million BC)
♪ The oldest angiosperm (floweringplant) pollen has been found in sediments in England that are 135 million years old. DNA-sequence analysis suggests that the very first flowering plants appeared as far back as 180 million years ago.

Carol, K., *Plant Personalities: Choosing and Growing Plants by Character* (Portland, Oregon: Timber Press, Inc., 2004).

Derderian, M., "Jordan's Black Iris," *First Jordan*, April 18, 2005, http://tinyurl.com/8plh4sz.

"First Flower," NOVA, PBS Airdate: April 17, 2007, http://tinyurl.com/nhdep3.

O'Donoghue, J., "Petal Power," *New Scientist*, 200(2680): 36–39, November 1, 2008.

O'Dowd, M. J., *The History of Medications for Women: Materia Medica* (New York: Parthenon, 2001).

Black Seadevil (c. 50 million BC)
Anitei, S., "Sexual Parazitism: Females Carrying Harems of Parazite Males— Deep Sea Anglers," *Softpedia*, http://tinyurl.com/378r77.

Flannery, T., "Where Wonders Await Us," 54(20), December 20, 2007, http://tinyurl.com/978dp3o.

Shrope, M. and Pickrell, J., "Instant Expert: Mysteries of the Deep," NewScientist.com news service, September 4, 2006, http://tinyurl.com/9z2r2cj.

Black Ghost Knifefish (10 million years BC)
Pickover, C., *The Science of Aliens* (New York: Basic Books, 1998).

Nelson, M. E. and Maciver, M., "Prey Capture in the Weakly Electric Fish Apteronotus Albifrons: Sensory Acquisition Strategies and Electrosensory Consequences," *The Journal of Experimental Biology* 202, 1195–1203 (1999).

Black Sea (6 million BC)
"Geological Evolution of the Black Sea," Black Sea Environmental Internet Node, http://tinyurl.com/9zb3kcg.

King, C., *The Black Sea: A History* (New York: Oxford University Press, 2004).

Holden, C., "Flood Theory Revised," *Science*, 323(5913): 443.

Black Tusk (c. 1.2 million years BC)
♪ According to the Squamish flood myth, every baby and small child was placed into the boat, along with a male and female adult guardian, food, and water.

Clark, E. E., *Indian Legends of the Pacific Northwest* (Berkeley, California: University of California Press, 2003).

Fleming, J. L., *Walking in British Columbia* (Cumbria, United Kingdom:

Cicerone Press, January 2003).

Rose, C., *Giants, Monsters, and Dragons: An Encyclopedia of Folklore*, (New York: W. W. Norton & Company, 2001).

Black Magic (c. 80,000 BC)

Cavendish, R., *The Black Arts* (New York: Perigee, 1967).

O'Neil, D., "Evolution of Modern Humans: Archaic Homo sapiens Culture," *http://tinyurl.com/awl6e*.

Black Pepper (1213 BC)

Coates, K. J., "'Cambodian Pepper Capital' Creates New Life From Old Spice," *Milwaukee Journal Sentinel*, Sept. 26, 2006, archived at *http://tinyurl.com/8tr83ex*.

Ravindran, P. N., *Black Pepper: Piper Nigrum* (Boca Raton, Florida: CRC Press, 2000). Also contains the quote from R. S. Paroda, who wrote the book's foreword.

Greek Dark Ages (c. 1100 BC–750 BC)

Ruprecht, L., "Why the Greeks?" in *Agon, Logos, Polis: The Greek Achievement and its Aftermath*, edited by Jóhann Páll Árnason and Peter Murphy (Stuttgart, Germany: Steiner, 2001).

Henry, R., *Synchronized Chronology: Rethinking Middle East Antiquity* (New York: Algora Publishing, 2003).

The Black Obelisk of Shalmaneser III (841 BC)

Barton, J. and Bowden, J., *The Original Story: God, Israel, and the World* (London: Darton, Longman, and Todd, 2004).

Black Pudding (700 BC)

Taylor, J. M., *Hoppin' John's Lowcountry Cooking: Recipes and Ruminations from Charleston* (New York: Bantam, 1992).

Outer Darkness (c. 80)

Faust, J. D., *The Rod: Will God Spare It?* (Hayesville, North Carolina: Schoettle Publishing Co., 2003).

Lockyer, H., *All the Parables of the Bible* (Grand Rapids, Michigan: Zondervan, 1988).

Williams, D., *Complete Idiot's Guide to Understanding Mormonism* (Indianapolis, Indiana: Alpha Books, 2003).

Black Mass (c. 100)

Cavendish, R., *The Black Arts* (New York: Perigee, 1967). Note: The Isaac Bashevis Singer quote appeared in *Book Week* and is reproduced on the back jacket of Cavendish's *The Black Arts*.

Dark Ages (476–1000)

Dahmus, J., *A History of the Middle Ages* (New York: Doubleday, 1968).

Newman, P. B., *Daily Life in the Middle Ages* (Jefferson, North Carolina: McFarland & Co., 2001).

Pyle, H., *Otto of the Silver Hand* (New York: Dover Publications, Inc, 1967), originally published in 1888.

Black Stone (602)

Bevan, A., and De Laeter, J., *Meteorites: A Journey through Space and Time* (Washington, D.C.: Smithsonian Books, 2002).

Glassé, C., *The New Encyclopedia of Islam* (Walnut Creek, California: AltaMira Press, 2001).

Black Madonna (c. 1000)

Begg, E., *The Cult of the Black Virgin* (New York: Penguin, 1989).

Smith, K., "The Cult of the Black Virgin," (review of Ean Begg's *The Cult of the Black Virgin*), *Whole Earth Review*, no. 74, p. 70, Spring 1992.

Van Sertima, I., *African Presence in Early Europe* (New Brunswick, New Jersey: Transaction Publishers, 1987).

Black Cat Fear (c. 1200)

♪ According to Jeffrey Burton Russell's *Witchcraft in the Middle Ages*, Luciferans are heard from for the first time between 1310 and 1350 in Austria. According to Gary K. Waite's *Eradicating the Devil's Minions*, sometime around 1233, "Pope Gregory IX proclaimed in his papal bull *Vox in Rama*, that the Luciferans were real . . . Devotees kissed Lucifer's anus."

Editors of Time-Life Books, *A World of Luck* (Alexandria, Virginia: Time-Life Books, 1991).

Elvidge, P., *Satanism: An Examination of Satanic Black Magic* (e-book) (New York: Globusz Publishing).

Lambert, M., *The Cathars* (Malden, Massachusetts: Blackwell, 1998).

Russell, J. B., *Witchcraft in the Middle Ages* (Ithaca: Cornell University Press, 1972).

Waite, G. K., *Eradicating the Devil's Minions* (Toronto, Canada: University of Toronto Press, 2007).

Black Prince (1330)

Barber, R., *The Life and Campaigns of the Black Prince* (Suffolk: United Kingdom, Boydell Press, 1979).

Cantor, N. F., *The Last Knight: The Twilight of the Middle Ages and the Birth of the Modern Era* (New York: Harper Perennial, 2005).

Fuller, T., *The Holy State and the Profane State* (London: Thomas Tegg, 1841), originally published in 1642.

Neillands, R., *The Hundred Years War* (New York: Routledge, 2001).

Black Crown (1339)

♪ The Karmapa lineage is ancient, dating back to the first Karmapa, Düsum Khyenpa (1110–1193).

Batchelor, S., *The Awakening of the West: The Encounter of Buddhism and Western Culture* (Berkeley, California: Parallax Press, 1994).

Terhune, L., *Karmapa: The Politics of Reincarnation* (Somerville, Massachusetts: Wisdom Publications, 2004).

Black Death (c. 1340)

♪ The first outbreaks of the plague

in China occurred in the early 1330s. The plague was reported in Constantinople in 1347.

Cantor, N. F., *In the Wake of the Plague: The Black Death and the World it Made* (New York: Free Press, 2001).

Blackbird Pie (1549)

Straight Dope Science Advisory Board, "What's the nursery rhyme 'Sing a Song of Sixpence' all about?" April 4, 2001, *http://tinyurl.com/8mh9jlp*.

Blackmail (1601)

The Merriam-Webster New Book of Word Histories (Chicago: Merriam-Webster, Inc., 1991).

Betts, R. K., *Nuclear Blackmail and Nuclear Balance* (Washington, D.C.: Brookings Institution Press, 1987).

Black Nazarene (1606)

Yancey, P., *Reaching for the Invisible God: What Can We Expect to Find?* (Grand Rapids, Michigan: Zondervan, 2002).

Blackbeard (c. 1680)

♪ Earlier in his life, Teach served on an English ship in the War of the Spanish Succession. Regarding his life of piracy, little or no trusted account exists of him actually killing people during his raids. He achieved his piracy largely by instilling fear in his opponents. Teach's fourteenth wife is said to have been a 16-year-old, whom he forced to sleep with his fellow pirates.

Johnson, C., *A General History of the Robberies and Murders of the Most Notorious Pirates* (London: Conway Maritime Press, 1998), originally published in 1724.

Perry, D., *Blackbeard: The Real Pirate of the Caribbean* (New York: Basic Books, 2006).

The Black Guard (1690)

"Birth of a Nation" (unsigned article), *TIME*, April 14, 1930, *http://tinyurl.com/yzp8ykj*.

Goodwin, S., *Africa's Legacies of Urbanization: Unfolding Saga of a Continent* (Lanham, Maryland: Lexington Books, 2006).

Howe, M., *Morocco: The Islamist Awakening and Other Challenges* (New York: Oxford University Press, 2005).

Black Act (1723)

Berman, H. J., *Law and Revolution, II: The Impact of the Protestant Reformations on the Western Legal Tradition*. (Cambridge, Massachusetts: Harvard University Press, 2003).

Malcolm, J. L., *Guns and Violence: The English Experience* (Cambridge, Massachusetts: Harvard University Press, 2002).

Monbiot, G., "Back to 1662," *Guardian*, October 26, 1994, *http://tinyurl.com/8h9p6ow*.

The Black Pullet (1740)

Anonymous, *The Black Pullet: Science of Magical Talismans* (Boston, Massachusetts: Red Wheel/Weiser, 2000).

Spence, Lewis, *Encyclopedia of Occultism and Parapsychology* (Whitefish, Montana: Kessinger Publishing, 2003).

Waite, A. E., *The Book of Ceremonial Magic* (San Diego, California: The Book Tree, 2006), first published in 1911.

Blackjack (c. 1750)

♪ Michael Benson writes, "There are professional blackjack players . . . who actually make a living from playing blackjack . . . Many look more like accountants than like secret agents . . . It is important that the professional blackjack player be inconspicuous. The more a pro can blend in with the scenery, the better off he is."

Benson, M., *Blackjack Strategy: Tips and Techniques for Beating the Odds* (Guildford, Connecticut: The Lyons Press, 2004).

Grabianowski, E., "How Blackjack Works," *http://tinyurl.com/8awwbxs*.

Patterson, J. L., *Casino Gambling: A Winner's Guide to Blackjack, Craps, Roulette, Baccarat, and Casino Poker* (New York: Perigee, 2000).

Thomason, W., *Blackjack for the Clueless: A Beginner's Guide to Playing and Winning* (New York: Kensington, 1998).

Black Hole of Calcutta (1756)

Holwell, J. Z., "A Genuine Narrative of the Deplorable Deaths of the Gentlemen Who were Suffocated in the Black Hole in Fort William, Calcutta," *India Tracts* (London: T. Becket, 1758, 1764).

Black Drop Effect (1761)

Bergman, T., "An Account of the Observations Made in the Same Transit at Upsal in Sweden," *Philosophical Transactions*, 52: 227–230 (1761).

Pasachoff, J. M., Glenn Schneider, and Leon Golub, "The Black-Drop Effect Explained," *Transits of Venus: New Views of the Solar System and Galaxy;*

Proceedings IAU Colloquium, 196: 242–253 (2004).

Pickover, C., *Archimedes to Hawking* (Oxford University Press, 2008).

Shiga, D., "Where Was the Black Drop?" *Sky and Telescope*, July 12, 2004, *http://tinyurl.com/yjjbtte*.

Black Eye Galaxy Discovery (1779)

O'Meara, S. J., *Deep-Sky Companions: Hidden Treasures* (New York: Cambridge University Press, 2007).

Darling, D., "The Internet Encyclopedia of Science," *http://tinyurl.com/yhulfpd*.

Black Holes (1783)

♪ More recent research indicates that some leakage of energy may occur at the boundary of a black hole. In 1974, Hawking determined that black holes should thermally create and emit subatomic particles in a process

known as Hawking radiation.

Hawking, S., "Particle Creation by Black Holes," *Communications in Mathematical Physics* 43(3): 199–220 (1975).

Hawking, S., *Black Holes and Baby Universes* (New York: Bantam, 1993).

Pickover, C., *Black Holes: A Traveler's Guide* (New York: Wiley, 1996).

Byron's "Darkness" (1816)

Greenblatt, S. G., *The Norton Anthology of English Literature*. (New York: W. W. Norton, 2006).

Paley, M. D., "Envisioning Lastness: Byron's 'Darkness,' Campbell's 'The Last Man,' and the Critical Aftermath," *Romanticism: The Journal of Romantic Culture and Criticism* 1: 1–14 (1995).

Goya's Black Paintings (1819)

♪ Mary Acton also notes that "the darkest areas of *The Witches' Sabbath* [painting] are where he [Goya] leaves the black to show through, as in the horrific horned figure of the devil in the foreground." Robert Hughes writes, "The Black Paintings obey no perceptible narrative. But they sum up certain obsessional themes of his art—pilgrims on the march, dances, demonic events—but now pushed to the orgiastic limit, and rendered in terms of the broadest, quickest gestures of the brush. Sly, autistic, crazy, leering, howling, glaring . . . a world of moral chaos, evoked in radical slashes and alla prima daubs of paint."

Acton, M., *Learning to Look at Paintings* (New York: Routledge, 1997).

Hughes, R., "The Unflinching Eye," *The Guardian*, October 4, 2003, http://tinyurl.com/5wam6or.

Hustvedt, S., *Mysteries of the Rectangle: Essays on Painting* (Princeton, New Jersey: Princeton Architectural Press, 2006).

Murray, C. J., *Encyclopedia of the Romantic Era, 1760–1850* (New York: Fitzroy Dearborn, 2004).

Black War (1828)

Cocker, M., *Rivers of Blood, Rivers of Gold*: (New York: Grove Press, 2001).

Diamond, J., *Guns, Germs, and Steel* (New York: W.W. Norton, 1997).

Diamond, J., "Ten Thousand Years of Solitude," *Discover*, March 1, 1993, http://tinyurl.com/2e97v3.

Macintyre, S., *A Concise History of Australia* (New York: Cambridge University Press, 2004).

Windschuttle, K., *The Fabrication of Aboriginal History, Volume One: Van Diemen's Land 1803–1847* (Paddington, New South Wales: Macleay Press, 2002). (Windschuttle provides a refutation of British massacres of Aboriginal people and suggests that the number of Aboriginal deaths has been inflated.)

"Coal Black Rose" (1829)

Blight, D. W. and Simpson, B., *Union & Emancipation: Essays on Politics and Race in the Civil War Era* (Kent, Ohio: The Kent State University Press, 1997).

Crawford, R., *America's Musical Life: A History* (New York: W. W. Norton, 2001).

Blackface (1830)

♪ Even though one of the aims of blackface may have been to assert white superiority, W. J. Thomas Mitchell writes that there is a celebratory element as well: "Why else would blackface minstrelsy have become the first popular culture industry in America? Why else would black music, dance, clothing, and ways of speaking become so widely imitated and appropriated by the white majority?" Also note that 1829 performances of the folk song "Coal Black Rose" are sometimes used to mark the origin of blackface because this is one of the earliest songs to be sung in a theater by a man in blackface.

Crawford, R., *America's Musical Life* (New York: W. W. Norton, 2001).

Ellison, R., "Twentieth-Century Fiction and the Black Mask of Humanity" in *The Collected Essays of Ralph Ellison*, John F. Callahan, ed. (New York: The Modern Library, 2003), 81–99.

Mitchell, W. J. T., *What Do Pictures Want?* (Chicago, University of Chicago Press, 2005).

Petrash, A., *More Than Petticoats* (Guilford, Connecticut: Globe Pequot Press, 2004).

Willis, S., *A Primer for Daily Life* (New York, Routledge, 1991).

Wintz, C. D. and Finkelman, P., *Encyclopedia of the Harlem Renaissance* (New York: Routledge, 2004).

Black Angus (1842)

Briggs, H. and Briggs, D., *Modern Breeds of Livestock*, Fourth Edition (New York: Macmillan Publishing Co., 1980).

"History of the Angus Breed," North Carolina State University, http://tinyurl.com/93tg72n.

Black Ice (1850)

♪ Michael Faraday's work was published in 1859, but many researchers had their doubts about his explanation.

Chang, K., "Explaining Ice: The Answers Are Slippery," February 21, 2006, http://tinyurl.com/8uqh59q.

Kestenbaum, D., "Science: The Secret of Ice's Slippery Character," *New Scientist*, 2061: p. 19, December 21, 1996; http://tinyurl.com/9sypagx.

"The Top Six Winter Driving Dangers and How to Handle Them Safely," SixWise.com; http://tinyurl.com/9gjmxym.

Rosenberg, R., "Why is Ice Slippery?" *Physics Today*, 58(12): 50–55, December, 2005.

Browning's Dark Tower (1855)

Atwood, M., *Negotiating with the Dead: A Writer on Writing* (New York: Cambridge University Press, 2002).

Sawyer, R., *Victorian Appropriations of Shakespeare*

(Cranbury, New Jersey: Associated University Presses, 2003).

"Black is Beautiful" (1858)

Gates, H. L. and Appiah, K., *Africana: The Encyclopedia of the African and African American Experience* (New York: Basic Civitas Books, 1999).

Oliver, M. and Shapiro, T., *Black Wealth / White Wealth: A New Perspective on Racial Inequality* (New York: Routledge, 1995).

Death by Blackdamp (1862)

♪ The activity of mining valuable material from the Earth goes back thousands of years. One of the oldest known mines is the "Lion Cave" in Swaziland, dating to 4100 BC, a location where Paleolithic people sought the iron-rich mineral hematite, which they used to produce red pigments.

Buckley, K. L., *Danger, Death and Disaster in the Crowsnest Pass Mines 1902–1928* (Calgary: University of Calgary Press, 2004).

Jones, A. V. and Tarkenter, R., *Electrical Technology in Mining: The Dawn of a New Age* (Stevenage, United Kingdom: Institution of Engineering and Technology, 1992).

Tranter, M., *Occupational Hygiene and Risk Management* (Crows Nest, New South Wales: Allen & Unwin, 2004).

Black Hawk War (1865)

♪ The term "Black Hawk War" also refers to another war fought in 1832 in the Midwestern United States. The war was named for a different Black Hawk (1767–1838), a leader of the Sauk American Indians.

Also note that violence occurred on both sides of the Utah Black Hawk war. For example, in 1865, three white girls, one as young as three years old, were killed by tomahawk blows to the head. Ute warriors drove off thousands of Mormon cattle.

In the late 1800s, thousands of Native American children were sent from their homes to be "civilized" at faraway schools and to learn how to be "white." Some lost their lives to tuberculosis and other diseases that spread through such schools.

Culmsee, C., *Utah's Black Hawk War* (Logan, Utah: State University Press, 1973), 90–91.

Jorgensen, J., "Ute," in *Encyclopedia of North American Indians*, Frederick E. Hoxie, Editor (Boston, Massachusetts: Houghton Mifflin, 1996).

Knack, M. C., *Boundaries Between: The Southern Paiutes, 1775–1995* (Lincoln, Nebraska: University of Nebraska Press, 2001).

Reeve, W. P., "Circleville Massacre, A Tragic Incident in the Black Hawk War," *History Blazer*, September 1995, http://tinyurl.com/8annfjn.

Winkler, A., "The Circleville Massacre: A Brutal Incident in Utah's Black Hawk War," *Utah Historical Quarterly* 55: 4–21 (1987).

Black Codes (1865)

Davis, A., *Are Prisons Obsolete?* (New York: Seven Stories Press, Open Media Series, 2003).

Harrell, D. E., Jr., Harrell, D., Gaustad, E., Boles, J., Griffith, S., Miller, R., and Wood, B., *Unto A Good Land: A History Of The American People* (Grand Rapids, Michigan: Wm. Eerdman's Publishing Company, 2005).

Nelson, S., *Steel Drivin' Man: John Henry, the Untold Story of an American Legend* (New York: Oxford University Press, 2006).

Black Bart (1875)

♪ Bolles was finally caught after he dropped his handkerchief bearing the laundry mark F.X.O.7. Using this piece of evidence, Wells Fargo detectives were able to track him down.

Hoeper, G., *Black Bart Boulevardier Bandit: The Saga of California's Most Mysterious Stagecoach Robber and the Men Who Sought to Capture Him* (Fresno, California: Word Dancer Press, 1995).

Walker, D. L., *Legends and Lies: Great Mysteries of the American West* (New York: Forge Books, 1998). This book is the source of the quotation from Black Bart's wife regarding his possible whereabouts.

Black Museum (1875)

Gollomb, J., *Master Man Hunters* (Whitefish, Montana: Kessinger Publishing, 2006), originally published in 1926.

Spoto, D., *The Dark Side of Genius: The Life of Alfred Hitchcock* (New York: Da Capo Press, 1999). This book was also the source of the Hitchcock quote.

Metropolitan Police, "The Crime Museum," http://tinyurl.com/nsqko.

Black Beauty (1877)

Hastings, A. W., Northern State University, "Anna Sewell–Black Beauty," *http://tinyurl.com/9c5re2k.*

Hunt, P., *Children's Literature* (Malden, Massachusetts: Blackwell Publishing, 2001).

Little Black Sambo (1899)

♪ Helen Bannerman, the author of *The Story of Little Black Sambo*, married a surgeon who was serving in the British Army in India, where she spent thirty years.

Bannerman, H., *The Story of Little Black Sambo* (New York: HarperCollins, 1923).

Spitz, E. H., *Inside Picture Books* (New Haven, Connecticut: Yale University Press, 2000).

Blackbody Radiation Law (1900)

Pickover, C., *Archimedes to Hawking: Laws of Science and the Great Minds Behind Them* (New York: Oxford University Press, 2008).

Black Dragon Society (1901)

Crowdy, T., *The Enemy Within: A History of Espionage* (New York: Osprey Publishing, 2006).

Jansen, M., *The Making of Modern Japan* (Cambridge, Massachusetts: Belknap Press, 2000).

Kaplan, D. E. and Dubro, A., *Yakuza: Japan's Criminal Underworld* (Berkeley, California: University of California Press, 2003).

Conrad's *Heart of Darkness* (1902)

Conrad, J., *Heart of Darkness* (New York: Penguin, 1999).

Moore, G. M., *Joseph Conrad's Heart of Darkness: A Casebook* (New York: Oxford University Press, 2004).

Black Light (1903)

Rielly, E. J., *The 1960s* (Westport, Connecticut: Greenwood Press, 2003).

Stover, L., *Bohemian Manifesto: A Field Guide to Living on the Edge* (New York: Bulfinch, 2004).

Shooting of the Last Black Mamo (1907)

♪ The Black Mamo population also suffered due to the importation of the Indian Mongoose, brought to catch rats without much thought as to the damage it would do to the birds.

Bryan, W. A., "Some Birds of Molokai" in *Occasional Papers of the Bernice Pauahi Bishop Museum of Polynesian Ethnology and Natural History, Volume 4.* (Honolulu, Hawaii: Bernice Pauahi Bishop Museum, 1911).

Black Hand of Serbia (1911)

♪ The name "Black Hand" comes from an older organization in Italy of the same name. "La Mano Nera" was involved in extortion since the mid-1700s. Sometimes, their threatening letters, demanding money, were decorated with hands in black ink.

Axelrod, A., *The Complete Idiot's Guide to World War I* (New York: Alpha, 2000).

Craig, J. S., *Peculiar Liaisons in War, Espionage, and Terrorism in the Twentieth Century* (New York: Algora, 2005).

Black Forest Cake (1915)

Krull, C., quoted in "The Week in Germany: German Town Puts the Icing on World's Largest Black Forest Cake," July 21, 2006, *http://tinyurl.com/8b93ohh*.

Café Schaefer, "Black Forest Cakes— From the Original Recipe," *http://tinyurl.com/9cpwjox*.

Blackshirts (1919)

♪ The term "Blackshirt" was later applied to a similar group of fascists in the United Kingdom in the 1930s.

Farrell, N., *Mussolini: A New Life* (London: Phoenix, 2005).

Levi, P., quoted in I. Thomson's *Primo Levi: A Life* (New York: Metropolitan Books, 2002).

Seldes, G., *Can These Things Be!* (New York: Garden City Publishing, 1931).

The Black Chamber (1919)

♪ The U.S. government was unhappy with Yardley's publication of *The American Black Chamber* because it provided many details of spying activities.

Kahn, D., *The Codebreakers* (New York: Scribner, 1996).

Black Sox Scandal (1919)

Asinof, E., *Eight Men Out: The Black Sox and the 1919 World Series* (New York: Henry Holt and Company, 2000).

Ginsburg, D. E., *The Fix Is in: A History of Baseball Gambling and Game Fixing* (Jefferson, North Carolina: McFarland & Company, 2004).

Grant, R. and Katz, J., *The Great Trials of the Twenties* (New York: Sarpedon, 1998).

Nathan, D. A., *Saying It's So: A Cultural History of the Black Sox Scandal* (Champaign, Illinois: University of Illinois Press, 2002).

Black Market (1920)

♪ The many millions of sellers on eBay must pay taxes, according to law, but authorities rarely take action to collect such monies. This is another example of a black market.

Chickering, R., *Imperial Germany and the Great War, 1914–1918* (New York: Cambridge University Press, 2004).

Schlosser, E., *Reefer Madness: Sex, Drugs, and Cheap Labor in the American Black Market* (New York: Houghton Mifflin Company, 2004).

Black Tuesday (1929)

Burns, E., *The Smoke of the Gods: A Social History of Tobacco* (Philadelphia, Pennsylvania: Temple University Press, 2006).

Woodard, D., "Black Tuesday— 1929: Worst Day in Stock Market History," *http://tinyurl.com/8tuar7a*.

"The Whisperer in the Darkness" (1931)

Lovecraft, H. P., *The Best of H. P. Lovecraft: Bloodcurdling Tales of Horror and the Macabre* (New York: Del Rey, 1987).

Dark Matter (1933)

♪ Additional evidence for dark matter comes from astronomical observations of the ways in which galactic clusters cause gravitational lensing of background objects. This lensing occurs when the path of light rays is "bent" due to the gravity of a massive object.

Arkani-Hamed, N., Savas, D., and Dvali, G., "The Universe's Unseen Dimensions," *Scientific American* 283(2): 62–69 (August 2000).

Gates, E., *Einstein's Telescope: The Hunt for Dark Matter and Dark Energy in the Universe* (New York: W. W. Norton, 2009).

McNamara, G. and Freeman, K., "In Search of Dark Matter" (New York: Springer, 2006).

Pickover, C., *The Stars of Heaven* (New York: Oxford University Press, 2001).

Williams, S., "Twinkle, Twinkle: Dark Matter may have Lit up the First Stars," *Science News* 173(1): 4–5 (January 5, 2008).

Black Velvet Paintings (1933)
Kofoed, K., "Paradise Painted: and We're Not Talking about Elvis Portraits," September 1, 1999, *Seattle Weekly*, http://tinyurl.com/coazhak.
Smith, M. and Kiger, P., *Poplorica: A Popular History of the Fads, Mavericks, Inventions, and Lore that Shaped Modern America* (New York: Collins, 2004).

Black Mold (1937)
Money, N. P., *Carpet Monsters and Killer Spores: A Natural History of Toxic Mold* (New York: Oxford University Press, 2004).
Nelson, B. D., "*Stachybotrys chartarum*: The Toxic Indoor Mold," American Phytopathological Society, 2001, http://tinyurl.com/9t3qyz3.

The Black Sun (c. 1940)
Emick, J., "Black Sun," http://tinyurl.com/8vt4vb7.
Goodrick-Clarke, N., *Black Sun: Aryan Cults, Esoteric Nazism, and the Politics of Identity* (New York: New York University Press, 2003).

Black Dahlia (1947)
Hansom, P. in *Violence in America: An Encyclopedia*, edited by R. Gottesman, (New York: Charles Scribner's Sons, 1999), p. 152.
McNamara, J., *The Justice Story: True Tales of Murder, Mystery, Mayhem* (New York: Bannon Multimedia Group, 2000).

Blacklist (1947)
Bosworth, P., "FILM; Daughter of a Blacklist That Killed a Father," September 27, 1992, *The New York Times*, http://tinyurl.com/9acmeuo.
Georgakas, D., "The Hollywood Blacklist" in *Encyclopedia of the American Left*, edited by M. Buhle, P. Buhle, and D. Georgakas (New York: Oxford University Press, 1998)

Men in Black Conspiracy (1953)
Bender, A., *Flying Saucers and the Three Men* (London: Neville Spearman, 1963).
Spignesi, S., *The Weird 100* (New York: Citadel Press, 2004).

Reinhardt's Black Paintings (1953)
Highmore, B., "Paint it Black: Ad Reinhardt's Paradoxical Avant-Gardism," in *Avant-Garde/Neo-Avant-Garde*, edited by D. Scheunemann (New York: Rodopi, 2005).
Rosenthal, S. (Editor), *Black Paintings: Robert Rauschenberg, Ad Reinhardt, Mark Rothko, Frank Stella* (Ostfildern, Germany: Hatje Cantz, 2007).
Taylor, M. C., *Disfiguring: Art, Architecture, Religion* (Chicago: University of Chicago Press, 1994).

Black Lightning (1956)
Golding, W., *Pincher Martin: The Two Deaths of Christopher Martin* (New York: Harvest Books, 2002).
Eagleton, T., *Figures of Dissent* (New York: Verso, 2003).
Redpath, P., *William Golding: A Structural Reading of His Fiction* (Totowa, New Jersey: Barnes and Noble Books, 1986).
Surette, L., "A Matter of Belief: Pincher Martin's Afterlife," *Twentieth Century Literature* 40(2): 205–225 (Summer, 1994). Source of Golding's radio quotation.

Hoyle's Black Cloud (1957)
♪ Hoyle's black clouds live solitary existences with occasional communication among the clouds via radio transmissions. These long-distance conversations are usually about mathematics, philosophy, and the nature of the universe. Perhaps life will evolve into whatever material embodiment best suits its purposes. Something like a black cloud may be possible as a large, organized assemblage of dust grains carrying positive and negative charges. While it's difficult for modern scientists to imagine this form of life, remember that, a century ago, we could not easily contemplate the biochemistry of life on Earth.
Dyson, F., "Time without End: Physics and Biology in an Open Universe," *Reviews of Modern Physics* 51(3): 447–460 (1979).
Hoyle, F., *The Black Cloud* (New York: Harper, 1957).
Pickover, C., *The Science of Aliens* (New York: Basic Books, 1998).

Dark Side of the Moon (1959)
The Dark Side of the Moon is also the title of a music album by the British rock band Pink Floyd, released in 1973.
Moore, P., *Patrick Moore on the Moon* (London: Cassell and Company, 2001).
Wickman, R., "Volcanism on the Moon," http://tinyurl.com/8tc4kgx.

"Baby's in Black" (1964)
McCartney P., quoted in *The Beatles Anthology* by B. Roylance (San Francisco, California: Chronicle Books, 2000).
Meltzer, R., *The Aesthetics of Rock* (New York: Da Capo Press, 1987).
Miles, B. and Badman, K., *The Beatles Diary: After the Break-Up 1970-2001* (London: Omnibus Press, 2001).
Unterberger, R., "Baby's in Black: Song Review," http://tinyurl.com/8aw4qzn.

Dark Shadows (1966)
Benshoff, H. M., "Dark Shadows. Gothic Soap Opera," http://tinyurl.com/97bzuth.
Hamrick, C., *Barnabas & Company: The Cast of the TV Classic Dark Shadows* (Lincoln, Nebraska: iUniverse, 2003).

"Paint It, Black" (1966)
♪ Another famous song from this era is "Black is Black" (1966) by Los Bravos, a rock group formed in 1965 and based in Madrid.
Dean, M., *Rock 'n' Roll Gold Rush* (New York: Algora, 2003).
Hector, J., *The Complete Guide to the Music of the Rolling Stones*

(London: Omnibus Press, 1995).

Keith, S. B., *Standing in the Shadows* (New York: St. Martin's Press, 1995). This book is the source for the Leonard Bernstein information.

Loewenstein D. and Dodd, P. (editors), *According to the Rolling Stones* (San Francisco, California: Chronicle Books, 2003). Source of Mick Jagger quote.

"Black Magic Woman" (1968)

Aykroyd D. and Manilla, B., *Elwood's Blues: Interviews With The Blues Legends & Stars* (San Francisco, California: Backbeat Books, 2004). Source of the quote of Carlos Santana.

Getzlaff, J. A., "Black Magic Woman? A Court Sentences a United Arab Emirates Woman to Four Months in Jail for Casting a Spell," June 7, 2000, *http://tinyurl.com/8fh5246*.

Black Sabbath (1969)

Christe, I., *Sound of the Beast: The Complete Headbanging History of Heavy Metal* (New York: HarperEntertainment, 2003).

Taylor, S., *The A to X of Alternative Music* (New York: Continuum International Publishing Group, 2006).

Black Volga Legend (c. 1970)

♪ More far-fetched versions of the Black Volga legend have involved Satan as the driver.

Brunvand, J. H., *The Baby Train and Other Lusty Urban Legends* (New York: W. W. Norton & Company, 1994).

Campion-Vincent, V., *Organ Theft Legends* (Jackson, Mississippi: University Press of Mississippi, 2005).

Waller, J. M., *The Public Diplomacy Reader* (Washington, D.C.: The Institute of World Politics Press, 2007).

Black Lion Tamarin Discovered (1971)

"Black Lion Tamarin," Bristol Zoo Gardens, *http://tinyurl.com/bm3e4st*.

Durrell, G., "Black Lion Tamarin," *http://tinyurl.com/8ssuclq*.

Padua, C. V. and Padua, S., "Conservation of black lion tamarins (*Leontopithecus chrysopygus*) in the Atlantic forest of the interior, Brazil," Society for Conservation Biology (SCB) Newsletter, 7 (1), *http://tinyurl.com/9sdjfx5*.

Pearl, M. C., "Natural Selections: Brazilian Rendezvous," November 1, 2006, *http://tinyurl.com/8enm6d3*.

Black Smoker Discovery (1977)

National Research Council (U.S.), *50 Years of Ocean Discovery* (Washington, D.C.: National Academies Press, 2000). Source of the Dudley Foster quote.

Schulz, H. D. and Zabel, M., *Marine Geochemistry* (New York: Springer, 2000).

The Dark Side (1977)

Danesi, M., *Popular Culture: Introductory Perspectives* (New York: Rowman & Littlefield Publishers, 2007).

Lawrence, J. S. and Jewett, R., *The Myth of the American Superhero* (Grand Rapids, Michigan: Wm. B. Eerdmans Publishing Company, 2002).

Lyden, J., *Film as Religion: Myths, Morals, and Rituals* (New York: NYU Press, 2003).

Black Black (1983)

"Black Black Gum: Hi-Technical Excellent Taste and Flavor!" *http://tinyurl.com/8owpxp7*.

Fleming-Michael, Karen, "Caffeine Gum Now in Army Supply Channels" *Infantry*, Vol. 95, No. 1, *http://tinyurl.com/8lglcsf*.

Redclift, M., *Chewing Gum: The Fortunes of Taste* (New York: Routledge, 2004).

Redclift, M., "Chewing Gum: Mass Consumption and the 'Shadowlands' of the Yucatan," in *Consuming Cultures, Global Perspectives: Historical Trajectories, Transnational Exchanges*, edited by J. Brewer and F. Trentmann (New York: Berg Publishers, 2006). Source of Redclift quotation.

Black Hole Antiterrorism (c. 1987)

♪ In effect, the Internet service provider routes the flood of malicious signals to a black hole in the form of a null interface (often written as *Null0*). Note that for networks of hundreds of routers, an approach known as *remote triggered black hole filtering* can be used to ensure that many routers all respond appropriately.

Cisco Systems, "Remotely Triggered Black Hole Filtering—Destination Based and Source Based," *http://tinyurl.com/6q84bfg*.

Greene, B. R., "Remote Triggering Black Hole Filtering," August 2, 2002, *http://tinyurl.com/8vxrm4t*.

Mockaitis, T. R. and Rich, P., *Grand Strategy in the War Against Terrorism* (London: Frank Cass, 2004).

Northcutt, S. and Novak, J., *Network Intrusion Detection* (Indianapolis, Indiana: New Riders Publishing, 2002).

Myers, S. L., "Look Out Below: The Arms Race in Space May Be On," *The New York Times*, March 9, 2008. p. 3. ("Week in Review" section.)

Young, S. and Aitel, D., *The Hacker's Handbook: The Strategy Behind Breaking Into and Defending Networks* (Boca Raton, Florida: CRC Press, 2004).

Dark Tourism (1996)

Lennon, J., "Journeys into Understanding: What is Dark Tourism?" *The Observer*, Sunday (October 23, 2005), *http://tinyurl.com/24zsbk*.

Foley, M. and Lennon, J., "JFK and Dark Tourism: A Fascination with Assassination," International *Journal of Heritage Studies* 2: 198–211 (1996).

Foley, M. and Lennon, J.,"Dark

Tourism— An Ethical Dilemma," in *Strategic Issues for the Hospitality: Tourism and Leisure Industries*, M. Foley, J. J. Lennon, and G. Maxwell, eds., (London: Cassell, 1997), pp. 153–164.

Lennon, J. and Foley, M., *Dark Tourism: The Attraction of Death and Disaster* (London: Continuum, 2000).

Rojek, C., *Ways of Seeing—Modern Transformations in Leisure and Travel* (London: Macmillan, 1993).

Seaton, A. V., "Thanatourism's Final Frontiers? Visits to Cemeteries, Churchyards and Funerary Sites as Sacred and Secular Pilgrimage, *Tourism Recreation Research*, 27: 73–82 (2002).

Yuill, S. M., *Dark Tourism: Understanding Visitor Motivation at Sites of Death and Disaster*, Master Thesis, Texas A&M University, December 2003, http://tinyurl.com/9mzshah.

"The Word: Dark Tourism" (unsigned article), *New Scientist* 2597: 50, March 31 2007.

Black Triangles (1997)

♪ Jacques Vallee writes, "If they are not an advanced race from the future, are we dealing instead with a parallel universe, another dimension where there are other human races living, and where we may go at our expense, never to return to the present? . . . From that mysterious universe, are higher beings projecting objects that can materialize and dematerialize at will? Are UFOs 'windows' rather than 'objects'?"

Knapp, G., Investigative Reporter, "Top Secret Black Triangles," *Las Vegas Now*, http://tinyurl.com/8zjtvyf.

Kurtz, P., "Escape to Oblivion," *Skeptical Inquirer*, 21(4), July/August 1997, http://tinyurl.com/8poumok.

Noory, G., "Foreword," in *The UFO Magazine UFO Encyclopedia* by W. J. Birnes (New York: Pocket, 2004).

Vallee, J., *Passport to Magonia: From Folklore to Flying Saucers* (Chicago: H. Regnery Co., 1969).

Dark Energy (1998)

Overbye, D., "9 Billion-Year-Old 'Dark Energy'", *The New York Times*, November 17, 2006, http://tinyurl.com/y99ls7r.

Tyson, N., "Gravity in Reverse," adapted from *Natural History Magazine* and appearing in *The Best American Science Writing 2004*, edited by D. Sobel. (New York: Ecco/HarperCollins, 2004), pp. 53–60.

Tyson, N. and Goldsmith, D., *Origins: Fourteen Billion Years of Cosmic Evolution* (New York: W. W. Norton, 2005).

Dark City (1998)

Lancaster, K. and Mikotowicz, T., *Performing the Force: Essays on Immersion into Science-Fiction, Fantasy and Horror Environments* (Jefferson, North Carolina: McFarland & Company, 2001).

Ebert, R., "Dark City," February 27, 1998, http://tinyurl.com/94ssj.

Darknets (2002)

Biddle, P., England, P., Peinado, M., and Willman, B., "The Darknet and the Future of Content Distribution," *Proceedings of the 2002 ACM Workshop on Digital Rights Management*, 2002, http://tinyurl.com/o7mpx.

Blackout (2003)

Munson, R., *From Edison to Enron: The Business of Power and What It Means for the Future of Electricity* (Westport, Connecticut: Praeger Publishers, 2005).

Black Admiral Restoration (2006)

Nash, G. B., *The Unknown American Revolution: The Unruly Birth of Democracy and the Struggle to Create America* (New York: Viking Adult, 2005).

Spencer, R. D., *The Expert Versus the Object: Judging Fakes and False Attributions in the Visual Arts* (New York: Oxford University Press, 2004).

Trivedi, B. P., "The Rembrandt Code," *WIRED* (December 2005), http://tinyurl.com/96xa4o.

Black Swan Theory (2007)

Pickover, C., *A Beginner's Guide to Immortality* (New York: Thunder's Mouth Press, 2006).

Taleb, N., "Learning to Expect the Unexpected," *New York Times*, April 8, 2004, http://tinyurl.com/9g9cvgs.

Taleb, N., *The Black Swan: The Impact of the Highly Improbable* (New York: Random House, 2007).

Blackest Black Color (2008)

Mizuno K., Ishii J.., Kishida H., Hayamizu Y., Yasuda S., Futaba D., Yumura M., and Hata K., "A Black Body Absorber from Vertically Aligned Single-Walled Carbon Nanotubes," *Proceedings of the National Academy of Sciences of the United States of America* 106(15): 6044-7 (2009).

Yang, Z., Ci, L., Bur, J.., Lin, S., and Ajayan, P., "Experimental Observation of an Extremely Dark Material Made By a Low-Density Nanotube Array," *Nano Letters*, 8(2): 446–451 (2008).

Lonely Black Sky (100 billion years AD)

Hopkins, B. and Rainey, C., *Sight Unseen: Science, UFO Invisibility and Transgenic* (New York: Pocket Star, 2004) Source of the John Ball quote.

Krauss, L. and Scherrer, R., "The End of Cosmology," *Scientific American* 298(3): 47–53 (March 2008).

Pickover, C., *The Science of Aliens* (New York: Basic Books, 1998).

Pickover, C., *The Stars of Heaven* (New York: Oxford University Press, 2001).

Verschuur, G., *Interstellar Matters* (New York: Springer, 1989).

Universe Fades to Black (100 trillion years AD)

♪ I always wonder about the possibility of life in this Dark Era

beyond 10^{100} years. Certainly, aliens that depend on water and organic compounds have vanished, but there may be a network of structures, spread out over unimaginably large distances, and these organized structures could store information. According to astrophysicist Gregory Laughlin, these structures, made out of whatever materials are available, will have extraordinarily low energy and will unfold extraordinarily slowly, but in some sense, the structure may always continue to exist in the universe. Could these structures be alive? What would the lives of these "Diffuse Ones" be like?

Pickover, C., *The Science of Aliens* (New York: Basic Books, 1998).

Adams, F. and Laughlin, G., *The Five Ages of the Universe: Inside the Physics of Eternity* (New York: Free Press, 2000).

Index

Act, Black, 64–65
Admiral, Black, 192–193
Angus, black, 88–89
Antiterrorism, black hole, 178–179

"Baby's in Black," 158–159
Bart, Black, 102–103
Black Beauty, 106–107
Black Black, 176–177
Black Drop Effect, 72–73
Black Hills, 4–5
Black holes, 76–77. *See also*
 Calcutta, Black Hole of;
 Antiterrorism, black hole.
"Black is Beautiful," 94–95
"Black Magic Woman," 164–165
Black Obelisk of Shalmaneser III,
 32–33
Black Prince, 48–49
Black Sea, 22–23
Black Sox Scandal, 128–129
Black Stone, 42–43
Black Tusk, 24–25
Blackbeard, 60–61
Blackbird Pie, 54–55
Blackdamp, 96–97
Blackface, 86–87
Blackjack, 68–69
Blacklist, 146–147
Blackmail, 56–57
Blackout, 190–191
Blackshirts, 124–125
Browning's Dark Tower, 92–93
Byron's "Darkness," 78–79

Cake, Black Forest, 122–123
Calcutta, Black Hole of, 70–71
Cat, black, 46–47
Chamber, Black, 126–127
"Coal Black Rose," 84–85
Codes, Black, 100–101
Color, blackest black, 196–197

Crown, Black, 50–51

Dahlia, Black, 144–145
Dark Ages, 40–41
Dark Ages, Greek, 30–31
Dark City, 186–187
Dark energy, 184–185
Dark matter, 136–137
Dark Shadows, 160–161
Dark Side, 174–175
Dark Side of the Moon, 156–157
Dark tourism, 180–181
Darknets, 188–189
Death, Black, 52–53
Diamonds, black, 2–3
Dragon Society, Black, 112–113

Fly, black, 10–11

Galaxy, Black Eye, 74–75
Goya's Black Paintings, 80–81
Guard, Black, 62–63

Hand of Serbia, Black, 120–121
Heart of Darkness, 114–115
Hoyle's Black Cloud, 154–155

Ice, black, 90–91
Iris, black, 16–17

Knifefish, black ghost, 20–21

Light, black, 116–117
Lightning, Black, 152–153
Lion Tamarin, Black, 170–171
Little Black Sambo, 108–109
Lonely black sky, 198–199

Madonna, Black, 44–45
Magic, black, 26–27
Mamba, black, 14–15
Mamo, Black, 118–119

Market, black, 130–131
Mass, black, 38–39
Men in Black, 148–149
Mold, black, 140–141
Museum, Black, 104–105

Nazarene, Black, 58–59

Outer Darkness, 36–37

"Paint It, Black," 162–163
Pepper, black, 28–29
Pudding, black, 34–35
Pullet, black, 66–67

Radiation Law, Blackbody, 110–111
Reinhardt's Black Paintings,
 150–151

Sabbath, Black, 166–167
Seadevil, black, 18–19
Slug, black, 6–7
Smoker, black, 172–173
Spider, Black Widow, 8–9
Sun, black, 142–143
Swallowtail, black, 12–13
Swan theory, black, 194–195

Triangles, black, 182–183
Tuesday, Black, 132–133

Universe fades to black, 200–201

Velvet paintings, black, 138–139
Volga legend, black, 168–169

War, Black, 82–83
War, Black Hawk, 98–99
"Whisperer in the Darkness,"
 134–135

Photo Credits

Because several of the old and rare illustrations shown in this book were difficult to acquire in a clean and legible form, I have sometimes taken the liberty to apply image-processing techniques to remove dirt and scratches, enhance faded portions, and occasionally add a slight coloration to a black-and-white figure in order to highlight details or to make an image more compelling. I hope that historical purists will forgive these slight artistic touches and understand that my goal was to create an attractive book that is aesthetically interesting and alluring to a wide audience. My love for the incredible depth and diversity of topics revolving around "black" should be evident through the photographs and illustrations.

Images Under License from Thinkstock.com: p. iii (Image 92836026), p. 5 (Image 92527630), p. 9 (Image 135138053), p. 13 (Image 155242522), p. 17 (Image 91766334), p. 23 (Image 147034718), p. 29 (Image 87646530), p. 35 (Image 84466876), p. 43 (Image 99420536), p. 47 (Image 140376856), p. 51 (Image 97744786), p. 59 (Image 101830359), p. 65 (Image 93433927), p. 69 (Image 92891942), p. 77 (Image 133883886), p. 79 (Image 126887527), p. 89 (Image 153741607), p. 91 (Image 147060243), p. 93 (Image 99264357), p. 97 (Image 92837369), p. 107 (Image 153884093), p. 111 (Image 87342689), p. 113 (Image 154240353), p. 123 (Image 159010040), p. 131 (Image 200259704), p. 135 (Image 87739980), p. 141 (Image 147444899), p. 149 (Image CC000017), p. 151 (Image 147878779), p. 159 (Image 92245197), p. 165 (Image 139735288), p. 167 (Image 134184317), p. 179 (Image E010326), p. 181 (Image 136736444), p. 185 (Image 133884295), p. 187 (Image 95268820), p. 195 (Image 120899915), p. 197 (Image 89614779), p. 212 (Image 164155145). All images copyright ©Thinkstock.com

Other Images: p. 3 NASA/DOE/Fermi LAT Collaboration, CXC/SAO/JPL-Caltech/Steward/O. Krause et al., and NRAO/AUI; p. 7 Peter Korkala/Wikimedia; p. 11 USDA (SEM Plate #04999); p. 15 Bill Love, Blue Chameleon Ventures; p. 19 Wikimedia; p. 21 Per Erik Sviland; p. 25 Andysonic777/Wikimedia; p. 27 Wikimedia; p. 31 Rosemania/Wikimedia; p. 33 Steven G. Johnson/Wikimedia; p. 37 Petrusbarbygere/Wikimedia; p. 39 ImagesFromBulgaria.com/Martha Forsyth/Wikimedia; p. 41 Gernot Keller/Wikimedia; p. 45 Deror Avi/Wikimedia; p. 49 Edward, the Black Prince, from *Cassell's Illustrated History of England, Century Edition* (c. 1902); p. 53 Wikimedia; p. 55 Wikimedia; p. 57 Wikimedia; p. 61 John Carter Brown Library; p. 67 Rex/Wikimedia; p. 71 Louis Figuier; p. 73 Gestrgangleri/Wikimedia; p. 75 NASA and The Hubble Heritage Team (AURA/STScI); p. 81 Museo Nacional del Prado/Wikimedia; p. 83 Wikipedia; p. 85 Wikipedia; p. 87 Wikimedia; p. 95 Wikimedia; p. 99 Sanjay Acharya/Wikimedia; p. 101 Randolph Linsly Simpson African-American Collection, Beinecke Rare Book & Manuscript Library, Yale University/Wikimedia; p. 103 Wikimedia; p. 105 Metropolitan Police Service, National Archives/Wikimedia; p. 115 U.S. Library of Congress; p. 117 Natasja Delang/Georges Jansoone; p. 121 Wikimedia; p. 125 Wikimedia; p. 127 USAF/NSA/Wikimedia; p. 129 Wikipedia; p. 133 Library of Congress; p. 137 NASA/ESA/Richard Massey (California Institute of Technology); p. 139 Wikipedia; p. 143 Ratatosk/Wikimedia; p. 145 Wikimedia; p. 147 *Los Angeles Times*; p. 153 Mario Roberto Duran Ortiz/Wikimedia; p. 155 ESO; p. 157 NASA/Goddard; p. 161 Jim McCullars/Wikimedia; p. 169 Laima Gutmane (Simka)/Wikimedia; p. 171 Alan Hill/Wikimedia; p. 173 NOAA PMEL Vents Program (www.pmel.noaa.gov); p. 175 Michael Neel/Wikimedia; p. 177 Yotoen/Wikimedia; p. 183 J. S. Henrardi/Wikimedia; p. 191 DMSP/NOAA; p. 193 Wikimedia; p. 199 NASA and ESA; p. 201 NASA, Dana Berry/Jörn Wilms/Wikimedia.

Cover images, front, l. to r.: p. 123, p. 179, p. 53, p. 17, p. 69, p. 61, p. 165, p. 131, p. 35, p. 167, p. 195, p. 9, p. 193, p. 81, p. 155, p. 145, p. 77, p. 11, p. 71, p. 115; back, l. to r.: p. 121, p. 75, p. 135, p. 181.

Black Diamonds Black Fly Black Code
Black Hills Black Slug Death by Blackdamp
Browning's Dark Tower Black Sea
Black Widow Spider Black Swallowtail
Black Mamba Black Iris Black Seadevil
Black Magic
Black Ghost Knifefish Black Tusk Blackma...
Black Act Greek Dark Ages Black Hawk War
Black Obelisk of Shalmaneser III Black Pepper
Outer Darkness Black Mass Black Stone
Black Pudding Blackbeard
Dark Ages Black Madonna Black Cat Fea...
The Black Guard
Black Crown Black Prince
Blackbird Pi...
Black Pullet Blackjack Black Wa...
Black Drop Effect Black Hole of Calcutta
Black Holes Black Eye Galaxy Discovery
Blackface Goya's Black Paintings Black Angus
Black Nazarene "Coal Black Rose"
Black Ice Byron's "Darkness"
"Black is Beautiful" Black Death